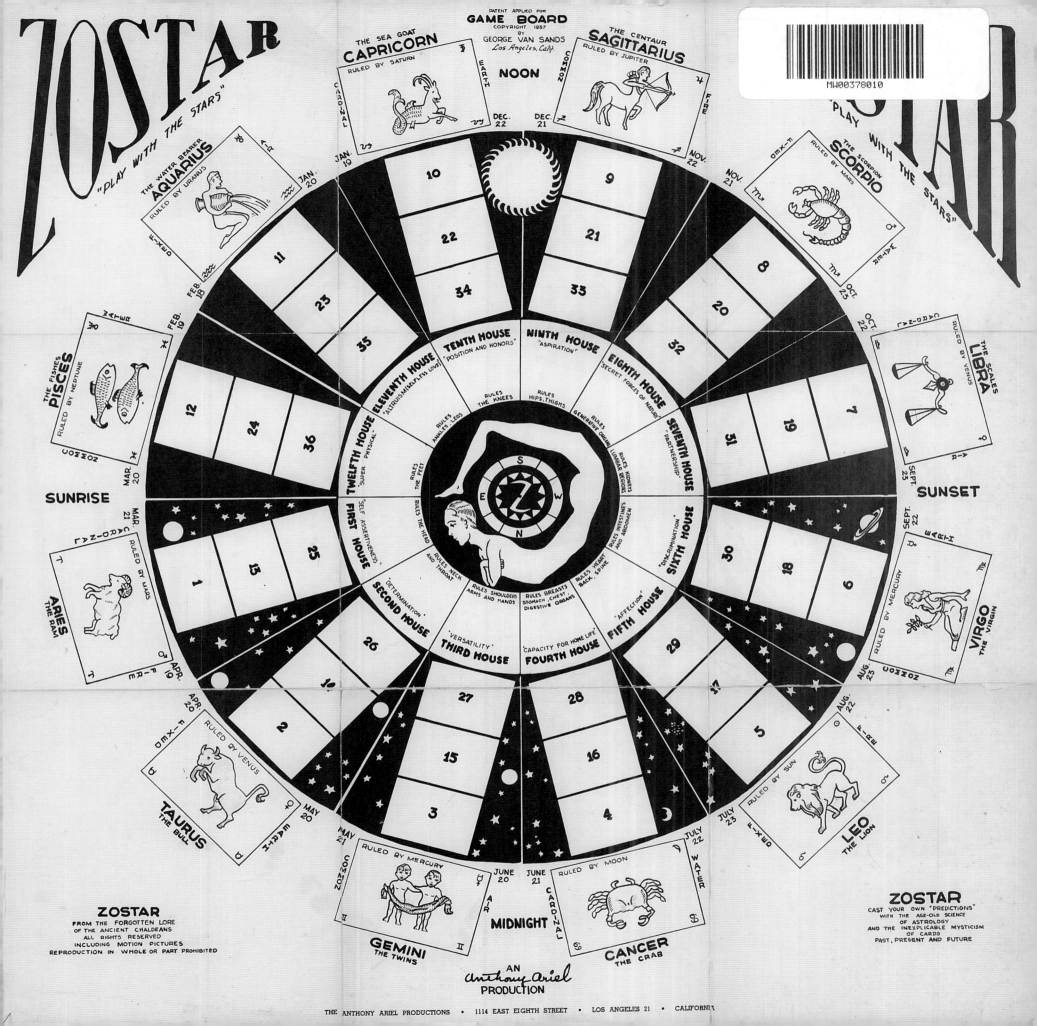

ASTROLOGY

ASTROLOGY PICTURES
IMÁGENES ASTROLÓGICAS
IMMAGINI ASTROLOGICHE
ASTROLOGIEBILDER
IMAGENS ASTROLÓGICAS
IMAGES ASTROLOGIQUES
АСТРОЛОГИЧЕСКИЕ КАРТИНКИ
占星術の絵柄集
占星图片集

THE PEPIN PRESS | AGILE RABBIT EDITIONS
AMSTERDAM & SINGAPORE

CARD No. 2
TAURUS
April 21st to May 20th
RULING PLANET—Venus
SECOND HOUSE
Pertains to Money and Property
The following are the astrological characteristics of this sign:—

POSITIVE	NEGATIVE
Trustworthy	Stubborn
Self-Reliant	Domineering
Practical	Meddlesome
Steady	Self-Centered
Persistent	Conceited
Cautious	Lazy
Domestic	Headstrong
Careful	Covetous

HARMONIZE BEST WITH—CAPRICORN, VIRGO; next best with PISCES, CANCER and SCORPIO.

OCCUPATION—Succeed best in constructive work and matters connected with the earth.

PECULIARITIES—Stubborn when interfered with. Steadfast and unshaken by adversity.

LUCKY DAY—FRIDAY.

LUCKY GEM—EMERALD.

LUCKY COLOR—ORCHID.

CARD No. 1
ARIES
March 21st to April 20th
RULING PLANET—Mars
FIRST HOUSE
Pertains to Personal Affairs
The following are the astrological characteristics of this sign:—

POSITIVE	NEGATIVE
Enterprising	Headstrong
Enthusiastic	Excitable
Ambitious	Belligerent
Generous	Selfish
Courageous	Reckless
Sincere	Jealous
Sensitive	Fiery
Industrious	Unsettled

HARMONIZE BEST WITH—LEO, SAGITTARIUS; next best with GEMINI, AQUARIUS and LIBRA.

OCCUPATION—Succeed best where individual talents and leadership are essential.

PECULIARITIES—Do not like opposition, possess originality but prefer to have others take care of the details.

LUCKY DAY—TUESDAY.

LUCKY GEM—BLOODSTONE, DIAMOND.

LUCKY COLOR—ALL SHADES OF RED.

CARD No. 12
PISCES
February 19th to March 20th
RULING PLANET—Neptune
TWELFTH HOUSE
Pertains to Secrets and Enemies
The following are the astrological characteristics of this sign:—

POSITIVE	NEGATIVE
Intuitive	Dreamy
Restful	Veritable
Proud	Promiscuous
Loving	Indolent
Abiding	Indecisive
Receptive	Apologetic
Sympathetic	Melancholy
Discreet	Shy

HARMONIZE BEST WITH — SCORPIO, CANCER; next best with TAURUS, CAPRICORN and VIRGO.

OCCUPATION—Succeed best where intuitive judgment, industry and discretion are important for success.

PECULIARITIES—A deep hidden love nature. Will defend their friends whether they are right or wrong.

LUCKY DAY—FRIDAY.

LUCKY GEM—BLOODSTONE.

LUCKY COLOR—LAVENDER.

CARD No. 11
AQUARIUS
January 20th to February 18th
RULING PLANET—Uranus
ELEVENTH HOUSE
Pertains to Friends, Hopes and Wishes
The following are the astrological characteristics of this sign:—

POSITIVE	NEGATIVE
Earnest	Irrational
Refined	Undecided
Pleasant	Over-Cautious
Independent	Chaotic
Sincere	Diffusive
Humane	Radical
Unbiased	Unimaginative
Patient	Over-Anxious

HARMONIZE BEST WITH—LIBRA, GEMINI; next best with SAGITTARIUS, ARIES and LEO.

OCCUPATION—Scientific investigation and employment requiring strength and firmness.

PECULIARITIES—Chronic promise-breakers. Waste time asking advice they never follow.

LUCKY DAY—WEDNESDAY.

LUCKY GEM—AMETHYST.

LUCKY COLOR—BRICK RED.

CARD No. 6
VIRGO
August 23rd to September 22nd
RULING PLANET—Mercury
SIXTH HOUSE
Pertains to Health, Work and Servants
The following are the astrological characteristics of this sign:—

POSITIVE	NEGATIVE
Thoughtful	Calculating
Active	Officious
Serious	Irritable
Generous	Apprehensive
Moderate	Discontented
Refined	Skeptical
Intellectual	Cold
Faithful	Selfish

HARMONIZE BEST WITH—TAURUS, CAPRICORN; next best with SCORPIO and PISCES.

OCCUPATION—Succeed best in positions requiring light work, detail and discrimination.

PECULIARITIES—They like to tell people their faults for their own good, but resent being told of their own.

LUCKY DAY—WEDNESDAY.

LUCKY GEM—SAPPHIRE.

LUCKY COLOR—PALE GREEN.

CARD No. 5
LEO
July 23rd to August 22nd
RULING PLANET—Sun
FIFTH HOUSE
Pertains to Love Affairs, Speculation and Children
The following are the astrological characteristics of this sign:—

POSITIVE	NEGATIVE
Ardent	Arrogant
Loyal	Dictatorial
Tolerant	Gullible
Fearless	Over-Bearing
Inspirational	Hot-Headed
Magnetic	Impetuous
Generous	Pompous
Outspoken	Sensitive

HARMONIZE BEST WITH—ARIES, SAGITTARIUS; next best with GEMINI, LIBRA and AQUARIUS.

OCCUPATION—Succeed best at the head of their own business or where they are able to command.

PECULIARITIES — Furious when aroused. Always ready with advice but seldom take it.

LUCKY DAY—SUNDAY.

LUCKY GEM—RUBY, SARDONYX.

LUCKY COLOR—GOLD.

CARD No. 4
CANCER
June 22nd to July 22nd
RULING PLANET—Moon
FOURTH HOUSE
Pertains to Home Affairs
The following are the astrological characteristics of this sign:—

POSITIVE	NEGATIVE
Tenacious	Grasping
Intent	Changeable
Kind	Touchy
Adaptable	Untruthful
Sociable	Variable
Studious	Restless
Versatile	Brooding
Domestic	Jealous

HARMONIZE BEST WITH—PISCES, SCORPIO; next best with TAURUS, VIRGO and CAPRICORN.

OCCUPATION—Succeed best as a teacher, educator or any profession pertaining to the masses.

PECULIARITIES—Fond of notoriety. Liable to gloomy periods.

LUCKY DAY—MONDAY.

LUCKY GEM—PEARL, RUBY.

LUCKY COLOR—PALE YELLOW.

CARD No. 3
GEMINI
May 21st to June 21st
RULING PLANET—Mercury
THIRD HOUSE
Pertains to Journeys and Relatives
The following are the astrological characteristics of this sign:—

POSITIVE	NEGATIVE
Ambitious	Flighty
Intellectual	Wayward
Active	Tricky
Resourceful	Complex
Diversified	Shifty
Tolerant	Erratic
Eloquent	Fickle
Idealistic	Unstable

HARMONIZE BEST WITH — AQUARIUS, LIBRA; next best with ARIES, LEO and SAGITTARIUS.

OCCUPATION—Succeed best where artistic or inventive expression is essential.

PECULIARITIES—Restless. Constantly changing their minds.

LUCKY DAY—WEDNESDAY.

LUCKY GEM—EMERALD, PEARL.

LUCKY COLOR—BROWN.

CARD No. 10
CAPRICORN
December 22nd to January 19th
RULING PLANET—Saturn
TENTH HOUSE
Pertains to Credit and Reputation
The following are the astrological characteristics of this sign:—

POSITIVE	NEGATIVE
Practical	Restless
Thoughtful	Selfish
Ambitious	Shy
Magnetic	Discontented
Diplomatic	Turbulent
Profound	Depressed
Conventional	Bigoted
Particular	Eccentric

HARMONIZE BEST WITH — VIRGO, TAURUS; next best with SCORPIO, PISCES and CANCER.

OCCUPATION—Make fine teachers, ministers, public speakers. Possess organizing and concentrative ability.

PECULIARITIES—Resent people prying into their affairs, but are great hands for prying into other people's business.

LUCKY DAY—SATURDAY.

LUCKY GEM—TURQUOISE, GARNET.

LUCKY COLOR—TAN.

CARD No. 9
SAGITTARIUS
November 22nd to December 21st
RULING PLANET—Jupiter
NINTH HOUSE
Pertains to Journeys and Legal Matters
The following are the astrological characteristics of this sign:—

POSITIVE	NEGATIVE
Independent	Proud
Generous	Secretive
Impulsive	Defiant
Dependable	Boisterous
Foresighted	Over-Confident
Active	Rash
Frank	Changeable
Honest	Calculating

HARMONIZE BEST WITH — LEO, ARIES; next best with LIBRA, AQUARIUS and GEMINI.

OCCUPATION — Natural mechanics. Success in travel and explorations.

PECULIARITIES—Blunt and outspoken. Hate anything secretive.

LUCKY DAY—THURSDAY.

LUCKY GEM—TURQUOISE.

LUCKY COLOR—SKY-BLUE.

CARD No. 8
SCORPIO
October 23rd to November 21st
RULING PLANET—Mars
EIGHTH HOUSE
Pertains to Inheritance and Deaths
The following are the astrological characteristics of this sign:—

POSITIVE	NEGATIVE
Active	Shrewd
Energetic	Sarcastic
Tenacious	Stingy
Pleasant	Pessimistic
Positive	Severe
Optimistic	Destructive
Thoughtful	Vindictive
Devoted	Eccentric

HARMONIZE BEST WITH—CANCER, PISCES; next best with VIRGO, CAPRICORN and TAURUS.

OCCUPATION—Succeed best in positions requiring patience and concentration. Make excellent surgeons and possess good mechanical skill.

PECULIARITIES—They will allow no one to impose upon them. Inclined to be sarcastic.

LUCKY DAY—TUESDAY.

LUCKY GEM—TOPAZ.

LUCKY COLOR—BLUE-GREEN.

CARD No. 7
LIBRA
September 23rd to October 22nd
RULING PLANET—Venus
SEVENTH HOUSE
Pertains to Marriage and Partnerships
The following are the astrological characteristics of this sign:—

POSITIVE	NEGATIVE
Thoughtful	Ambitious
Gracious	Elusive
Impartial	Vain
Compassionate	Cowardly
Modest	Shallow
Artistic	Susceptible
Affectionate	Reckless
Refined	Indecisive

HARMONIZE BEST WITH — GEMINI, AQUARIUS; next best with LEO, SAGITTARIUS and ARIES.

OCCUPATION—Succeed best in professions requiring good taste, art or music.

PECULIARITIES—Worry over trifles. Always looking for something better. Excellent intuition.

LUCKY DAY—FRIDAY.

LUCKY GEM—OPAL.

LUCKY COLOR—GRAY.

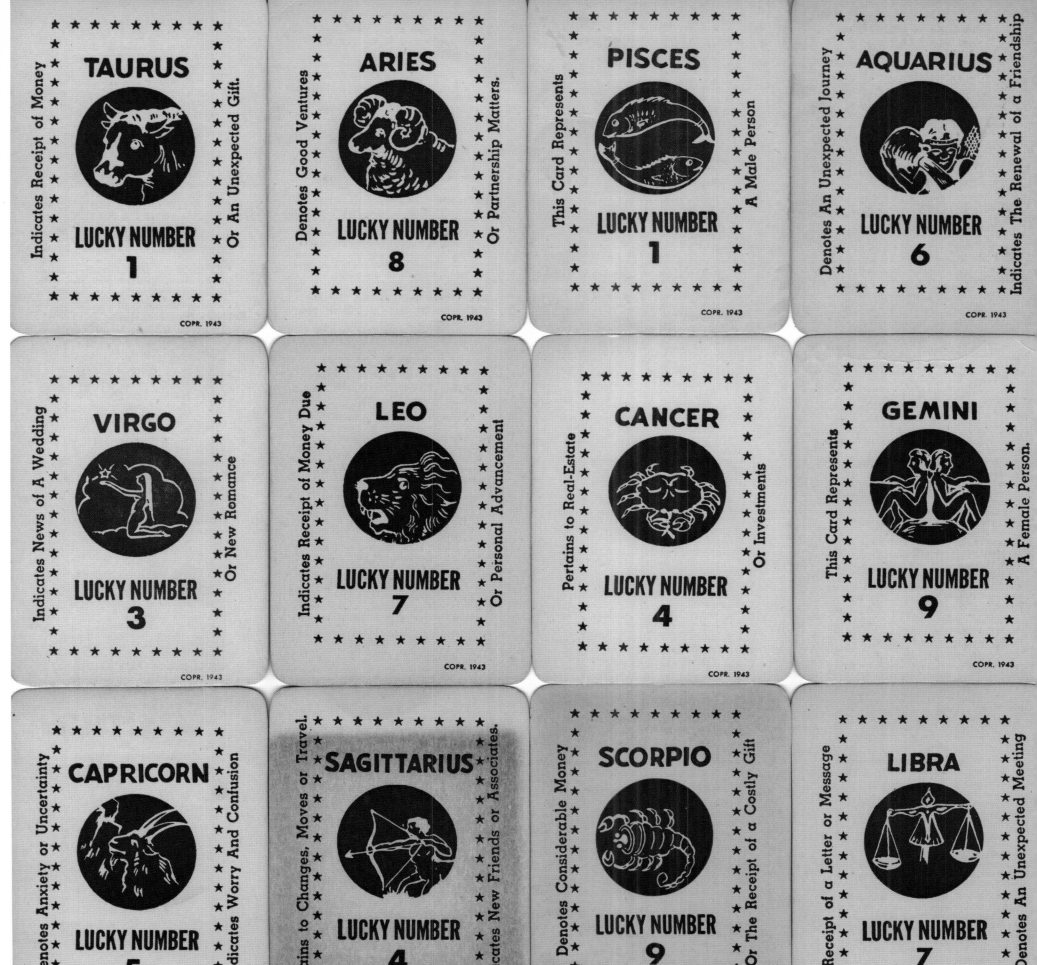

LES DOUZE SIGNES DU ZODIAQUE.

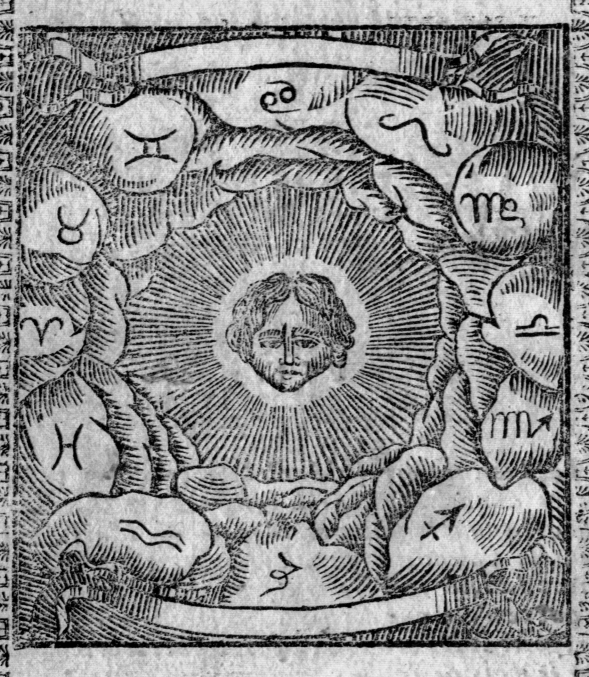

En ces Signes ne saignerez ,
Quand la Lune y sera entrée.

The Pepin Press BV
P.O. Box 10349
1001 EH Amsterdam
The Netherlands

tel +31 20 4202021
fax +31 20 4201152
mail@pepinpress.com
www.pepinpress.com

Text & design by Pepin van Roojen
Layout by Pepin van Roojen &
 Tosca Lindenboom
Editorial contributions by Heine Scholtens

All images are from the Pepin Press archives

ISBN 978 90 5768 052 6

10 9 8 7 6 5 4 3 2 1
2012 11 10 09 08

Manufactured in Singapore

Contents

CD-ROM inside the back cover

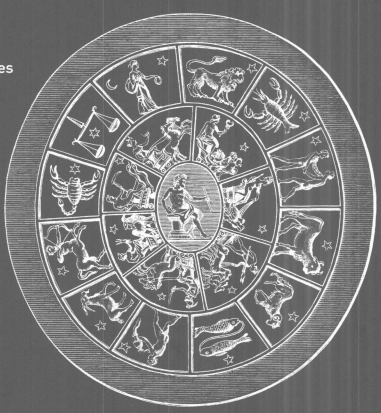

THE PEPIN PRESS | AGILE RABBIT EDITIONS

Picture Collections
978 90 5768 051 9 Historical & Curious Maps
978 90 5768 116 5 World Musical Instruments
978 90 5768 035 9 Skeletons
978 90 5768 007 6 Images of the Human Body
978 90 5768 066 3 Mythology Pictures
978 90 5768 014 4 Menu Designs

Tile Designs
978 90 5768 115 8 Havana Tile Designs
978 90 5768 099 1 Tile Designs from Portugal
978 90 5768 123 3 Barcelona Tile Designs (new edition)
978 90 5768 022 9 Traditional Dutch Tile Designs

Graphic Themes
978 90 5768 001 4 1000 Decorated Initials
978 90 5768 003 8 Graphic Frames
978 90 5768 016 8 Graphic Ornaments (2 CDs)
978 90 5768 055 7 Signs & Symbols
978 90 5768 062 5 Fancy Alphabets

Textile Patterns
978 90 5768 102 8 European Folk Patterns
978 90 5768 101 1 Flower Power
978 90 5768 100 4 Kimono Patterns
978 90 5768 113 4 Tapestry
978 90 5768 004 5 Batik Patterns
978 90 5768 030 4 Weaving Patterns
978 90 5768 037 3 Lace
978 90 5768 038 0 Embroidery
978 90 5768 058 8 Ikat Patterns
978 90 5768 009 0 Indian Textile Prints
978 90 5768 075 5 Textile Motifs of India
978 90 5768 112 7 Fabric: Textures & Patterns

Pattern & Design Collections
978 90 5768 005 2 Floral Patterns
978 90 5768 096 0 Paisley Patterns
978 90 5768 107 3 Marbled Paper Design
978 90 5768 076 2 Watercolour Patterns
978 90 5768 061 8 Wallpaper Designs
978 90 5768 108 0 Geometric Patterns (new edition)

Fonts
978 90 5768 124 0 Free Font Index

Historical Styles
978 90 5768 119 6 Repeating Patterns 1100~1800
978 90 5768 027 4 Mediæval Patterns
978 90 5768 092 2 Gothic Patterns
978 90 5768 034 2 Renaissance Patterns
978 90 5768 033 5 Baroque Patterns
978 90 5768 043 4 Rococo Patterns
978 90 5768 013 7 Art Nouveau Designs
978 90 5768 097 7 Jugendstil
978 90 5768 060 1 Fancy Designs 1920
978 90 5768 059 5 Patterns of the 1930s

Cultural Styles
978 90 5768 104 2 Islamic Designs from Egypt
978 90 5768 036 6 Turkish Designs
978 90 5768 121 9 Islamic Designs (new edition)
978 90 5768 071 7 Arabian Geometric Patterns
978 90 5768 029 8 Persian Designs
978 90 5768 006 9 Chinese Patterns
978 90 5768 020 5 Japanese Patterns
978 90 5768 110 3 Japanese Papers
978 90 5768 125 7 Decorative Patterns from Italy

Web Design
978 90 5768 093 9 Web Design Index 6
978 90 5768 105 9 Web Design Index 7
978 90 5768 122 6 Web Design Index 8
978 90 5768 103 5 Web Design Index by Content.02
978 90 5768 111 0 Web Design Index by Content.03

Packaging & Folding
978 90 5768 039 7 How To Fold
978 90 5768 040 3 Folding Patterns for Display & Publicity
978 90 5768 044 1 Structural Package Designs
978 90 5768 114 1 Take One
978 90 5768 054 0 Special Packaging

Photographs
978 90 5768 047 2 Fruit
978 90 5768 048 9 Vegetables
978 90 5768 057 1 Female Body Parts
978 90 5768 070 0 Flowers

Fashion Books
978 90 5496 138 3 Fifties Fashion
978 90 5496 140 6 Fashion Prints
978 90 5496 086 7 Fashion Design 1800-1940
978 90 5496 135 2 Art Deco Fashion
978 90 5496 110 9 Spectacles & Sunglasses
978 90 5496 109 3 Bags
978 90 5496 080 5 Figure Drawing for Fashion Design
978 90 5496 125 3 Wrap & Drape Fashion
978 90 5496 068 3 Traditional Henna Designs
978 90 5496 058 4 Fashion Accessories

Art Books
978 90 5496 090 4 Crown Jewellery
978 90 5496 141 3 Ethnic Jewellery
978 90 5496 008 9 The Straits Chinese
978 90 5496 005 8 Batik Design

Many more titles in preparation
In addition to the Agile Rabbit series of book+CD-ROM sets, The Pepin Press publishes a wide range of books on graphic and web design, typography, art, architecture, fashion, costume, textiles, jewellery and popular culture.

Please visit www.pepinpress.com for more information.

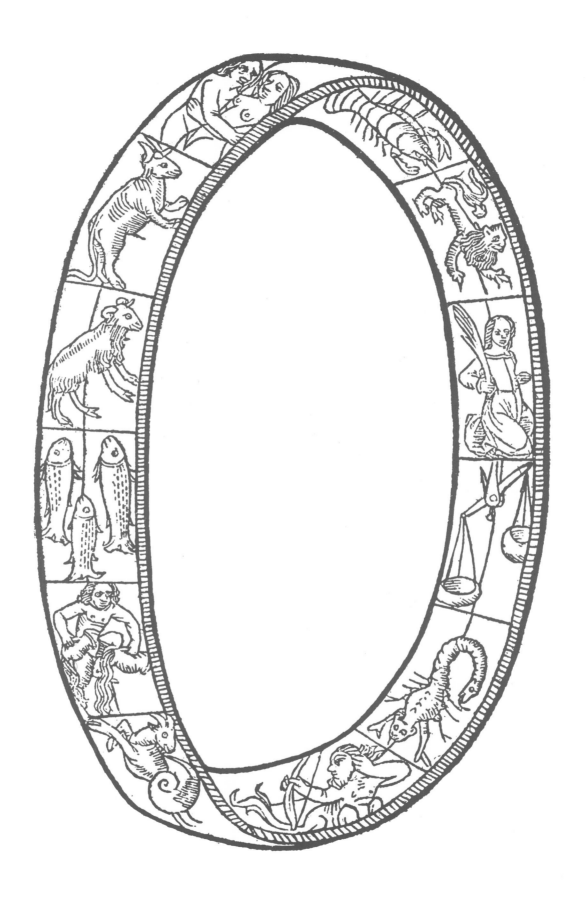

Astrology Pictures

The scope of this book is to present a collection of amazing, interesting and beautiful images associated with the spiritual discipline of astrology.

In the quest to understand more about our existence and the forces that drive us, people have studied the influence of the movement of planetary bodies on our life on earth. The oldest form of horoscopic astrology is probably the Hindu or Vedic variant, which is over 5000 years old. The Western and Arabian tradition originates from Mesopotamia and started some 4000 years ago. Both forms adhere to the same underlying principle, namely the interpretation of the heavens at a specific moment in time. Thus, the placement of the planets at the moment of a person's birth, for instance, would have an influence on that person's character and future. The planets seem to move along a band of constellations called the zodiac, from which twelve astrological signs have been derived. Believers think that these twelve signs each represent a basic type of personality.

In contrast to the Western and Indian form of Astrology, Chinese astrology is based on the moon's movement through the sky. From this, the Chinese have derived a very different system with its own zodiac, also with twelve signs, each corresponding with years of the Chinese calendar.

This book starts with pictures featuring astrologers (pages 12-21), followed by visualizations of celestial influences (pages 22-26), representations of the planets (pages 26-33) and signs of the Western zodiac (pages 34-65). Pages 66-75 contain images from Egypt and Arabia, and pages 76-79 from India and Java. The imagery of Chinese astrology (and its related forms from Japan, Tibet and Mongolia) can be found on pages 80-101. Pages 102-109 contain images of the ancient Mayan date system. Horoscopes, including those of some very famous people, are on pages 110-119. The last part of the book, pages 120-127, contains charts that show the perceived influence of the zodiac on the human body.

CD-Rom & Image Rights

The images in this book can be used as a graphic resource and for inspiration. All the illustrations are stored on the enclosed CD-ROM and are ready to use for printed media and web page design. The pictures can also be used to produce postcards, either on paper or digitally, or to decorate your letters, flyers, T-shirts, etc. They can be imported directly from the CD into most software programs. Some programs will allow you to access the images directly; in others, you will first have to create a document, and then import the images. Please consult your software manual for instructions.

The names of the files on the CD-ROM correspond with the page numbers in this book. The CD-ROM comes free with this book, but is not for sale separately. The files on Pepin Press/Agile Rabbit CD-ROMs are sufficiently large for most applications. However, larger and/or vectorised files are available for most images and can be ordered from The Pepin Press/Agile Rabbit Editions. For non-professional applications, single images can be used free of charge. The images cannot be used for any type of commercial or otherwise professional application – including all types of printed or digital publications – without prior permission from The Pepin Press/Agile Rabbit Editions. Our permissions policy is very reasonable and fees charged, if any, tend to be minimal.

For inquiries about permissions and fees, please contact:
mail@pepinpress.com
Fax +31 20 4201152

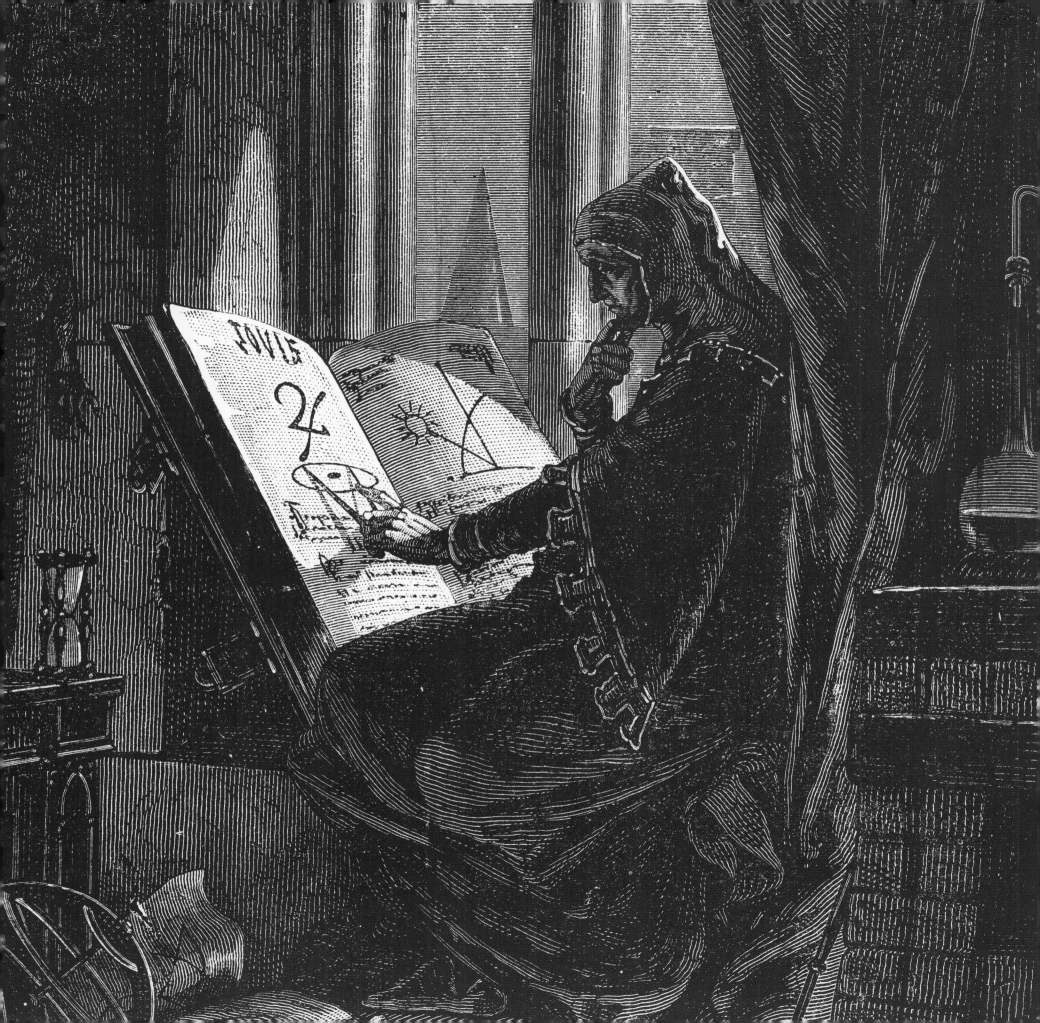

Immagini astrologiche

L'idea di questo libro è di mostrare tutta una serie di immagini belle, interessanti e sorprendenti legate alla disciplina spirituale dell'astrologia.

Desideroso di conoscere di più sulla sua esistenza e sulle forze che guidano la nostra vita, l'essere umano ha da sempre studiato l'influenza del movimento dei corpi celesti sulla nostra presenza sulla terra. Le prime tracce di astrologia dell'oroscopo si possono far risalire a più di 5000 anni fa, se si pensa alla variante hindu o vedica, mentre in Occidente e nei paesi arabi la tradizione nasce nella Mesopotamia 4000 anni or sono. Entrambe le forme sono fedeli allo stesso principio fondamentale che si basa sull'interpretazione dei cieli in un periodo di tempo ben definito. Per questo motivo, ad esempio c'è chi pensa che la posizione dei pianeti al momento della nascita di una persona influisca sul carattere o sul futuro della persona stessa. Sembra che i pianeti si muovano lungo una serie di costellazioni chiamate zodiaco, da cui sono nati dodici segni zodiacali, ciascuno dei quali, secondo alcuni, rappresenta un tipo di personalità differente.

A differenza della forma di astrologia sviluppata in Occidente e in India, quella cinese si basa sul movimento della luna nel cielo, e ha dato vita a un sistema zodiacale completamente diverso, anch'esso formato da dodici segni, ciascuno dei quali corrisponde a determinati anni del calendario cinese.

La prima parte del libro mostra le illustrazioni di alcuni astrologi (pagine 12-21) seguite da immagini riguardanti le influenze celesti (pagine 22-26), le rappresentazioni di pianeti (pagine 26-33) e i segni dello zodiaco Occidentale (pagine 34-65). Le pagine 66-75 mostrano immagini dell'Egitto e dell'Arabia, mentre le pagine 76-79 sono dedicate all'India e a Giava. L'iconografia dell'astrologia cinese (e le corrispettive forme sviluppate in Giappone, Tibet e Mongolia) si trova alle pagine 80-101, mentre le pagine 102-109 sono occupate dall'antico calendario maya. Gli oroscopi, compresi quelli di alcuni personaggi famosi, si trovano alle pagine 110-119, mentre l'ultima parte del libro (pagine 120-127) contiene alcune tabelle che illustrano in che modo lo zodiaco influisce sul corpo umano.

CD ROM e diritti d'immagine

Le immagini contenute in questo libro possono essere utilizzate come risorsa grafica e come ispirazione. Tutte le illustrazioni sono salvate sul CD ROM incluso e sono pronte ad essere utilizzate per la stampa su qualsiasi tipo di supporto e per il design di pagine web. Le immagini possono anche essere utilizzate per produrre delle cartoline, in forma stampata o digitale, o per decorare le vostre lettere, volantini, magliette, eccetera. Possono essere direttamente importate dal CD nella maggior parte dei programmi software. Alcuni programmi vi permetteranno l'accesso diretto alle immagini; in altri, dovrete prima creare un documento, e poi importare le immagini. Vi preghiamo di consultare il manuale del vostro software per ulteriori istruzioni.

I nomi dei file sul CD ROM corrispondono ai numeri di pagina indicati nel libro. Il CD ROM viene fornito gratis con il libro, ma non è in vendita separatamente. I file sui CD ROM della Pepin Press/Agile Rabbit sono di dimensione adatta per la maggior parte delle applicazioni. In ogni caso, per la maggior parte delle immagini sono disponibili file più grandi o vettoriali, che possono essere ordinati alla Pepin Press/Agile Rabbit Editions. Delle singole immagini possono essere utilizzate senza costi aggiuntivi a fini non professionali. Le immagini non possono essere utilizzate per nessun tipo di applicazione commerciale o professionale – compresi tutti i tipi di pubblicazioni stampate e digitali – senza la previa autorizzazione della Pepin Press/Agile Rabbit Editions. La nostra gestione delle autorizzazioni è estremamente ragionevole e le tariffe addizionali applicate, qualora ricorrano, sono minime.

Per ulteriori domande riguardo le autorizzazioni e le tariffe, vi preghiamo di contattarci ai seguenti recapiti:
mail@pepinpress.com
Fax +31 20 4201152

Astrologiebilder

Ziel dieses Buches ist es, eine Sammlung erstaunlicher, interessanter und wunderschöner Abbildungen zu präsentieren, die mit der spirituellen Disziplin der Astrologie verbunden sind.

Im Bestreben, mehr von unserer Existenz zu verstehen und die Kräfte zu begreifen, die uns antreiben, haben Menschen den Einfluss der Bewegung der Planeten auf unser Leben auf der Erde studiert. Die älteste Form der Horoskop-Astrologie ist wahrscheinlich die hinduistische oder vedische Variante, die über 5000 Jahre alt ist. Der Ursprung der westlichen und arabischen Tradition liegt in Mesopotamien und begann vor etwa 4000 Jahren. Beide Formen halten sich dabei an das gleiche zugrunde liegende Prinzip, nämlich die Interpretation des Sternenhimmels zu einem bestimmten Zeitpunkt. Daher haben die Position der Planeten, beispielsweise zum Zeitpunkt der Geburt einer Person, einen Einfluss auf den Charakter und die Zukunft dieses Menschen. Die Planeten scheinen sich dabei an einem Band von Konstellationen vorbei zu bewegen, das als Tierkreis bezeichnet wird. Von diesem Kreis wurden zwölf astrologische Zeichen abgeleitet. Gläubige sind der Meinung, dass jedes dieser zwölf Zeichen jeweils eine grundlegende Persönlichkeit darstellt.

Im Gegensatz zur westlichen und indischen Form der Astrologie basiert die chinesische Astrologie auf den Bewegungen des Mondes am Himmel. Hiervon haben die Chinesen ein vollkommen anderes System mit ihren eigenen Tierkreiszeichen abgeleitet, das ebenfalls zwölf Zeichen hat und den Jahren des chinesischen Kalenders entspricht.

Dieses Buch beginnt mit Bildern von Astrologen (Seite 12-21), gefolgt von Veranschaulichungen von himmlischen Einflüssen (Seite 22-26), Darstellungen der Planeten (Seite 26-33) und den Zeichen des westlichen Tierkreises (Seite 34-65). Seite 66-75 beinhaltet Abbildungen aus Ägypten und Arabien und Seite 76-79 aus Indien und Java. Die Bilder der chinesischen Astrologie (und der damit verwandten Formen aus Japan, Tibet und der Mongolei) sind auf Seite 80-101 zu finden. Seite 102-109 beinhaltet Bilder des antiken Datumssystems der Maya. Horoskope, darunter einige für Berühmtheiten, werden auf Seite 110-119 präsentiert. Der letzte Teil des Buches, Seite 120-127, enthält Veranschaulichungen, die den wahrgenommenen Einfluss des Tierkreises auf den menschlichen Körper darstellen.

CD-ROM und Bildrechte

Dieses Buch enthält Bilder, die als Ausgangsmaterial für grafische Zwecke oder als Anregung genutzt werden können. Alle Abbildungen sind auf der beiliegenden CD-ROM gespeichert und lassen sich direkt zum Drucken oder zur Gestaltung von Webseiten einsetzen. Sie können die Designs aber auch als Motive für Postkarten (auf Karton bzw. in digitaler Form) oder als Ornament für Ihre Briefe, Broschüren, T-Shirts usw. verwenden. Die Bilder lassen sich direkt von der CD in die meisten Softwareprogramme laden. Bei einigen Programmen lassen sich die Grafiken direkt einladen, bei anderen müssen Sie zuerst ein Dokument anlegen und können dann die jeweilige Abbildung importieren. Genauere Hinweise dazu finden Sie im Handbuch Ihrer Software.

Die Namen der Bilddateien auf der CD-ROM entsprechen den Seitenzahlen dieses Buchs. Die CD-ROM wird kostenlos mit dem Buch geliefert und ist nicht separat verkäuflich. Alle Bilddateien auf den CD-ROMs von The Pepin Press/Agile Rabbit wurden so groß dimensioniert, dass sie für die meisten Applikationen ausreichen; zusätzlich können jedoch größere Dateien und/oder Vektorgrafiken der meisten Bilder bei The Pepin Press/Agile Rabbit Editions bestellt werden. Einzelbilder dürfen für nicht-professionelle Anwendungen kostenlos genutzt werden; dagegen muss für die Nutzung der Bilder in kommerziellen oder sonstigen professionellen Anwendungen (einschließlich aller Arten von gedruckten oder digitalen Medien) unbedingt die vorherige Genehmigung von The Pepin Press/Agile Rabbit Editions eingeholt werden. Allerdings handhaben wir die Erteilung solcher Genehmigungen meistens recht großzügig und erheben – wenn überhaupt – nur geringe Gebühren.

Für Fragen zu Genehmigungen und Preisen wenden Sie sich bitte an:
mail@pepinpress.com
Fax +31 20 4201152

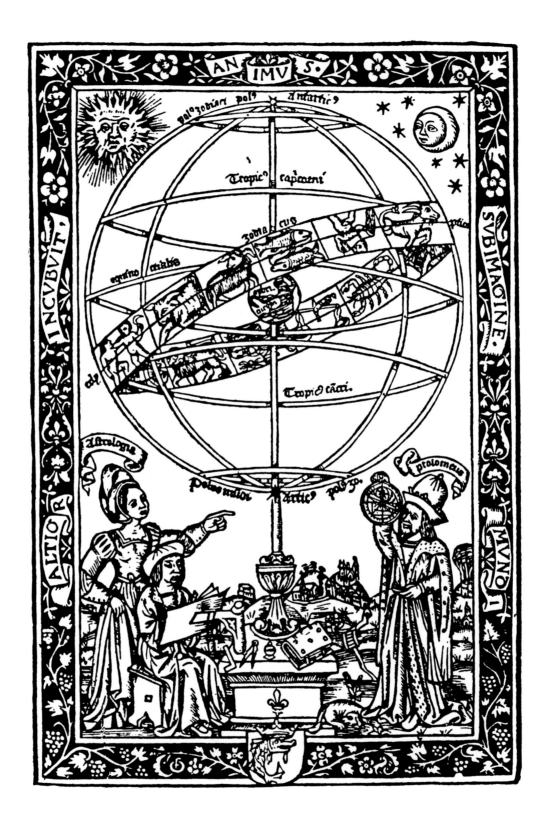

14

Images astrologiques

Ce livre constitue un recueil de superbes images étonnantes et inspiratrices ayant trait à la discipline spirituelle de l'astrologie.

Dans la quête d'une meilleure compréhension de notre existence et des forces qui nous régissent, l'être humain s'est intéressé à l'influence du mouvement des planètes sur notre vie terrestre. La plus ancienne forme d'astrologie par l'horoscope semble provenir de la variante hindoue ou védiste, datant de plus de 5 000 ans. Les traditions arabe et occidentale proviennent, pour leur part, de Mésopotamie et ont débuté il y a 4 000 ans. Ces deux courants adhèrent au même principe sous-jacent, à savoir l'interprétation des cieux à un moment précis dans le temps. Ainsi, la position des planètes à la naissance d'une personne, par exemple, aurait une influence sur son caractère et sur son avenir. Les planètes semblent se déplacer le long d'une bande de constellations appelée zodiaque, de laquelle douze signes astrologiques sont dérivés. Les adeptes de cette science considèrent que ces douze signes représentent chacun une personnalité de base.

Contrairement aux astrologies occidentale et indienne, l'astrologie chinoise est fondée sur le mouvement de la Lune dans le ciel. Les Chinois ont ainsi élaboré un tout autre système avec son propre zodiaque, présentant également douze signes, chacun correspondant aux années du calendrier chinois.

Cet ouvrage met tout d'abord en images des astrologues (pages 12 à 21), puis propose des représentations des influences célestes (pages 22 à 26), celles des planètes (pages 26 à 33) et les signes du zodiaque occidental (pages 34 à 65). Les pages 66 à 75 contiennent des illustrations provenant d'Égypte et d'Arabie et les pages 76 à 79, de l'Inde et de Java. Les images de l'astrologie chinoise (et ses formes apparentées du Japon, du Tibet et de Mongolie) se trouvent aux pages 80 à 101. Les pages 102 à 109 présentent des images du calendrier ancestral de la civilisation maya. Des horoscopes, dont certains élaborés par des célébrités dans le domaine, se trouvent aux pages 110 à 119. La dernière partie du livre, les pages 120 à 127, contient des graphiques illustrant l'influence du zodiaque perçue par le corps humain.

CD-ROM et droits d'auteur

Les images contenues dans ce livre peuvent servir de ressources graphiques ou de source d'inspiration. Toutes les illustrations sont stockées sur le CD-ROM ci-joint et sont prêtes à l'emploi sur tout support imprimé ou pour la conception de site Web. Elles peuvent également être employées pour créer des cartes postales, en format papier ou numérique, ou pour décorer vos lettres, prospectus, T-shirts, etc. Ces images peuvent être importées directement du CD dans la plupart des logiciels. Certaines applications vous permettent d'accéder directement aux images, tandis que d'autres requièrent la création préalable d'un document pour pouvoir les importer. Veuillez vous référer au manuel de votre logiciel pour savoir comment procéder.

Les noms des fichiers du CD-ROM correspondent aux numéros de page de cet ouvrage. Le CD-ROM est fourni gratuitement avec ce livre, mais ne peut être vendu séparément. Les fichiers des CD-ROM de The Pepin Press/Agile Rabbit sont d'une taille suffisamment grande pour la plupart des applications. Cependant, des fichiers plus grands et/ou vectorisés sont disponibles pour la plupart des images et peuvent être commandés auprès des éditions The Pepin Press/Agile Rabbit. Des images seules peuvent être utilisées gratuitement à des fins non professionnelles. Les images ne peuvent pas être employées à des fins commerciales ou professionnelles (y compris pour tout type de publication sur support numérique ou imprimé) sans l'autorisation préalable expresse des éditions The Pepin Press/Agile Rabbit. Notre politique d'autorisation d'auteur est très raisonnable et le montant des droits, le cas échéant, est généralement minime.

Pour en savoir plus sur les autorisations et les droits d'auteur, veuillez contacter :
mail@pepinpress.com
Fax +31 20 4201152

Астрологические картинки

Цель книги – представить коллекцию удивительных, захватывающих и прекрасных изображений, связанных с миром астрологии.

В попытках больше узнать о бытии человечества и движущих им силах люди изучали влияние движения планетарных тел на жизнь на Земле. По всей вероятности, старейшей формой гороскопной астрологии можно считать ее индуистский или ведический вариант, которому насчитывается уже более 5000 лет. Западная и арабская традиции, берущие начало из Месопотамии, зародились свыше 4000 лет назад. Обе эти формы исповедуют один принцип, а именно интерпретируют текущее состояние небес как конкретный момент во времени. Таким образом, расположение планет, например в момент рождения ребенка, оказывает влияние как на его характер, так и на будущее. В своем кажущемся движении планеты проходят через ряд созвездий, называемых зодиакальными, которые дали жизнь двенадцати астрологическим символам. Верящие в астрологию полагают, будто каждый из этих двенадцати символов представляет один из базовых типов личности.

В противоположность западной и индийской формам астрологии, китайская астрология берет за основу движение Луны по небесной сфере. Исходя из этой предпосылки, китайцы разработали совершенно иную систему со своим зодиаком, также включающим двенадцать символов, каждый из которых соответствует тому или иному году китайского календаря.

Книгу открывают картины с изображениями астрологов (страницы 12-21), за ними следуют символы влияния небес (страницы 22-26), представления планет (страницы 26-33) и знаки западного зодиака (страницы 34-65). На страницах 66-75 представлены изображения из Египта и Аравии, а на страницах 76-79 – из Индии и с Явы. Символику китайской астрологии (и родственных ей форм из Японии, Тибета и Монголии) можно найти на страницах 80-101. На страницах 102-109 представлены символы из системы летоисчисления древних майя. На страницах 110-119 можно увидеть гороскопы, среди них есть составленные на весьма известных людей. В заключительной части книги, на страницах 120-127, можно найти таблицы, отражающие представления древних о влиянии зодиака на человеческое тело.

Авторские права на компакт-диск и изображения

Изображения, представленные в этой книге, можно использовать в качестве графического ресурса и как источник вдохновения. Все иллюстрации хранятся на прилагаемом компакт-диске. Их можно распечатывать и применять при разработке веб-страниц. Кроме того, иллюстрации можно использовать при изготовлении открыток, как на бумаге, так и цифровых, а также для украшения писем, рекламных материалов, футболок и т.д. Изображения можно непосредственно импортировать в большинство программ. В одних приложениях можно получить прямой доступ к иллюстрациям, в других придется сначала создать документ, а затем уже импортировать изображения. Конкретные рекомендации см. в руководстве по программному обеспечению.

Имена файлов на компакт-диске соответствуют номерам страниц этой книги. Компакт-диск прилагается к книге бесплатно, но отдельно он не продается. Файлы на компакт-дисках Pepin Press/Agile Rabbit достаточно велики для большинства приложений. Однако для многих изображений в The Pepin Press/Agile Rabbit Editions можно заказать и файлы большего объема или файлы векторизованных изображений. В применениях непрофессионального характера отдельные изображения можно использовать бесплатно. Изображения нельзя использовать в любых видах коммерческих или других профессиональных применений – включая все виды печатной и цифровой публикации – без предварительного разрешения The Pepin Press/Agile Rabbit Editions. Наша политика выдачи разрешений достаточно обоснована и расценки оплаты, если таковая вообще потребуется, обычно минимальны.

С запросами по поводу разрешений и оплаты обращайтесь:
mail@pepinpress.com
Факс +31 20 4201152

Imágenes astrológicas

El objetivo de este libro es presentar una serie de imágenes hermosas, interesantes y sorprendentes asociadas a la disciplina espiritual de la astrología.

Con el fin de saber más acerca de nuestra existencia y del poder del universo, a lo largo de la historia el hombre ha estudiado cómo influye el movimiento de los cuerpos planetarios en nuestra vida en la Tierra. Posiblemente, la forma más primitiva del horóscopo sea la variante hindú o védica, de más de 5.000 años de antigüedad. La tradición occidental y árabe nació en Mesopotamia hace unos 4.000 años. Ambas formas se adhieren al mismo principio básico, a saber, la interpretación de los cielos en un determinado plano temporal. Según estas creencias, la posición de los planetas cuando nacemos, por ejemplo, influiría en nuestro carácter y nuestro futuro. Los planetas parecen desplazarse a través de una banda de constelaciones denominada Zodiaco, de la que se derivan los doce signos astrológicos. Según las personas que creen en la astrología, cada uno de estos doce signos representa una personalidad determinada.

Al contrario que la occidental o la india, la astrología china se basa en el movimiento de la Luna a través del cielo. En base a esto, los chinos han concebido un sistema muy distinto con un Zodiaco propio, también de doce signos, cada uno correspondiente a uno de los años del calendario chino.

Este libro comienza con imágenes de astrólogos (páginas 12-21), seguidas de visualizaciones de influencias celestiales (páginas 22-26), representaciones de los planetas (páginas 26-33) y signos del Zodiaco occidental (páginas 34-65). Las páginas 66-75 contienen imágenes de Egipto y Arabia, y las 76-79 de India y Java. Las imágenes correspondientes a la astrología china (y las variantes de Japón, Tíbet y Mongolia) se encuentran en las páginas 80-101. En las páginas 102-109 encontrará imágenes del antiguo sistema de calendario maya, mientras que los horóscopos, incluidos los de personajes famosos, están en las páginas 110-119. La parte final del libro (páginas 120-127) incluye una serie de cuadros que muestran la percepción de la influencia del Zodiaco en el cuerpo humano.

CD-ROM y derechos sobre las imágenes
Este libro contiene imágenes que pueden servir como material gráfico o simplemente como inspiración. Todas las ilustraciones están incluidas en el CD-ROM adjunto y pueden utilizarse en medios impresos y diseño de páginas web. Las imágenes también pueden emplearse para crear postales, ya sea en papel o digitales, o para decorar sus cartas, folletos, camisetas, etc. Pueden importarse directamente desde el CD a diferentes tipos de programas. Algunas aplicaciones informáticas le permitirán acceder a las imágenes directamente, mientras que otras le obligarán a crear primero un documento y luego importarlas. Consulte el manual de software pertinente para obtener instrucciones al respecto.

Los nombres de los archivos contenidos en el CD-ROM se corresponden con los números de página del libro. El CD-ROM se suministra de forma gratuita con el libro. Queda prohibida su venta por separado. Los archivos incluidos en los discos CD-ROM de Pepin Press/Agile Rabbit tienen una resolución suficiente para su uso con la mayoría de aplicaciones. Sin embargo, si lo precisa, puede encargar archivos con mayor definición y/o vectorizados de la mayoría de las imágenes a The Pepin Press/Agile Rabbit Editions. Para aplicaciones no profesionales, pueden emplearse imágenes sueltas sin coste alguno. Estas imágenes no pueden utilizarse para fines comerciales o profesionales (incluido cualquier tipo de publicación impresa o digital) sin la autorización previa de The Pepin Press/Agile Rabbit Editions. Nuestra política de permisos es razonable y las tarifas impuestas tienden a ser mínimas.

Para solicitar información sobre autorizaciones y tarifas, póngase en contacto con:
mail@pepinpress.com
Fax +31 20 4201152

Imagens Astrológicas

O presente livro visa apresentar uma colecção de surpreendentes, interessantes e belas imagens associadas à disciplina espiritual da Astrologia.

Procurando entender mais acerca da nossa existência e das forças que nos movem, tem sido estudada a influência do movimento dos corpos planetários na nossa vida na Terra. A forma mais antiga da astrologia dos horóscopos é, talvez, a variante Hindu ou Védica, que conta já com mais de 5.000 anos. A tradição ocidental e árabe é oriunda da Mesopotâmia e data de há cerca de 4.000 anos. Ambas as formas aderem ao mesmo princípio subjacente, nomeadamente a interpretação dos céus, num determinado momento no tempo. Assim, a disposição dos planetas no momento do nascimento de uma pessoa, por exemplo, teria influência no carácter e no futuro dessa pessoa. Os planetas parecem mover-se ao longo de uma faixa de constelações denominada Zodíaco, da qual se derivaram doze signos astrológicos. Quem acredita, pensa que cada um destes doze signos representa um tipo básico de personalidade.

Ao contrário da forma ocidental e indiana da Astrologia, a Astrologia chinesa baseia-se no movimento da lua pelo céu. Daqui, os chineses derivaram um sistema muito diferente, com um Zodíaco próprio, também composto por doze signos, correspondentes a anos do calendário chinês.

O livro começa com imagens de astrólogos (páginas 12-21), seguidas de visualizações de influências celestes (páginas 22-26), representações dos planetas (páginas 26-33) e signos do Zodíaco ocidental (páginas 34-65). Nas páginas 66-75 encontramos imagens do Egipto e da Arábia e, nas páginas 76-79, da Índia e de Java. O conjunto de imagens da Astrologia chinesa (e as formas relacionadas do Japão, do Tibete e da Mongólia) encontra-se nas páginas 80-101. As páginas 102-109 contêm imagens do sistema de datas da antiga civilização Maia. Os horóscopos, incluindo os de algumas personalidades famosas, estão nas páginas 110-119. A última parte do livro, as páginas 120-127, inclui gráficos onde se verifica a influência observada do Zodíaco no corpo humano.

CD-ROM e direitos de imagem
As imagens neste livro podem ser usadas como recurso gráfico e fonte de inspiração. Todas as ilustrações estão guardadas no CD-ROM incluído e prontas a serem usadas em suportes de impressão e design de páginas web. As imagens também podem ser usadas para produzir postais, tanto em papel como digitalmente, ou para decorar cartas, brochuras, T-shirts e outros artigos. Podem ser importadas directamente do CD para a maioria dos programas de software. Alguns programas permitem aceder às imagens directamente, enquanto que noutros terá de primeiro criar um documento para poder importar as imagens. Consulte o manual do software para obter instruções.

Os nomes dos ficheiros no CD-ROM correspondem aos números de páginas no livro. O CD-ROM é oferecido gratuitamente com o livro e não pode ser vendido separadamente. A dimensão dos ficheiros nos CD-ROMs da Pepin Press/Agile Rabbit é suficiente para a maioria das aplicações. Contudo, os ficheiros maiores e/ou vectorizados estão disponíveis para a maioria das imagens e podem ser encomendados junto da Pepin Press/Agile Rabbit Editions. Podem ser usadas imagens individuais gratuitamente no caso de utilizações não profissionais. As imagens não podem ser usadas para qualquer tipo de utilização comercial ou profissional, incluindo todos os tipos de publicações digitais ou impressas, sem autorização prévia da Pepin Press/Agile Rabbit Editions. A nossa política de autorizações é muito razoável e as tarifas cobradas, caso isso se aplique, tendem a ser bastante reduzidas.

Para esclarecimentos sobre autorizações e tarifas, queira contactar:
mail@pepinpress.com
Fax +31 20 4201152

占星術の絵柄集

本書には、占星術の精神分野に関連した、興味深く美しいイメージが収録されています。

自身の存在理由と原動力を詳しく理解するために、人々は天体の動きが地上の生命に及ぼす影響について研究してきました。最も古い占星術は、おそらくヒンズー教またはヴェーダ教の変種で、5000年以上も前のものです。西洋やアラビアの伝統は、4000年ほど前のメソポタミアに起源を発しており、両文化とも同じ基本原理に固執しています。それは、特定の瞬間の天体についての解釈です。つまり、人が誕生した瞬間の天体の配置が、その人の性格と将来性に影響を与えるという考えです。 運星は、黄道帯（ゾディアック）という星座帯に沿って動いていると考えられています。占星術の12の星座は、この黄道帯に由来しています。 占星術によると、この12の星座が基本的な人格を表しています。

西洋やインドの占星術とは対照的に、中国の占星術は月の天空運動に基づいています。中国人はそこから独自の黄道帯のシステムを発展させ、12の星座もそれぞれ中華暦の各年に対応したものとなりました。

本書はまず、占星術師を写真で紹介し（12～21ページ）、続いて天体の影響についての視覚的な説明（22～26ページ）、運星の説明（26～33ページ）、さらには西洋の黄道帯の星座 （34～65ページ）へと続きます。 66～75ページには、エジプトとアラビアからのイメージ、また76～79ページにはインドとジャワからのイメージが紹介されています。 80～101ページには、中国の占星術 (また、それに関連した日本やチベット、モンゴルの占星術) のイメージを紹介しています。 102～109ページには、古代マヤの日付システムのイメージも紹介しています。 さらには、著名人のホロスコープなどを110～119ページに掲載しています。本書の最後、120～127ページでは黄道帯の理論上の人体への影響を図表で示しています。

CD-ROM及びイメージの版権について

占星图片集

本书展示了一组与占星术属灵操练有关的图片，这些精美的图片新奇有趣，令人大开眼界。

为了对我们的存在以及推动我们的原动力有进一步的了解，人们研究了星体运动对于我们地球生命的影响。占星术的最古老形式可能是印度教或吠陀占星术，它具有超过 5000 年的历史。西方和阿拉伯的占星术起源自美索不达米亚，创始于大约 4000 年以前。这两种形式的占星术秉持相同的底层原理，即对于特定时刻天象的判读。因此，举例而言，一个人出生时星体所处的位置，对这个人的性格和将来具有影响。星体看似沿着称为黄道带的带状星群运动，从中得出了十二个星座。信奉占星术的人认为每个星座代表不同的基本性格类型。

与西方和印度的占星术不同，中国的占星术以月亮在天空中的运动为基础。中国人从中得出了他们独特的黄道带体系，同样具有十二宫，每宫对应于中国的农历年份。

本书从介绍占星家的图片开始（第 12-21 页），然后是天体影响的直观表现（第 22-26 页）、星体的表示方式（第 26-33 页）以及西方黄道带的十二宫（第 34-65 页）。第 66-75 页包含来自埃及和阿拉伯的图片，第 76-79 页包含来自印度和爪哇的图片。第 80-101 页是中国占星术（及日本、西藏和蒙古的同类占星术）的相关图片。第 102-109 页包含古马雅日期系统的图片。第 110-119 页是具体的星象，包括一些非常著名人士的星象。本书的最后一部分，即第 120-127 页，包含展示黄道带对人体影响的图表。

CD-ROM及图像的版权

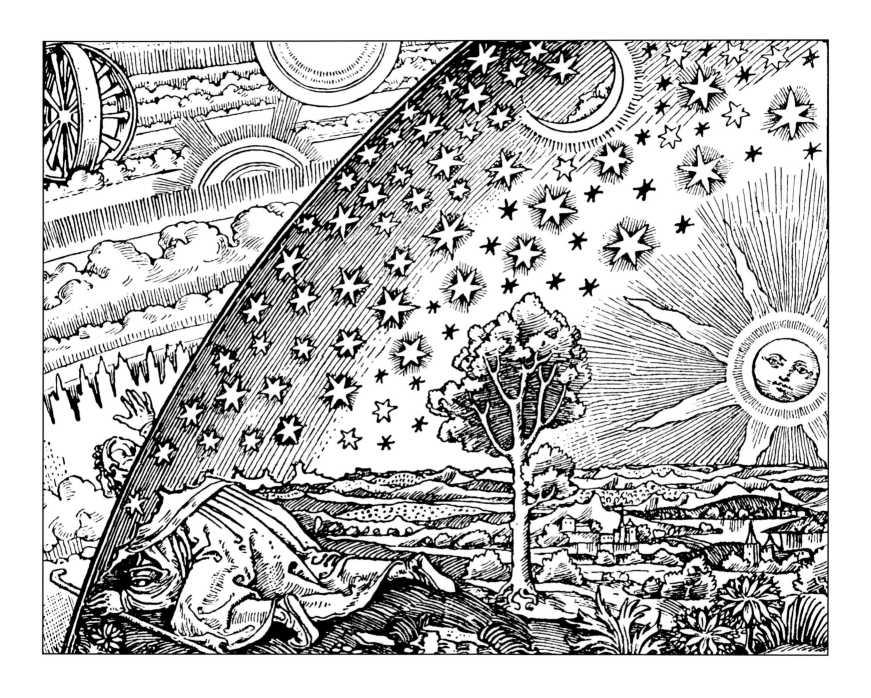

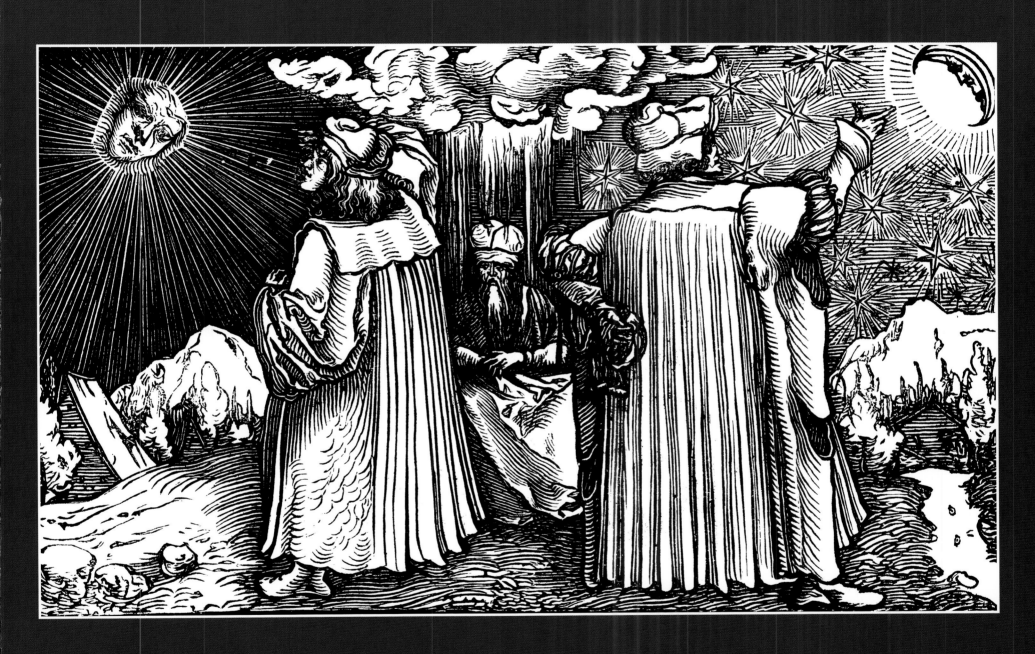

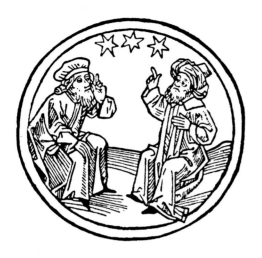

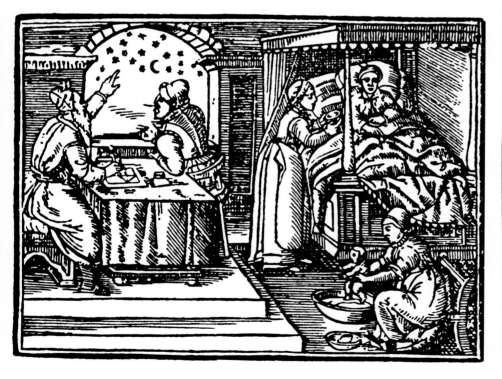

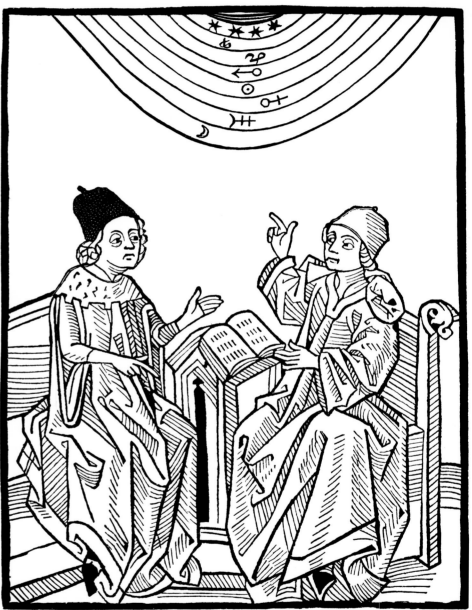

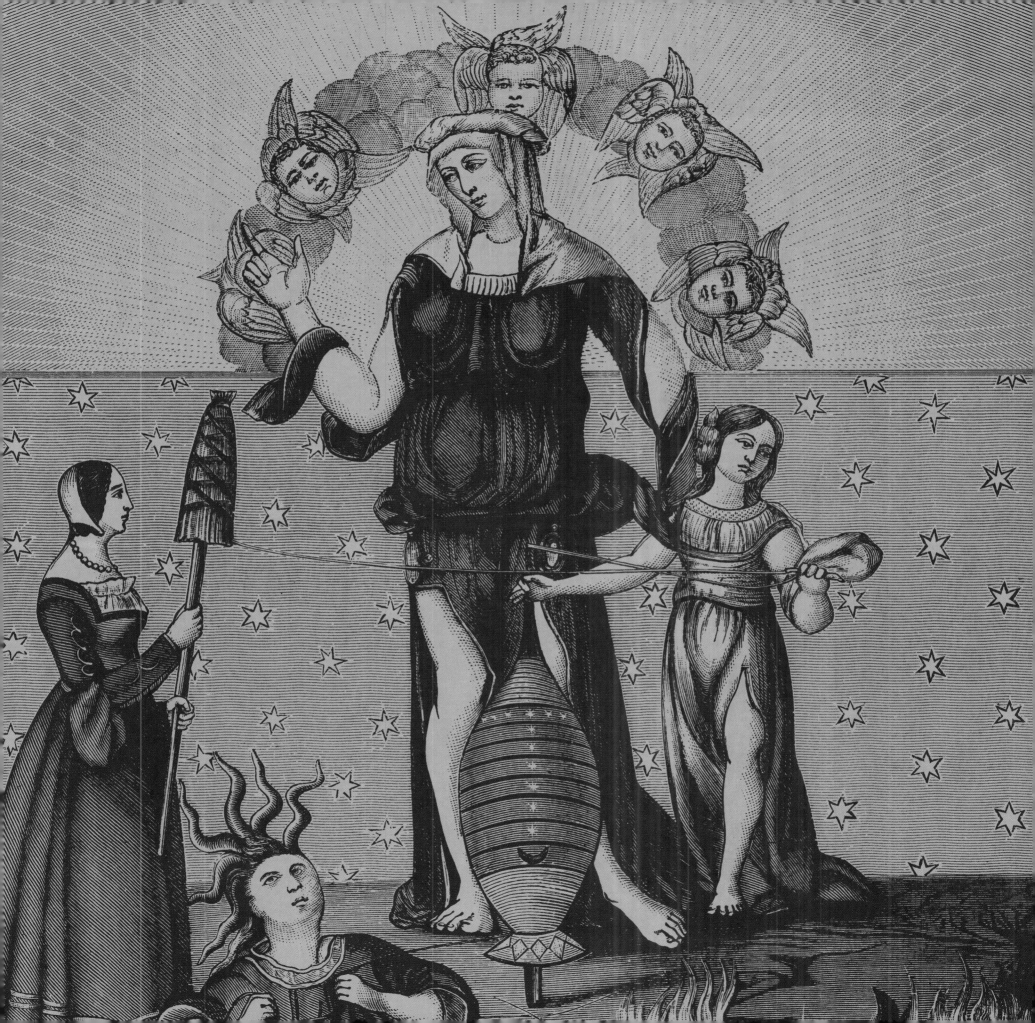

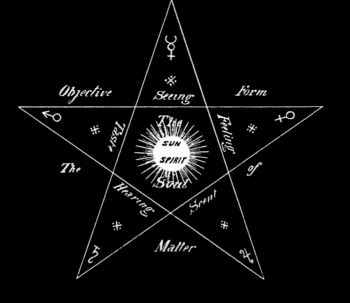

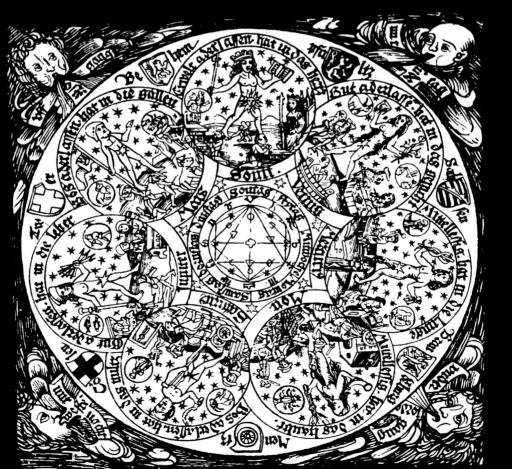

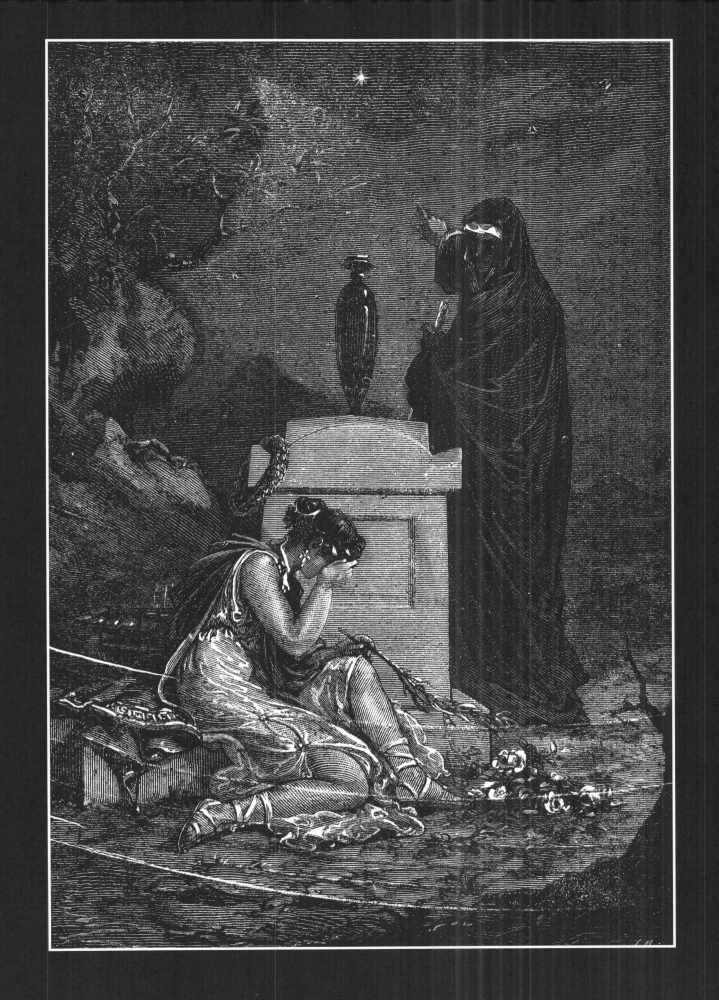

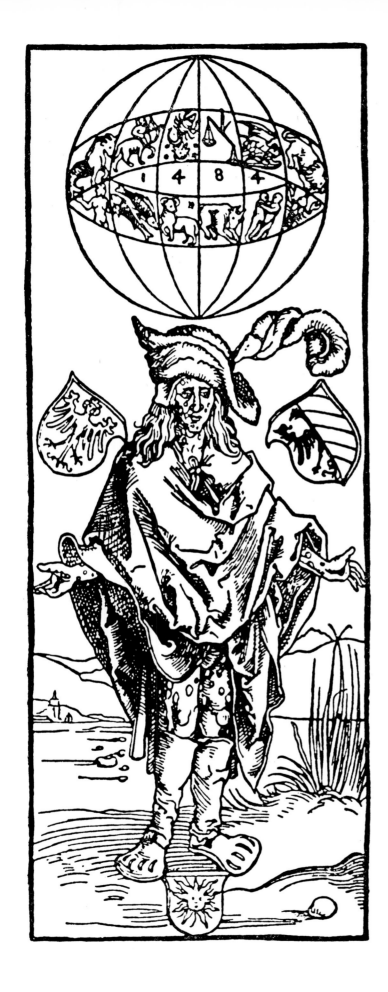

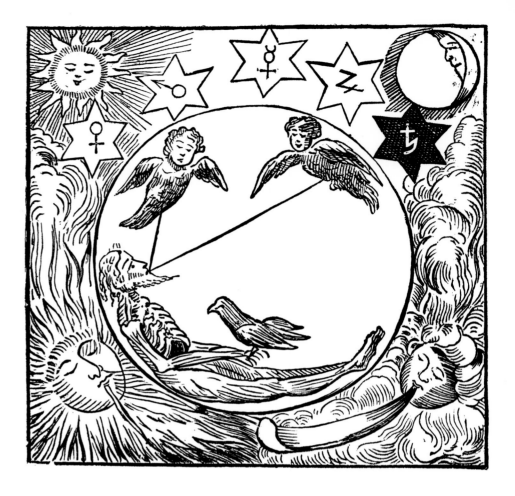

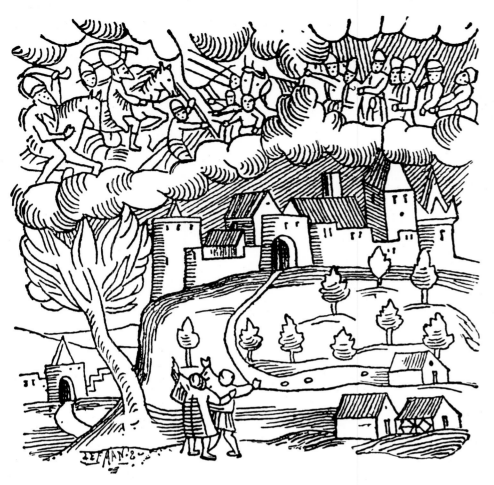

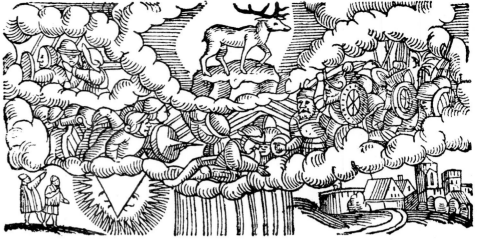

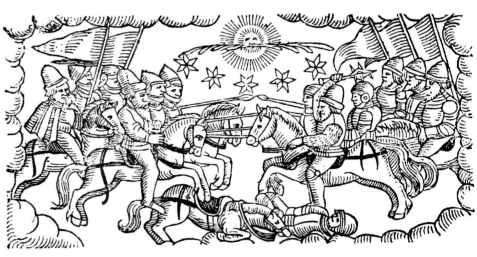

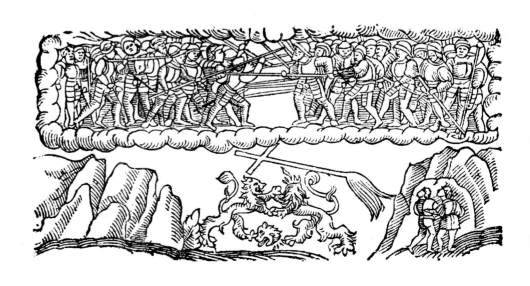

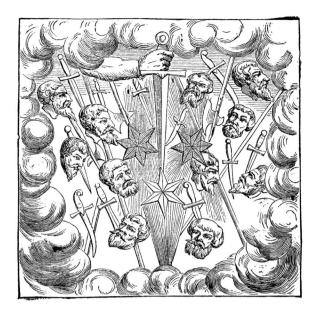

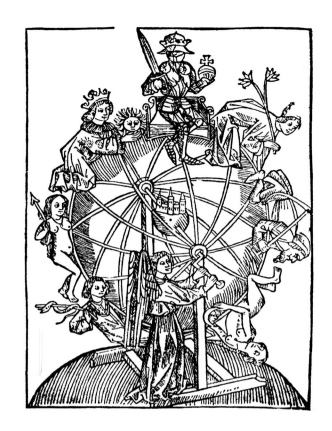

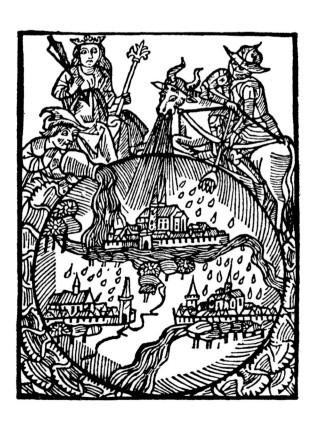

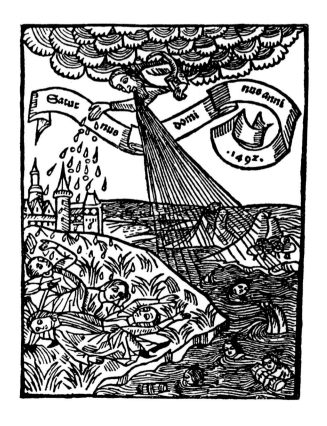

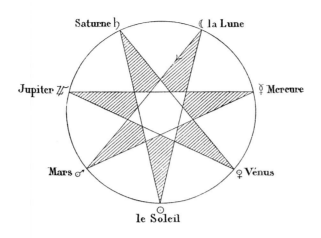

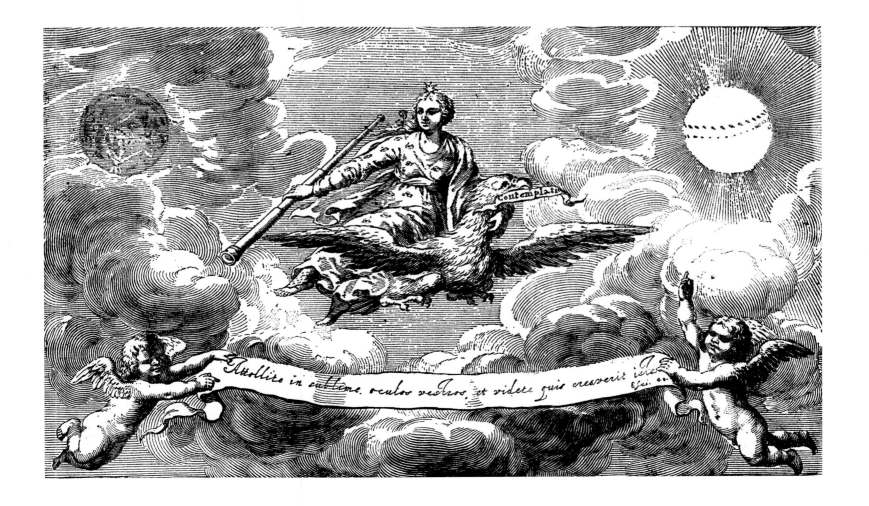

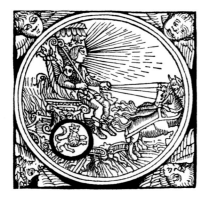

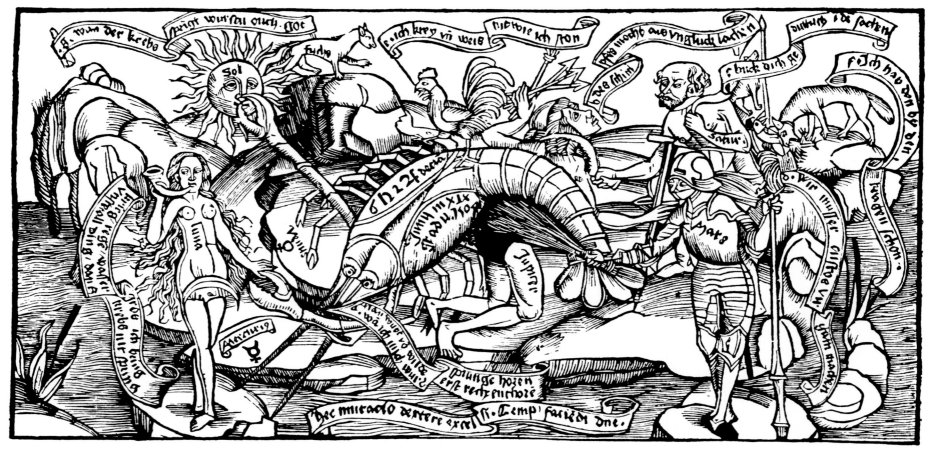

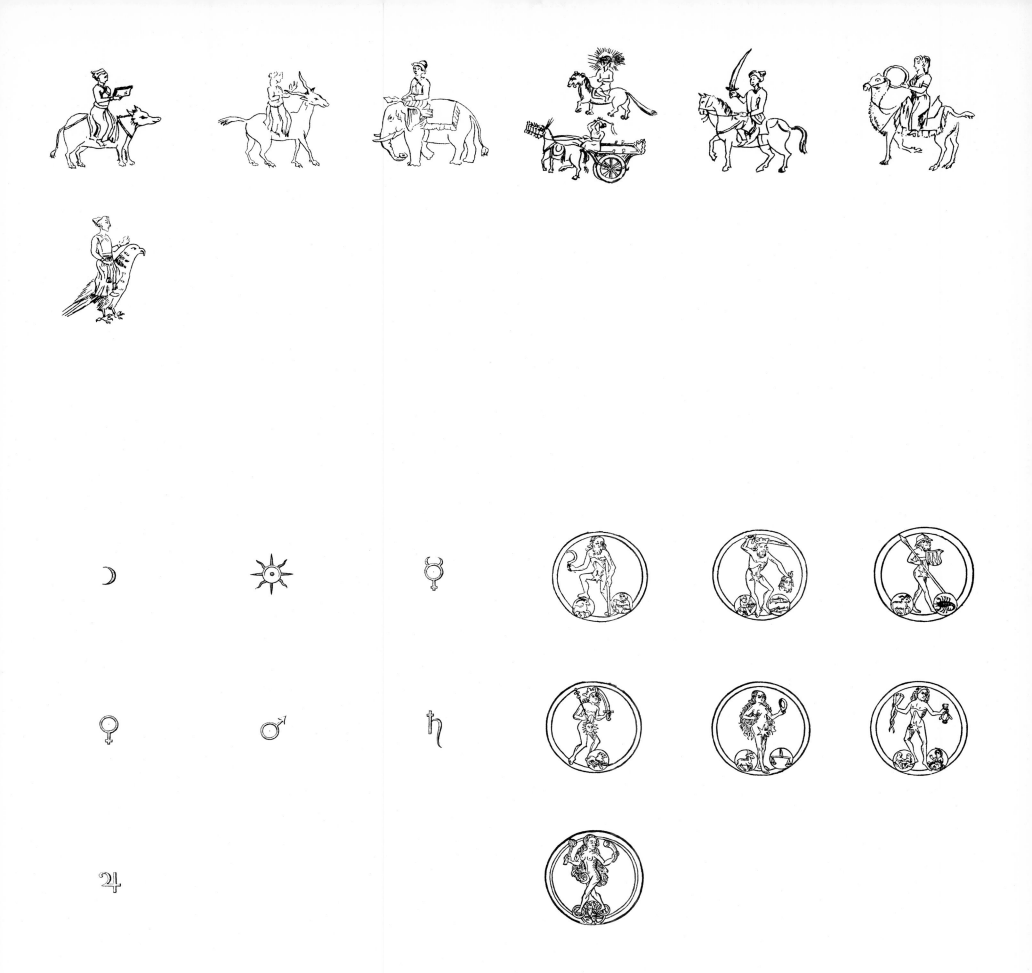

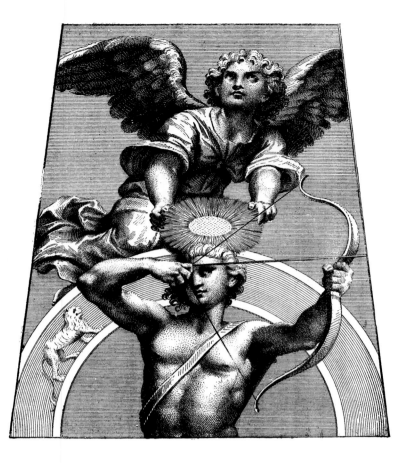

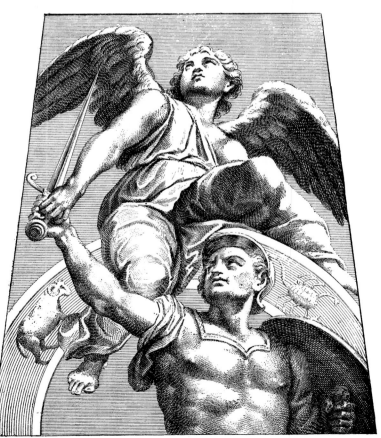

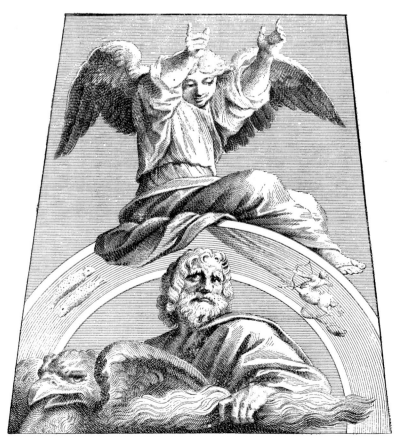

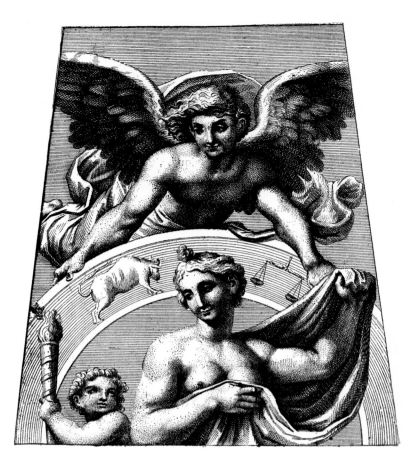

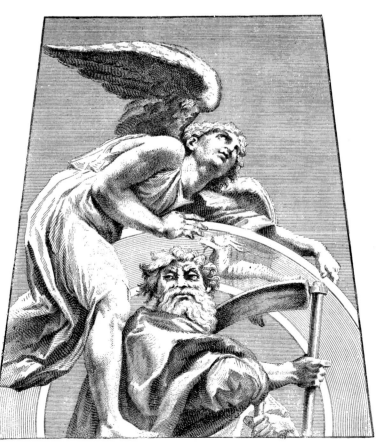

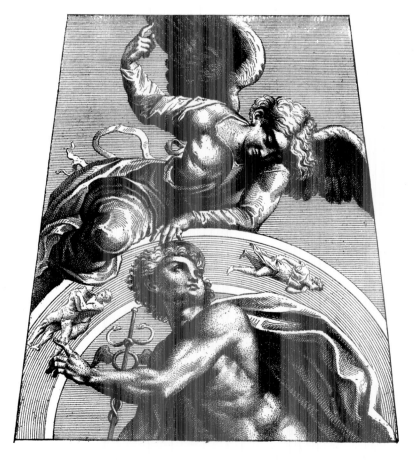

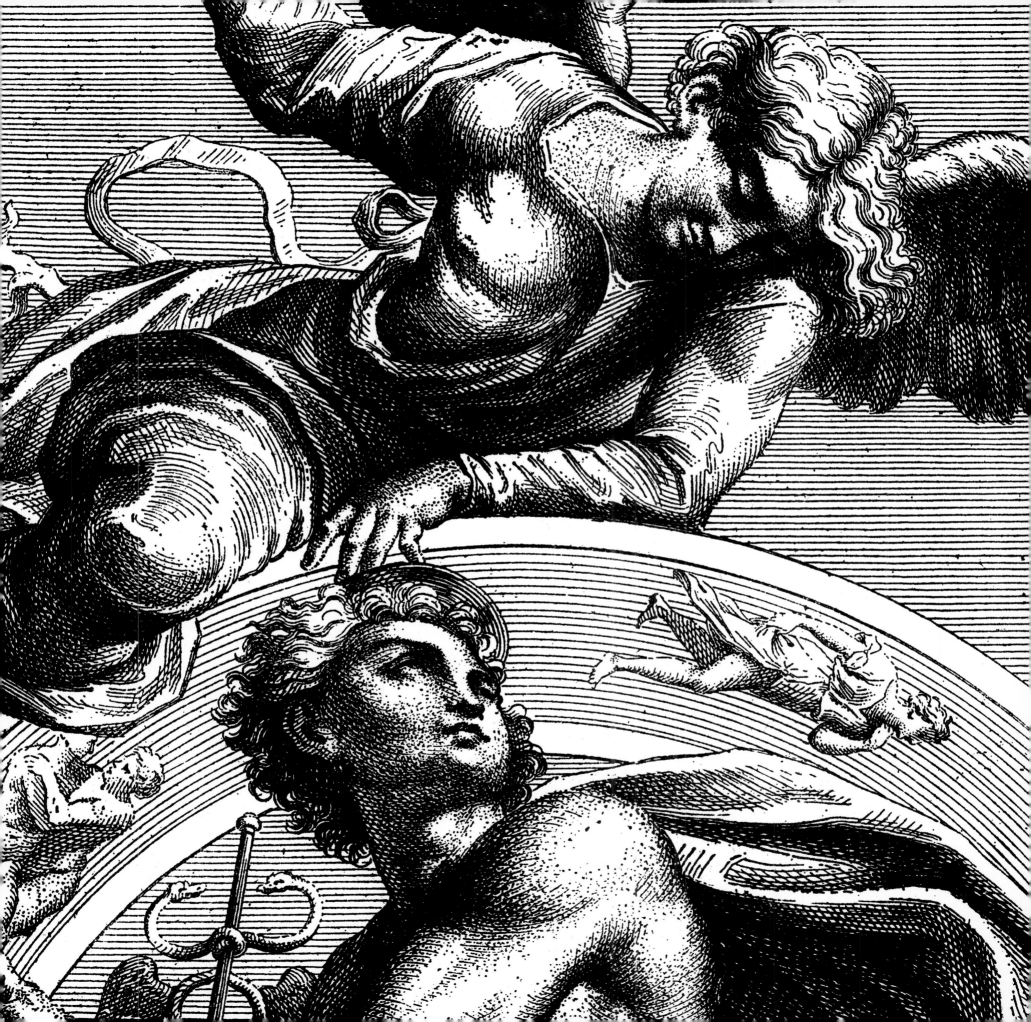

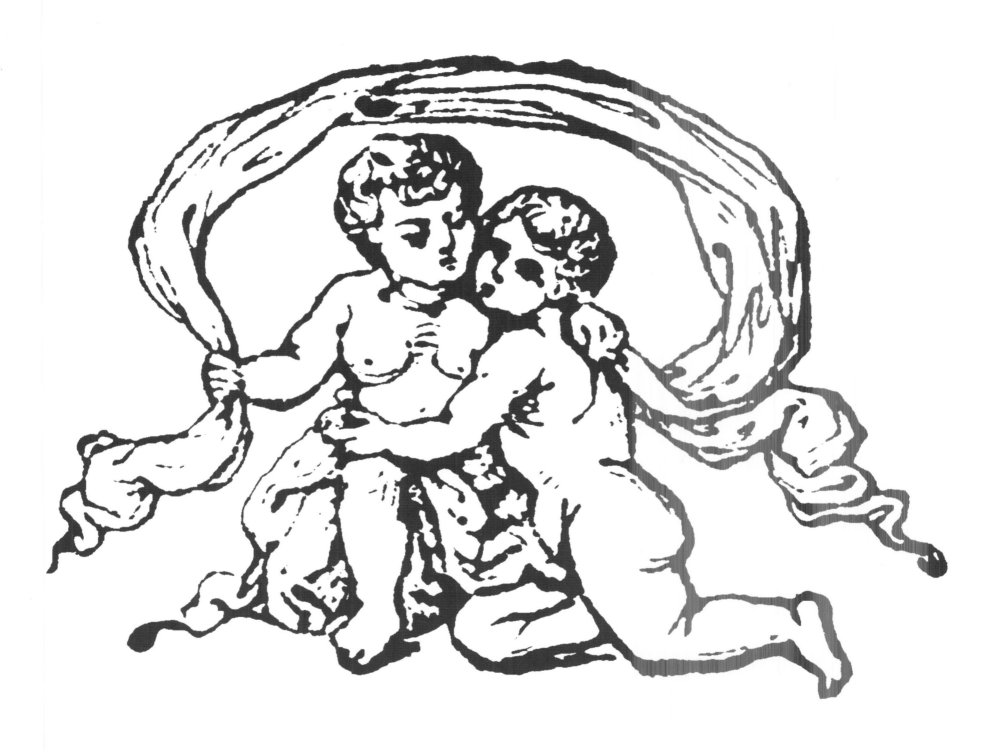

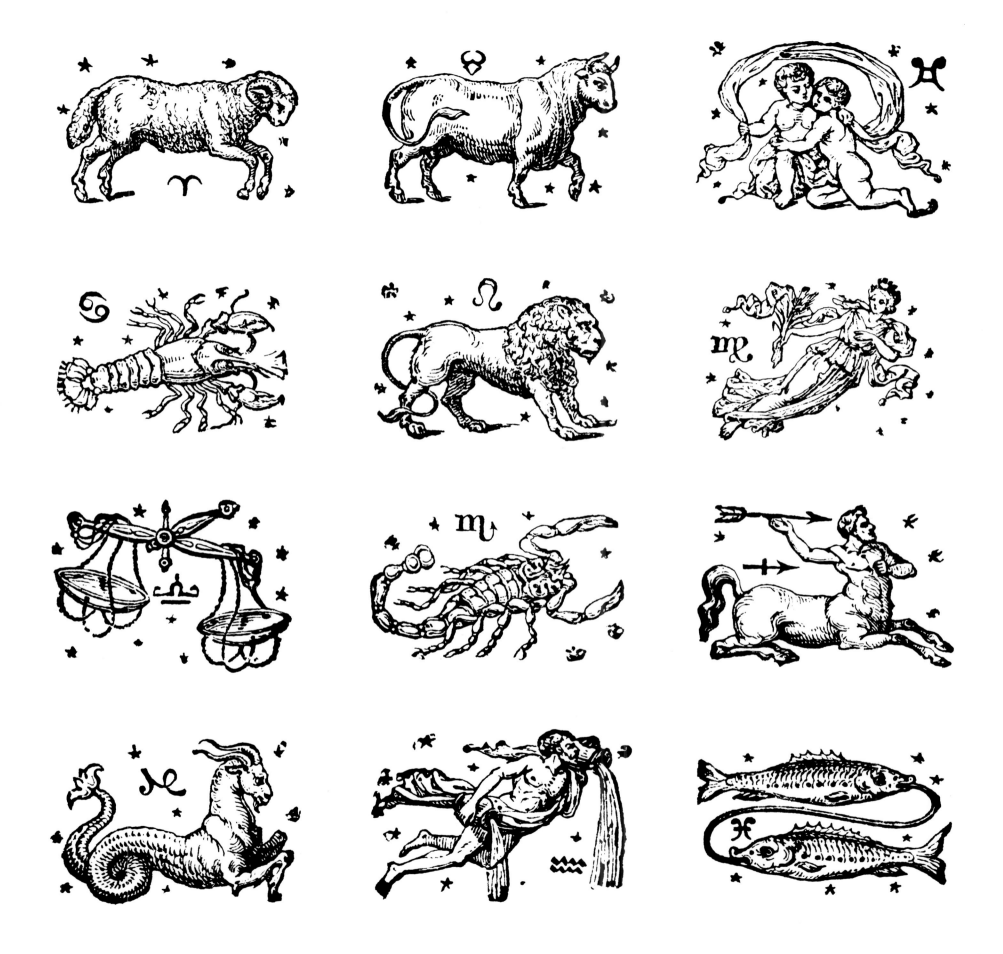

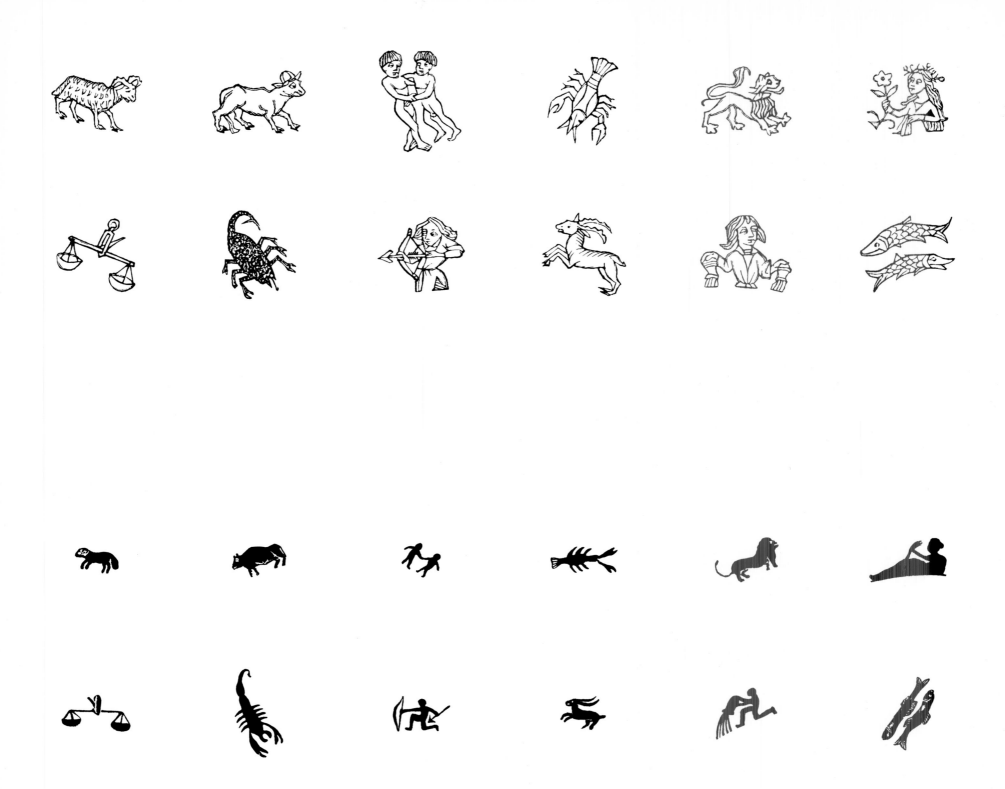

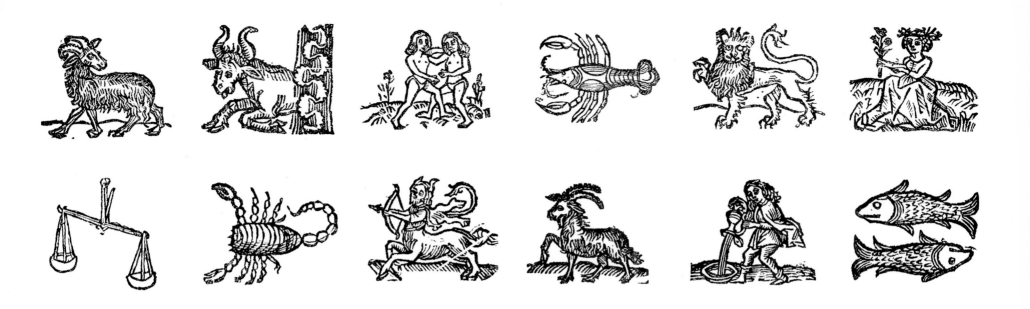

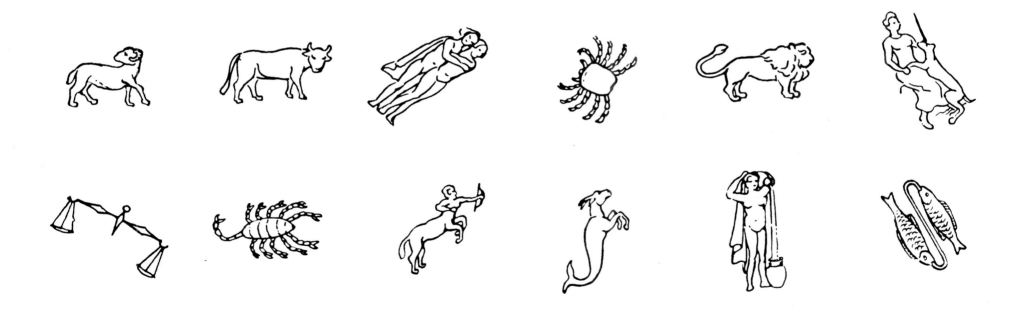

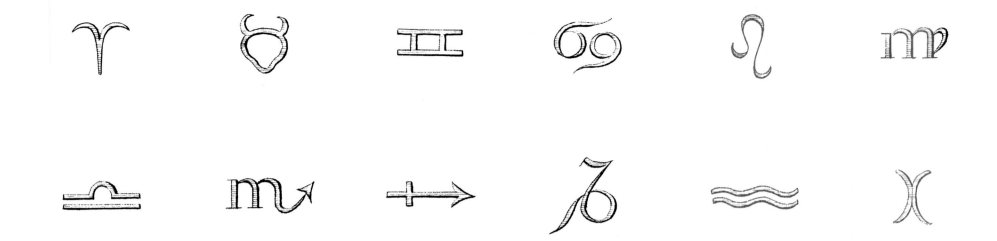

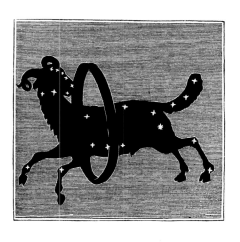
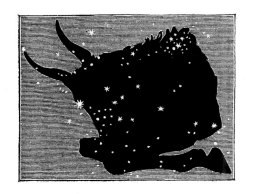
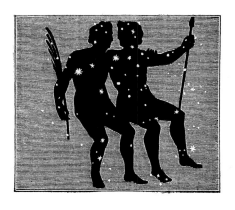
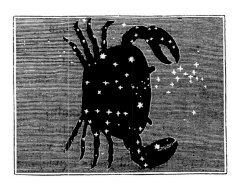
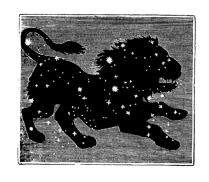

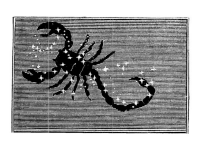
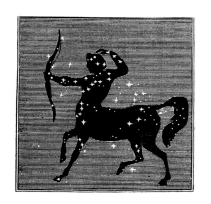
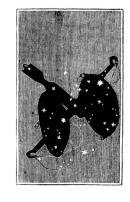
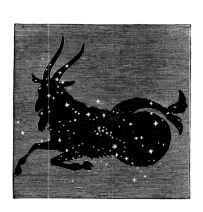
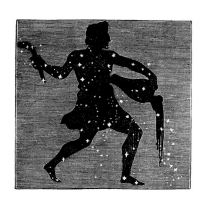
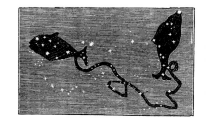

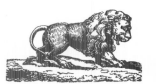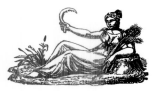

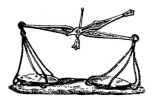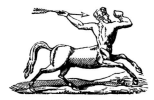

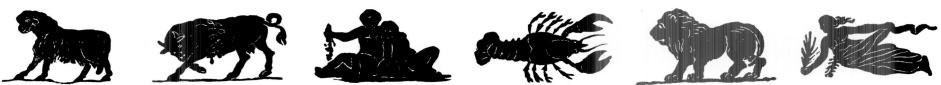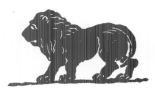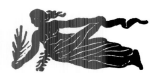

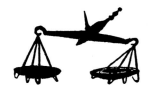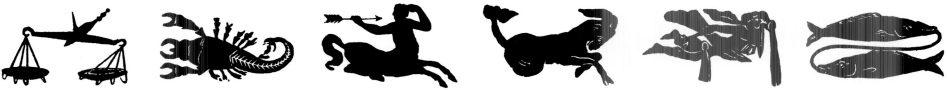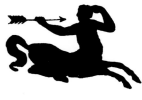

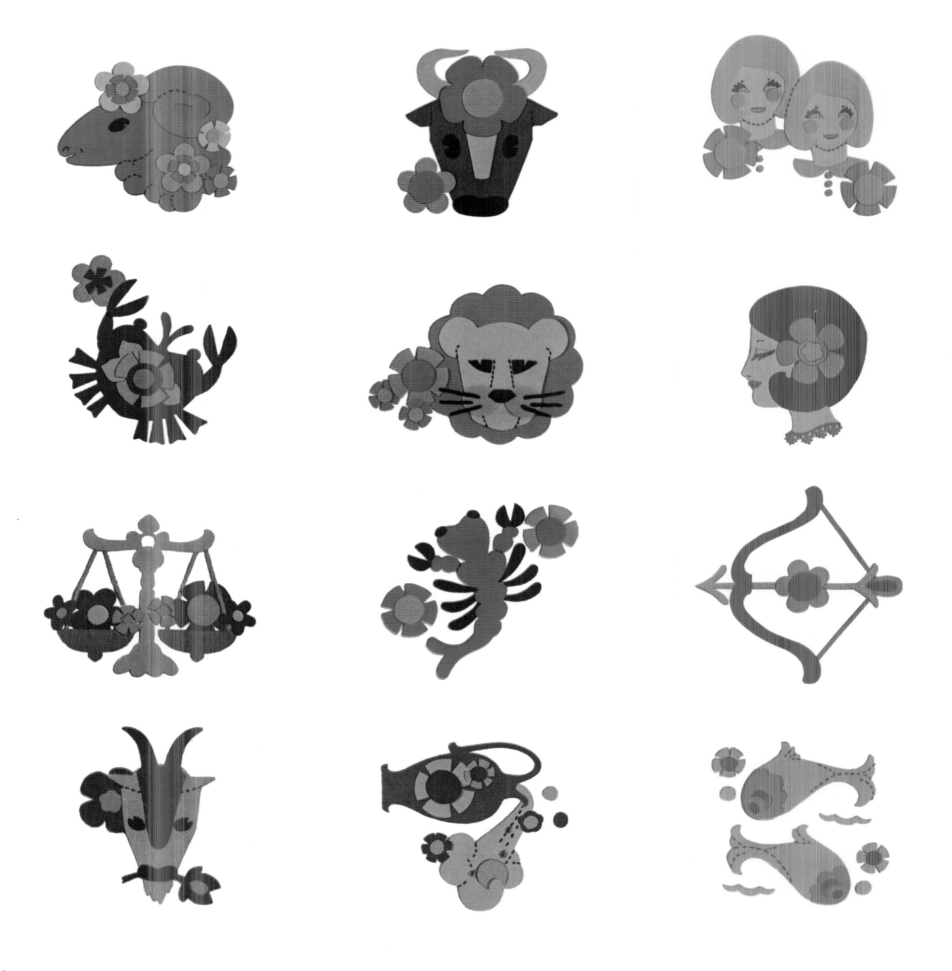

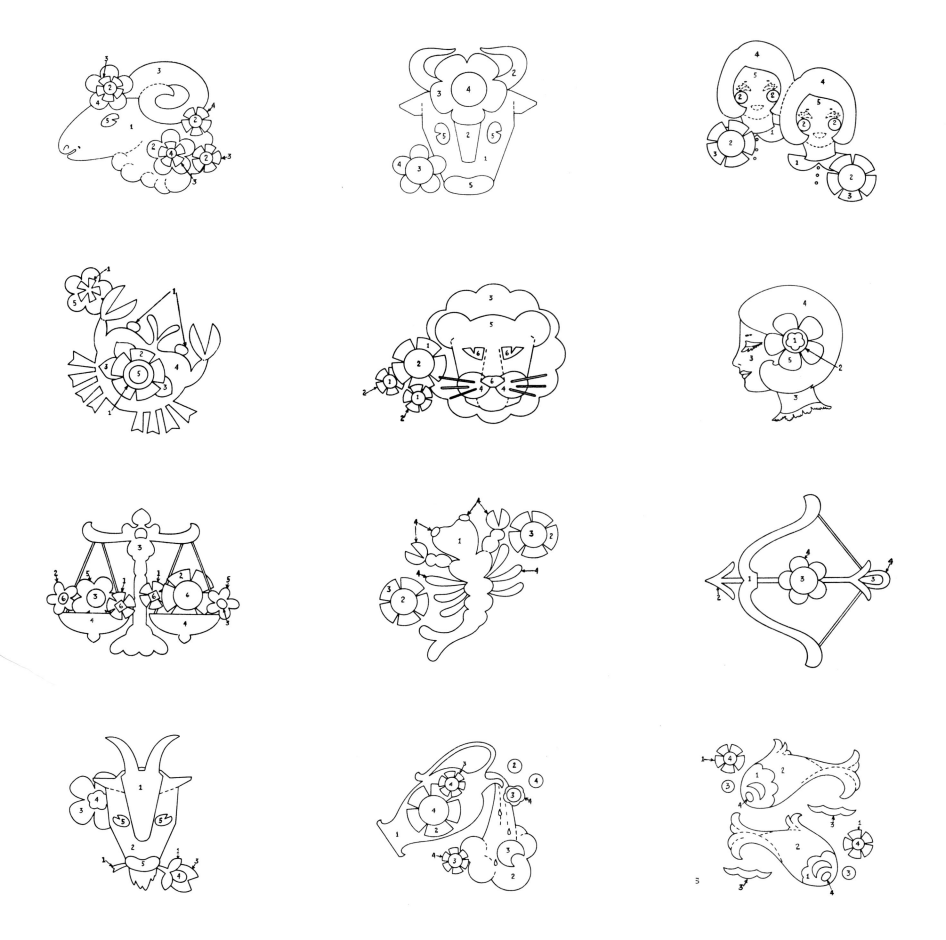

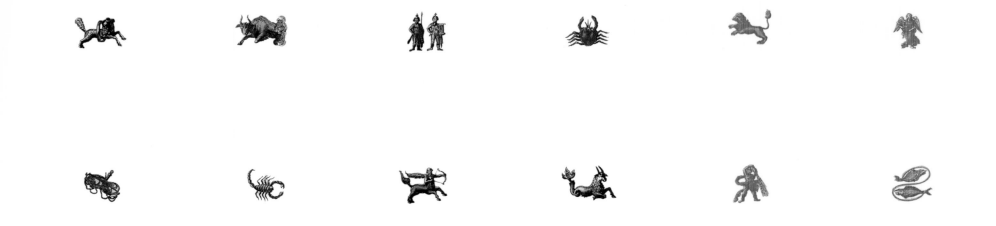

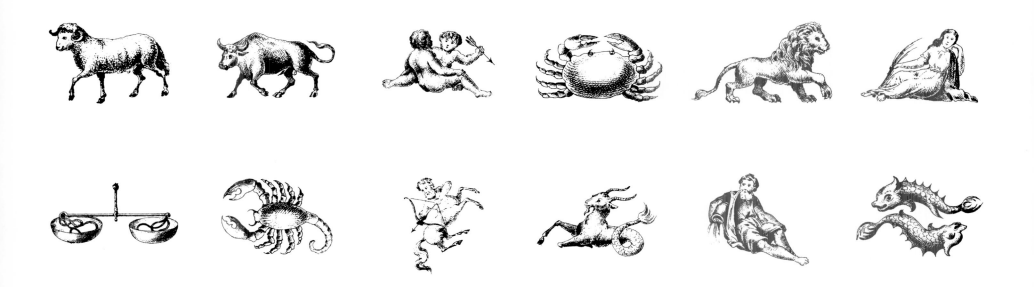

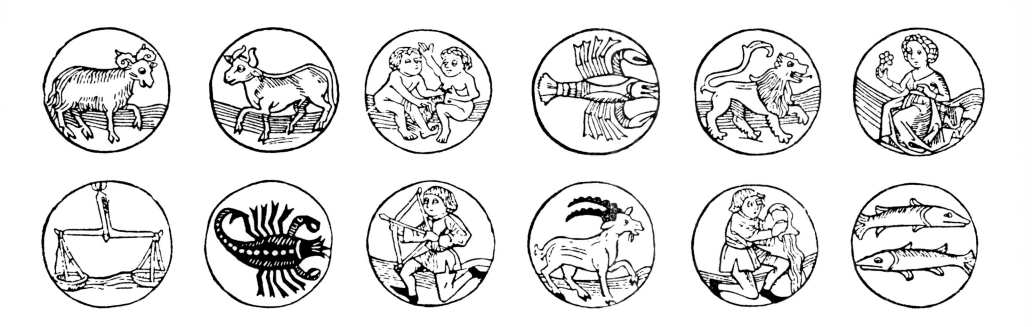

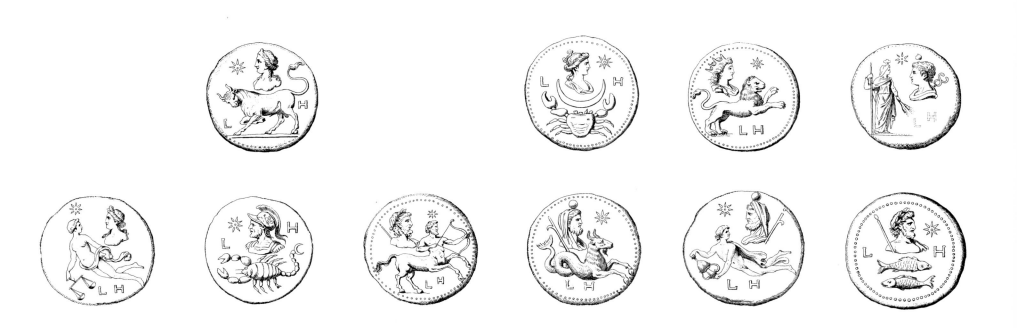

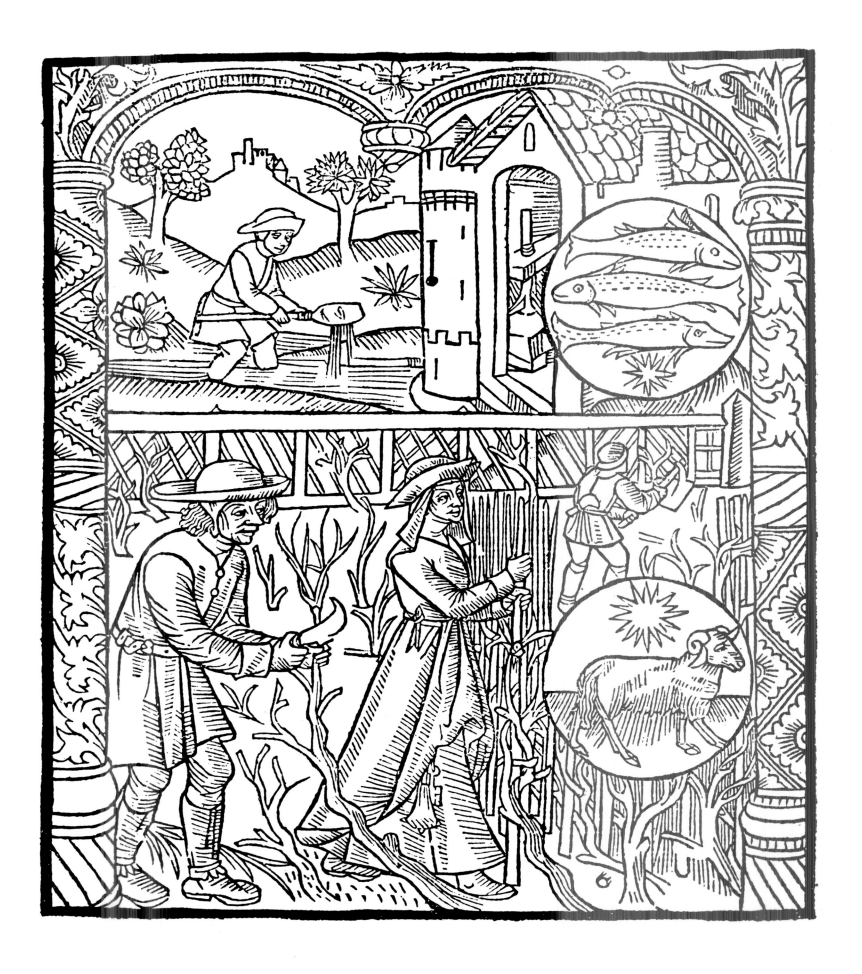

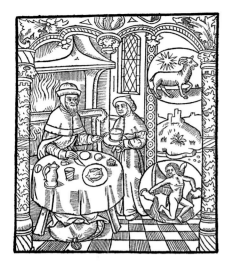
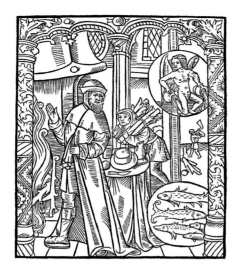
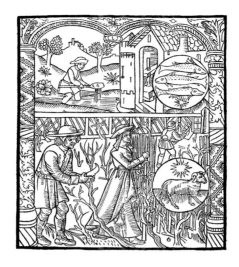
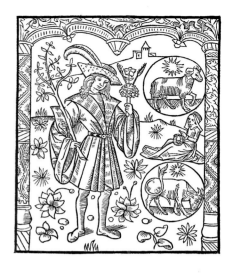
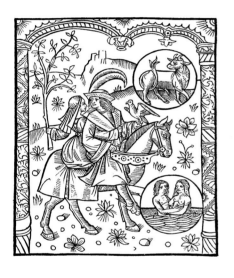
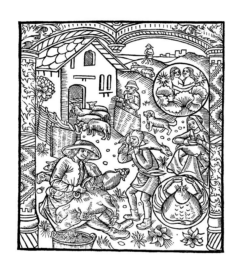
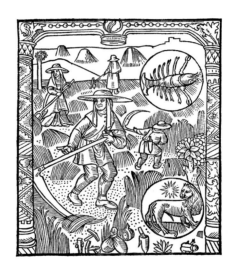
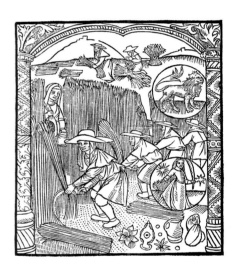
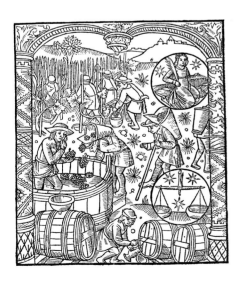
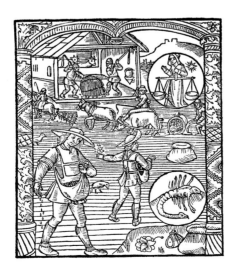
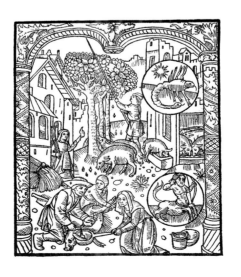
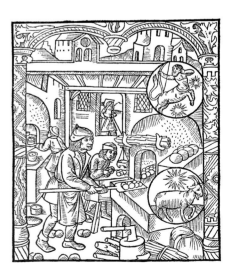

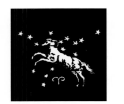
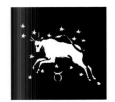
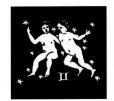
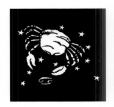
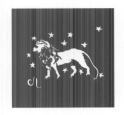
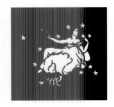

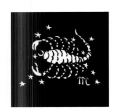
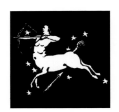

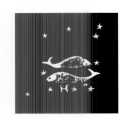

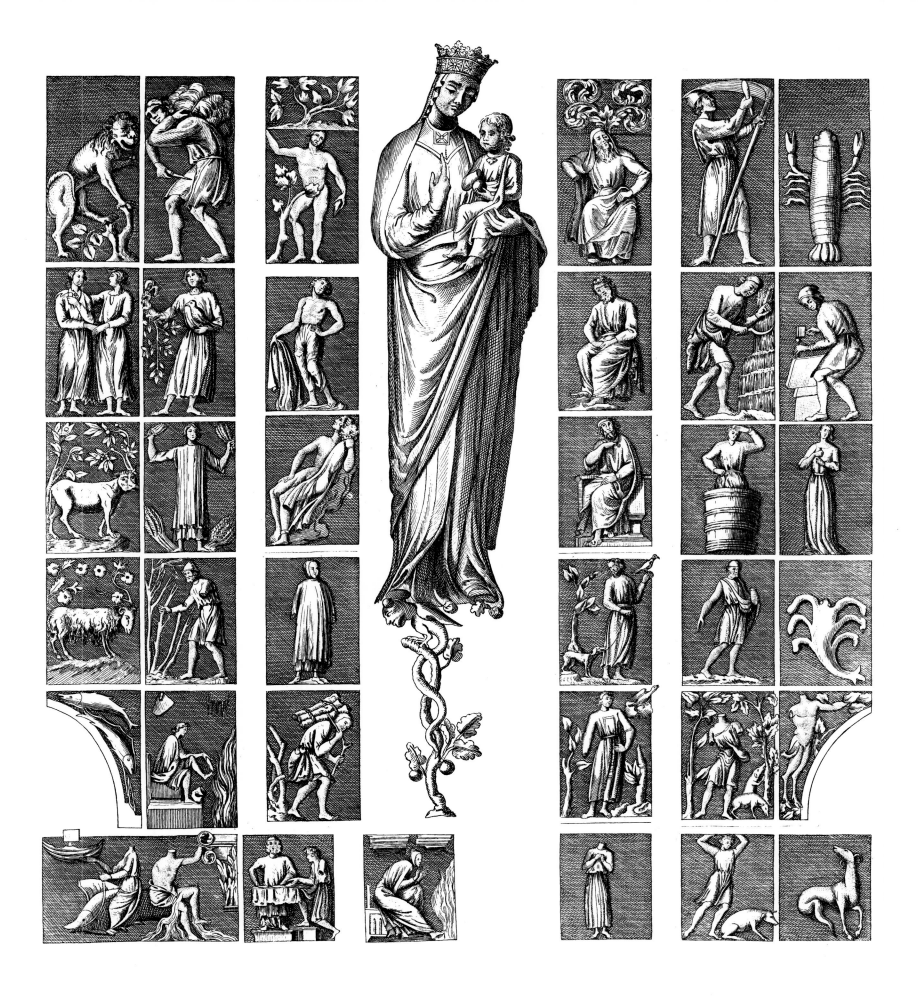

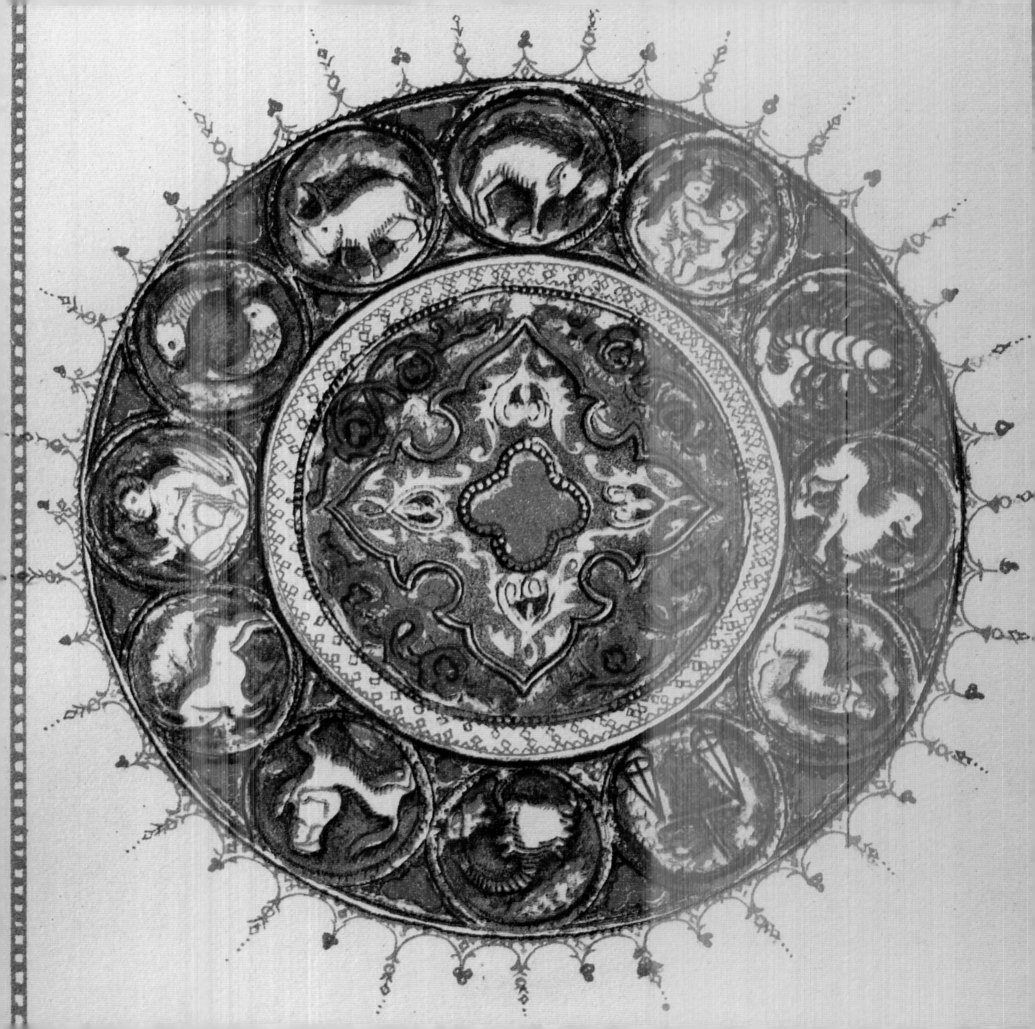

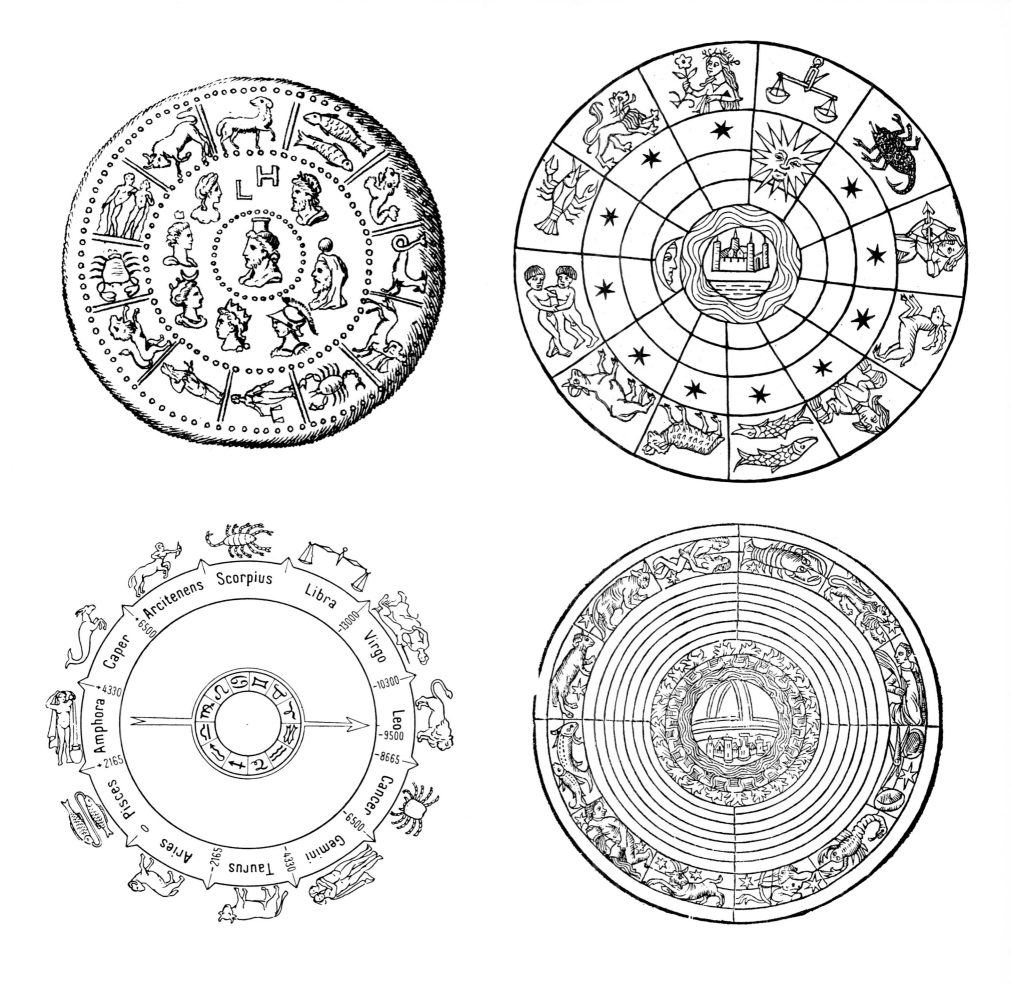

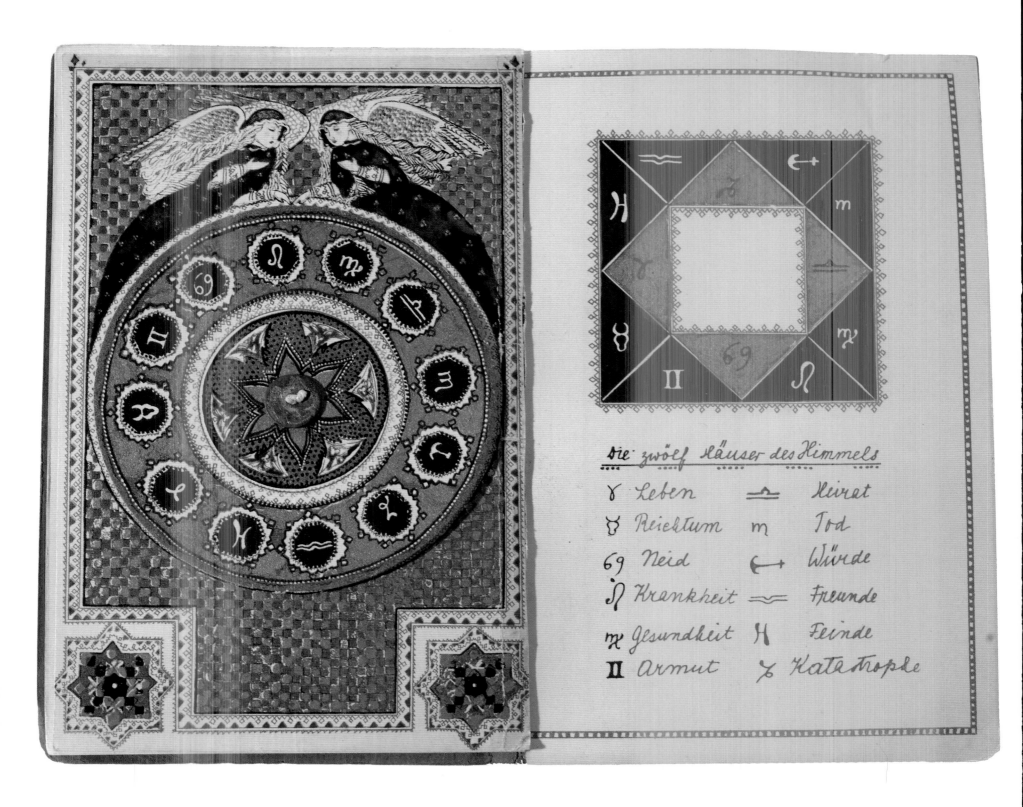

Die zwölf Häuser des Himmels

♈ Leben ♎ Heirat

♉ Reichtum ♏ Tod

♋ Neid ♐ Würde

♌ Krankheit ♒ Freunde

♍ Gesundheit ♓ Feinde

♊ Armut ♑ Katastrophe

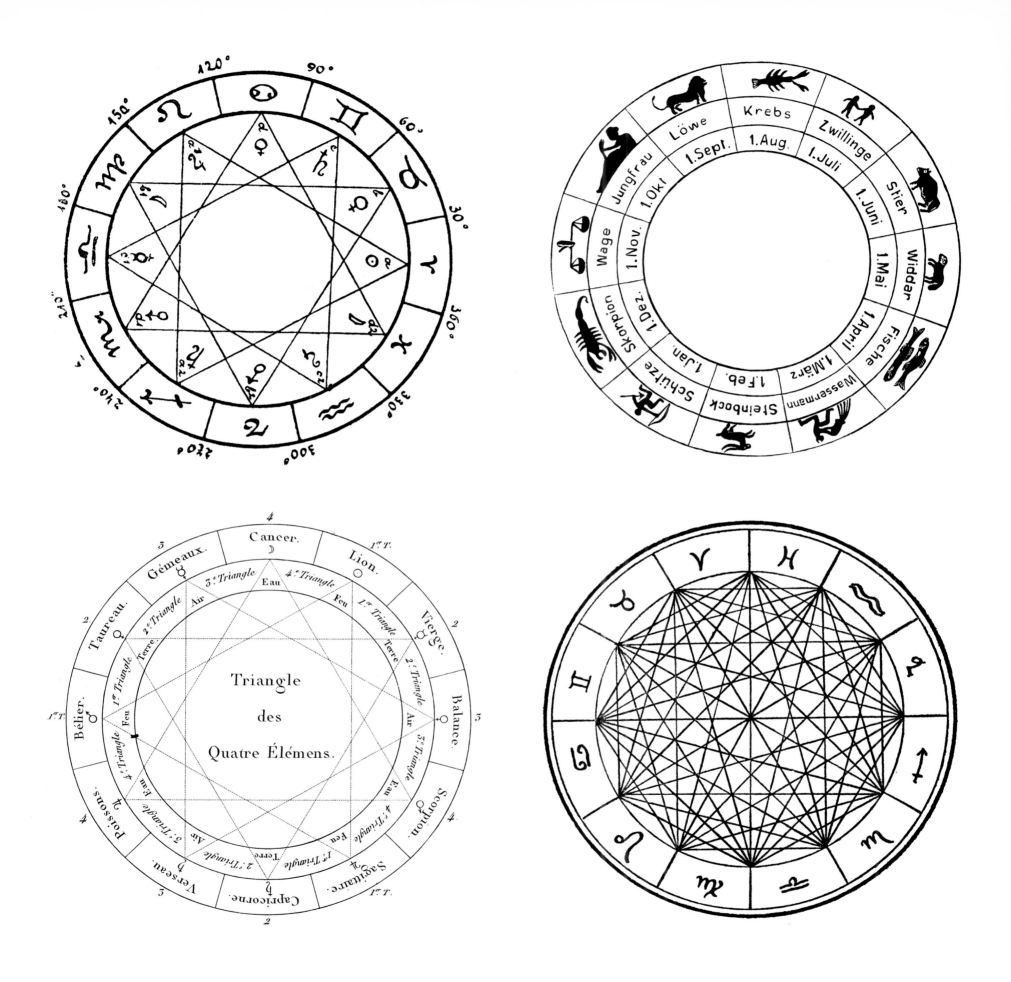

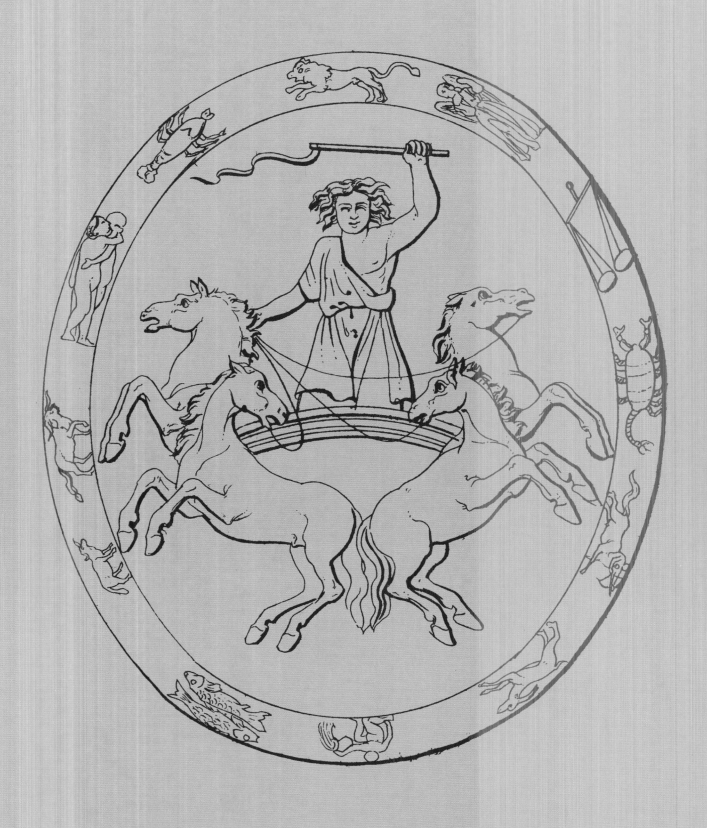

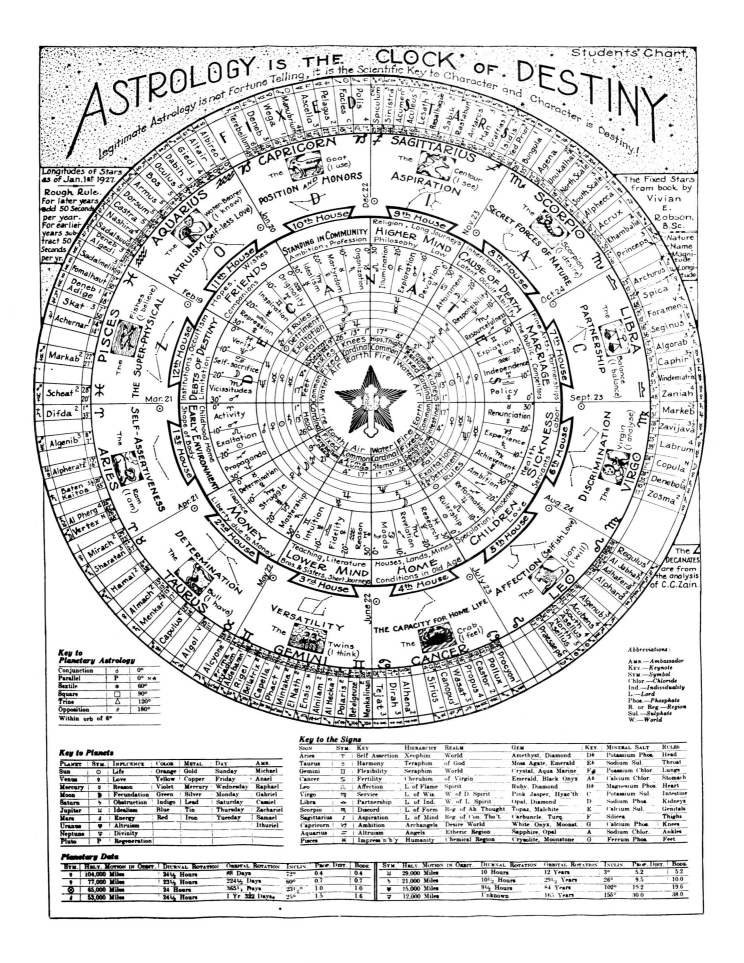

Key to Planetary Astrology

Conjunction	♂	0°
Parallel	P	0° N-S
Sextile	*	60°
Square	□	90°
Trine	△	120°
Opposition	☍	180°

Within orb of 6°

Key to Planets

PLANET	SYM.	INFLUENCE	COLOR	METAL	DAY	AMB.
Sun	☉	Life	Orange	Gold	Sunday	Michael
Venus	♀	Love	Yellow	Copper	Friday	Anael
Mercury	☿	Reason	Violet	Mercury	Wednesday	Raphael
Moon	☽	Fecundation	Green	Silver	Monday	Gabriel
Saturn	♄	Obstruction	Indigo	Lead	Saturday	Cassiel
Jupiter	♃	Idealism	Blue	Tin	Thursday	Zachariel
Mars	♂	Energy	Red	Iron	Tuesday	Samael
Uranus	♅	Altruism				Ithuriel
Neptune	♆	Divinity				
Pluto	P	Regeneration				

Key to the Signs

SIGN	SYM.	KEY	HIERARCHY	REALM	GEM	KEY	MINERAL SALT	RULES
Aries	♈	Self Assertion	Xeophim	World	Amethyst, Diamond	D♭	Potassium Phos.	Head
Taurus	♉	Harmony	Teraphim	of God	Moss Agate, Emerald	E♭	Sodium Sul.	Throat
Gemini	♊	Flexibility	Seraphim	World	Crystal, Aqua Marine	F♯	Potassium Chlor.	Lungs
Cancer	♋	Fertility	Cherubim	of Virgin	Emerald, Black Onyx	A♭	Calcium Chlor.	Stomach
Leo	♌	Affection	L. of Flame	Spirit	Ruby, Diamond	B♭	Magnesium Phos.	Heart
Virgo	♍	Service	L. of Wis.	W. of D. Spirit	Pink Jasper, Hyac'th	C	Potassium Sul.	Intestine
Libra	♎	Partnership	L. of Ind.	W. of L. Spirit	Opal, Diamond	D	Sodium Phos.	Kidneys
Scorpio	♏	Discord	L. of Form	Reg of Ab Thought	Topaz, Malchite	E	Calcium Sul.	Genitals
Sagittarius	♐	Aspiration	L. of Mind	Reg of Con. Tho't.	Carbuncle, Turq.	F	Silicea	Thighs
Capricorn	♑	Ambition	Archangels	Desire World	White Onyx, Moonst.	G	Calcium Phos.	Knees
Aquarius	♒	Altruism	Angels	Etheric Region	Sapphire, Opal	A	Sodium Chlor.	Ankles
Pisces	♓	Impress'n b'y	Humanity	Chemical Region	Crysolite, Moonstone	G	Ferrum Phos.	Feet

Planetary Data

SYM.	HRLY. MOTION IN ORBIT.	DIURNAL ROTATION	ORBITAL ROTATION	INCLIN.	PROP. DIST.	BODE	SYM.	HRLY. MOTION IN ORBIT	DIURNAL ROTATION	ORBITAL ROTATION	INCLIN.	PROP. DIST.	BODE
☿	104,000 Miles	24½ Hours	88 Days	7°	0.4	0.4	♃	29,000 Miles	10 Hours	12 Years	3°	5.2	5.2
♀	77,000 Miles	23¼ Hours	224½ Days	60°	0.7	0.7	♄	21,000 Miles	10½ Hours	29½ Years	26°	9.5	10.0
⊗	65,000 Miles	24 Hours	365½ Days	23½°	1.0	1.0	♅	15,000 Miles	9¾ Hours	84 Years	102°	19.2	19.6
♂	53,000 Miles	24½ Hours	1 Yr 322 Days	25°	1.5	1.6	♆	12,000 Miles	Unknown	165 Years	155°	30.0	38.0

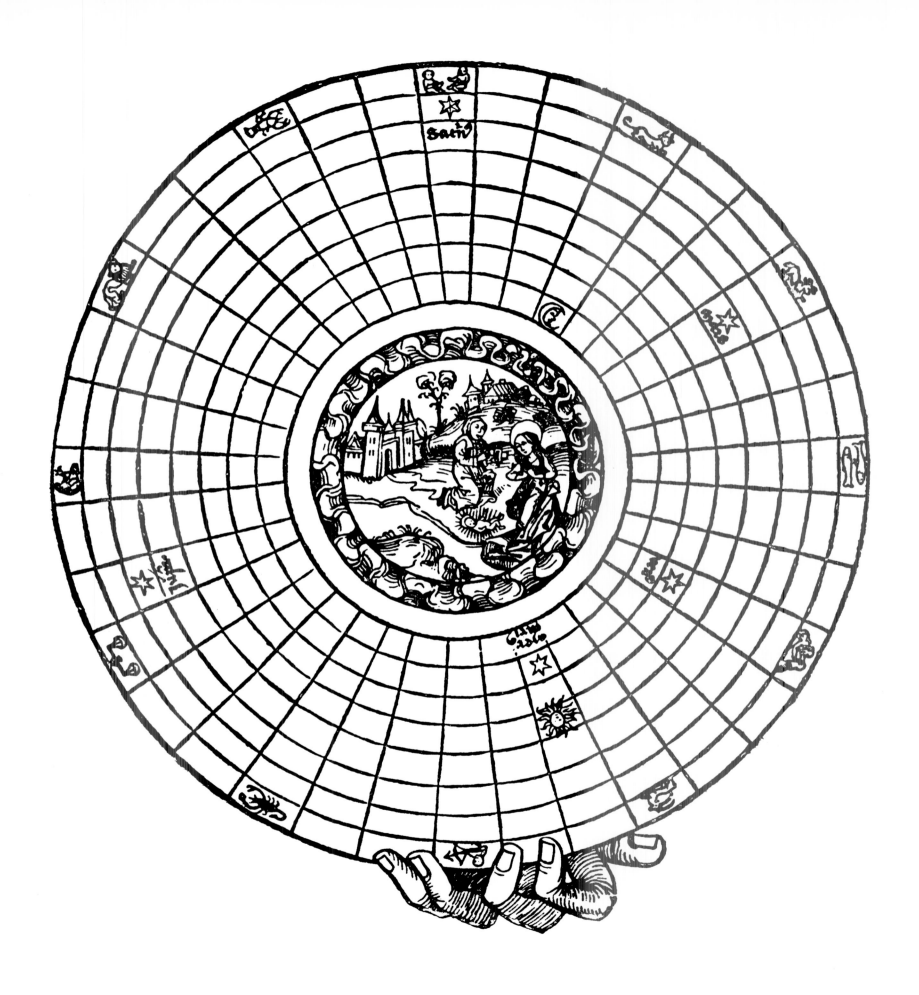

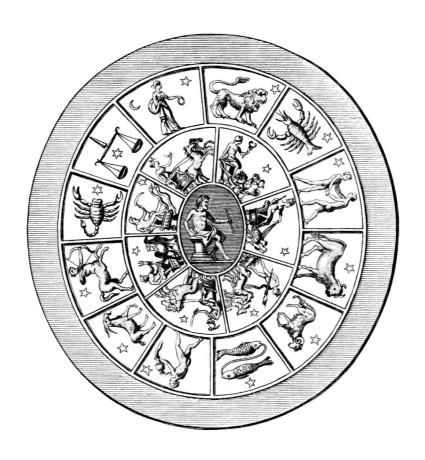

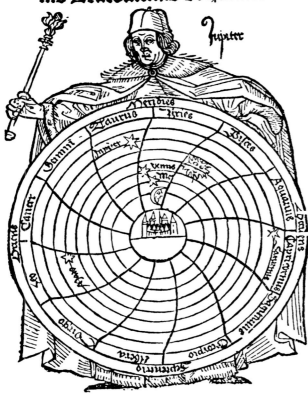

**Practica Baccalaurij Johā
nis Cracouiensis de haſſurt·**

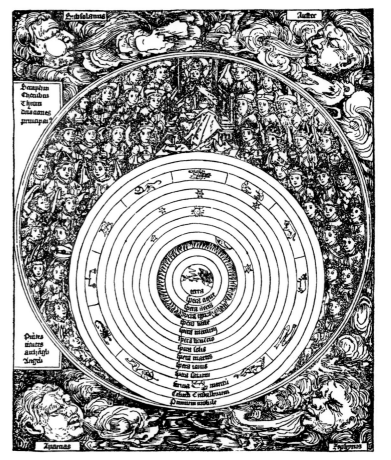

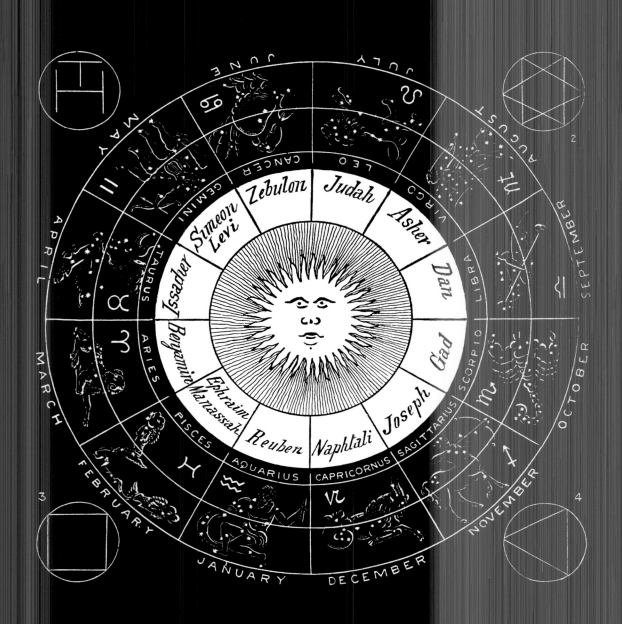

SIGNS OF THE ZODIAC

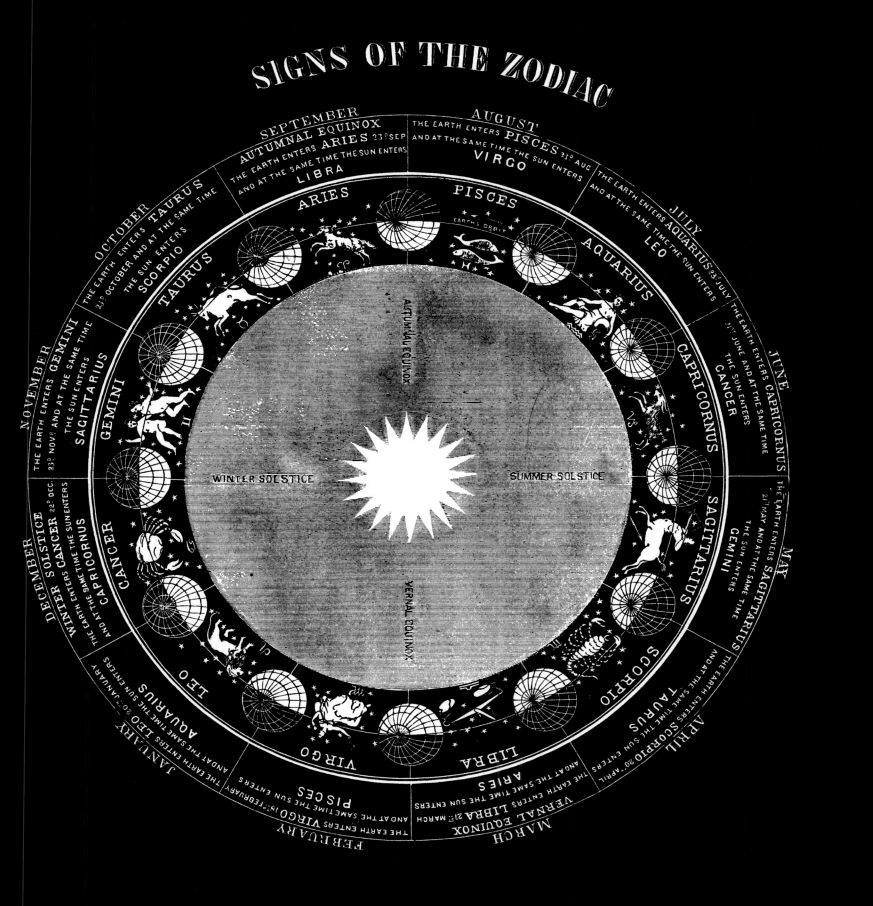

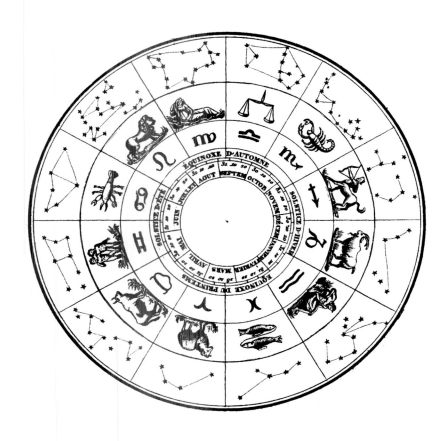

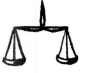 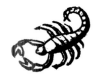 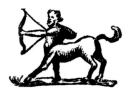 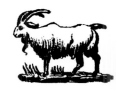

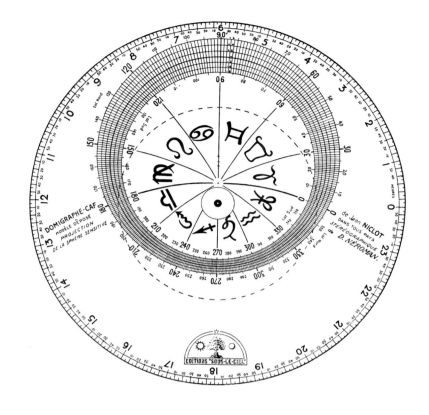

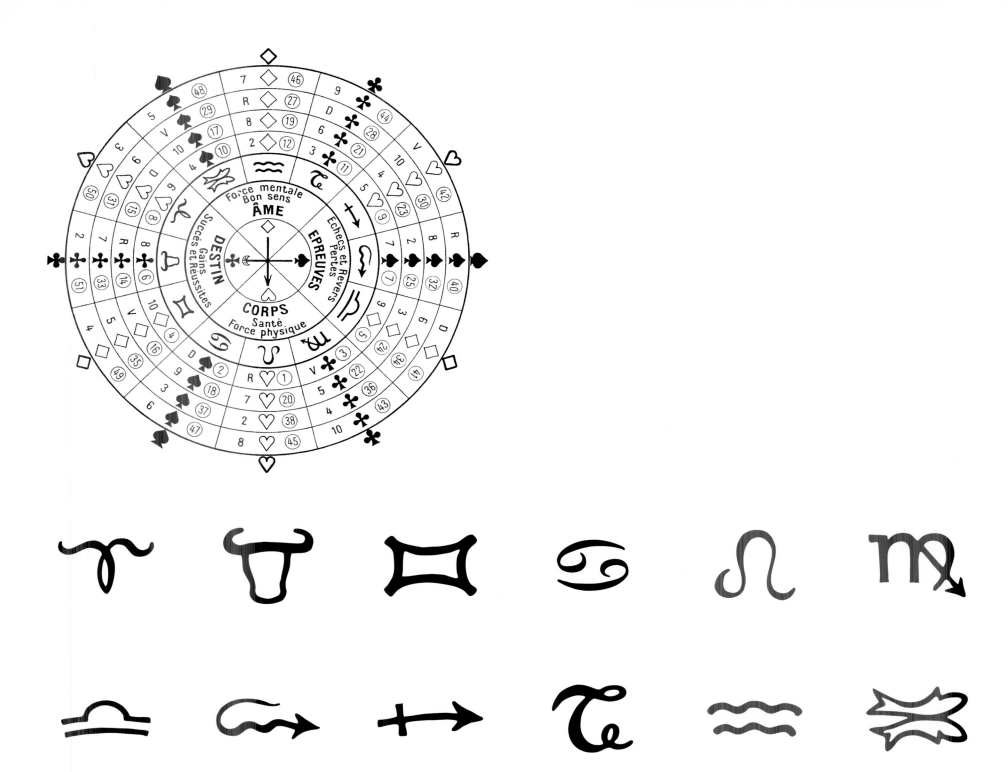

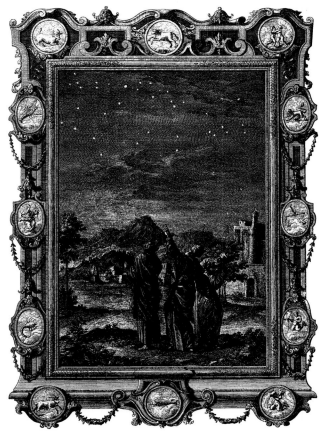

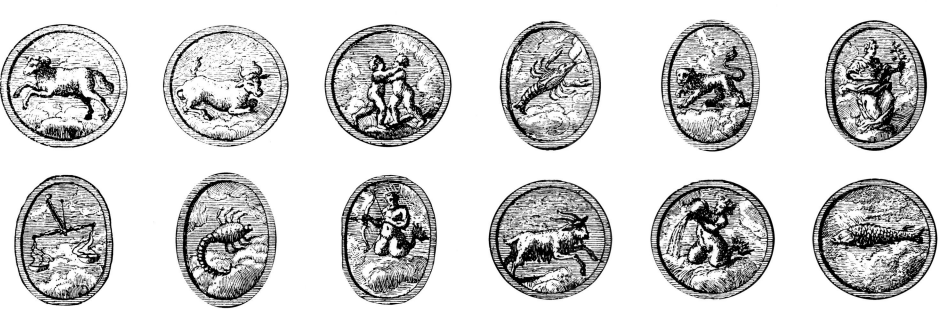

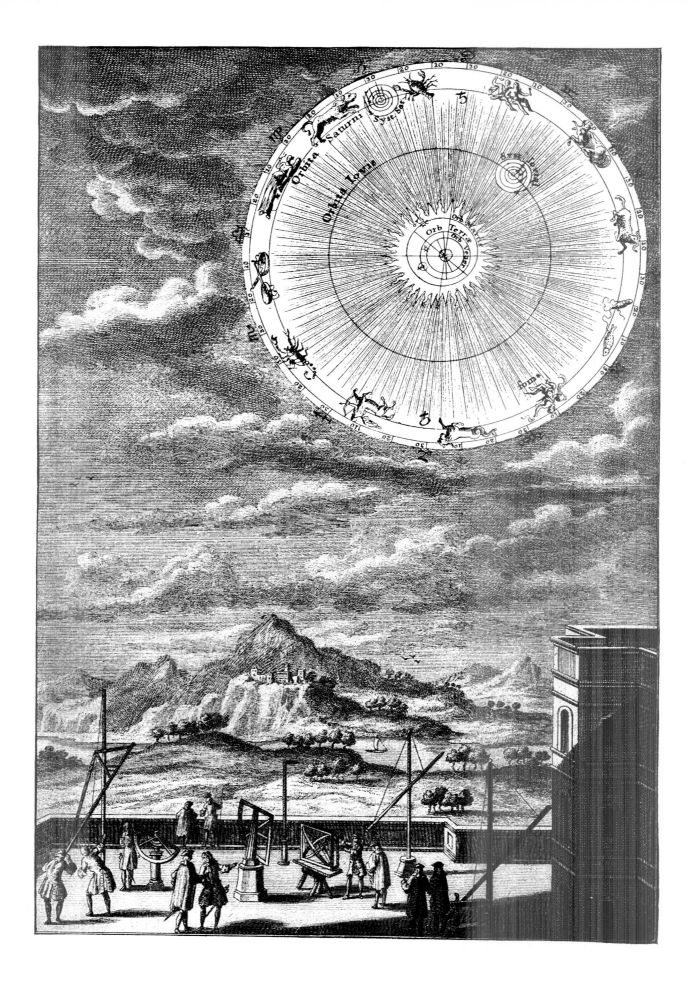

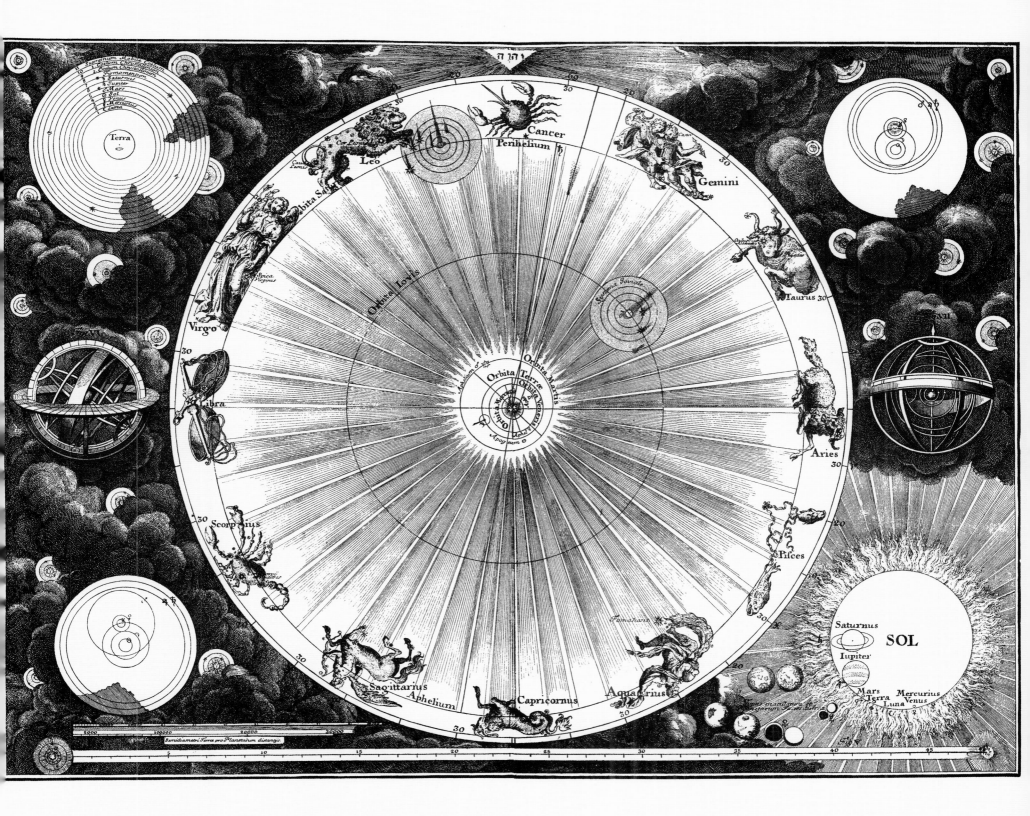

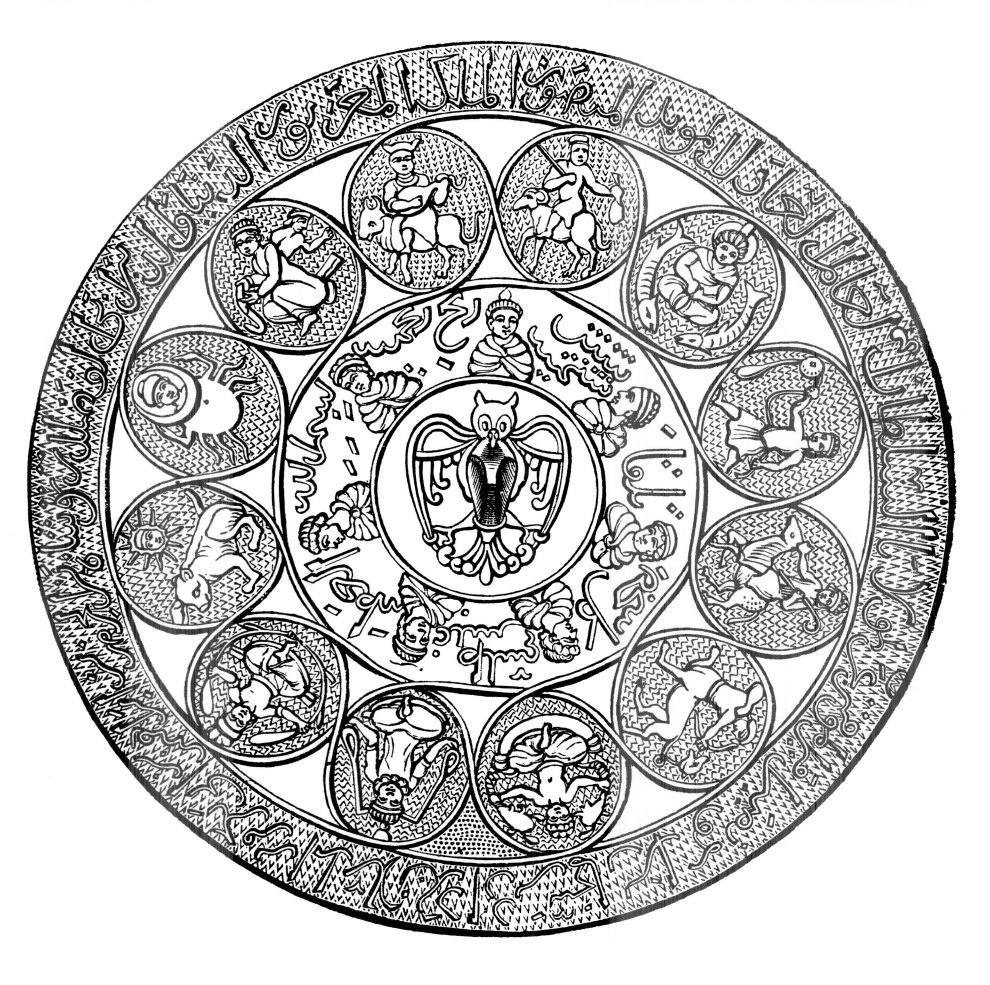

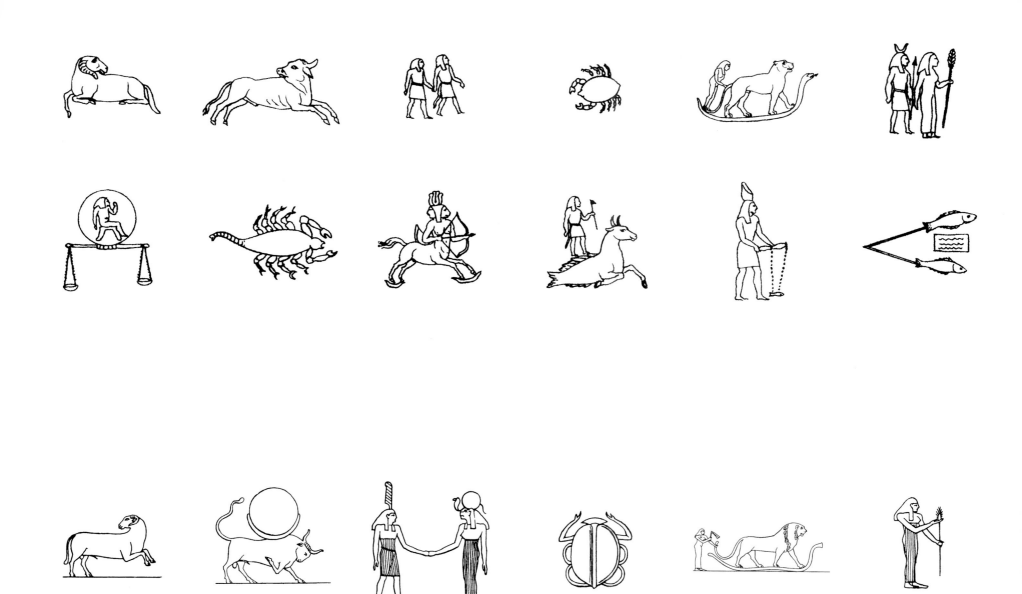

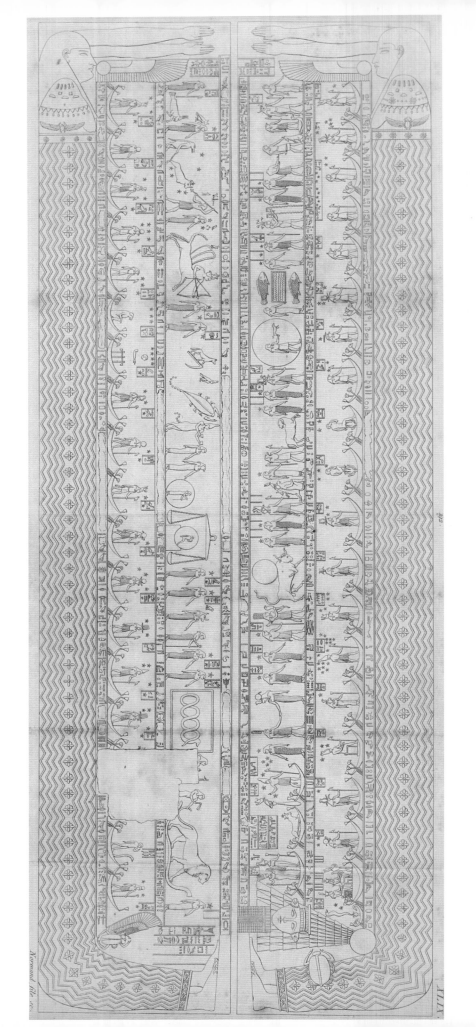

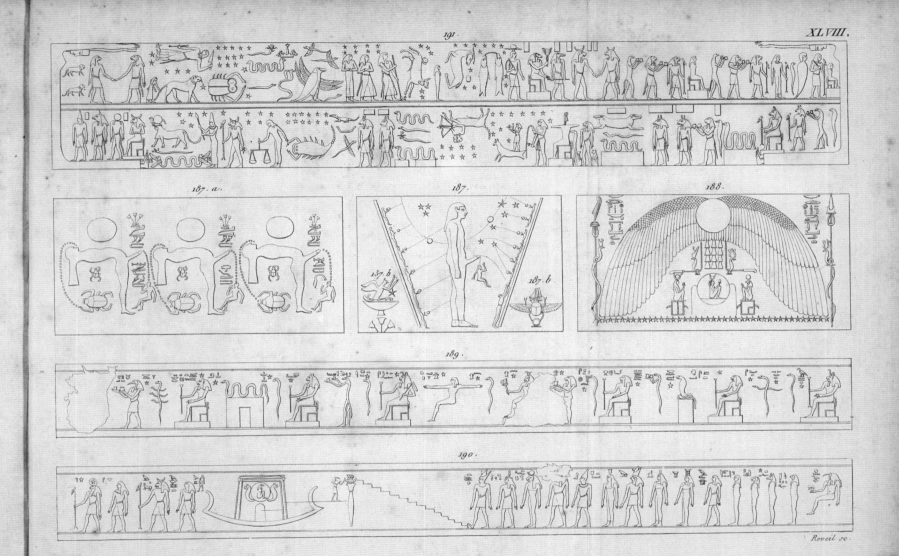

191.

187. a. 187. 188.

187. b. 187. b.

189.

190.

Reveil sc.

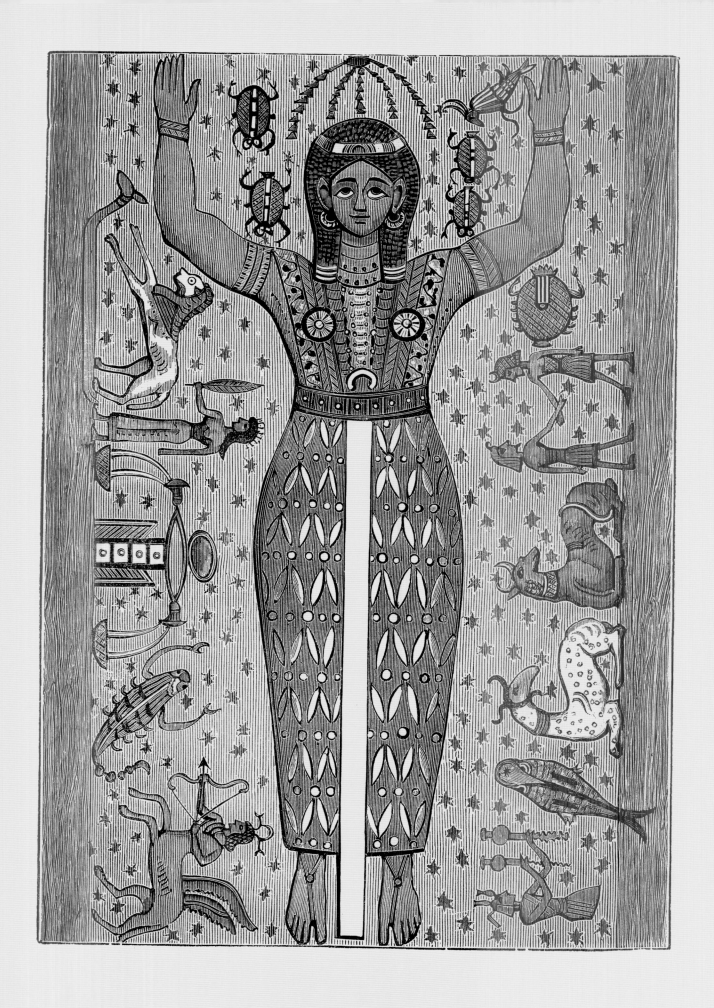

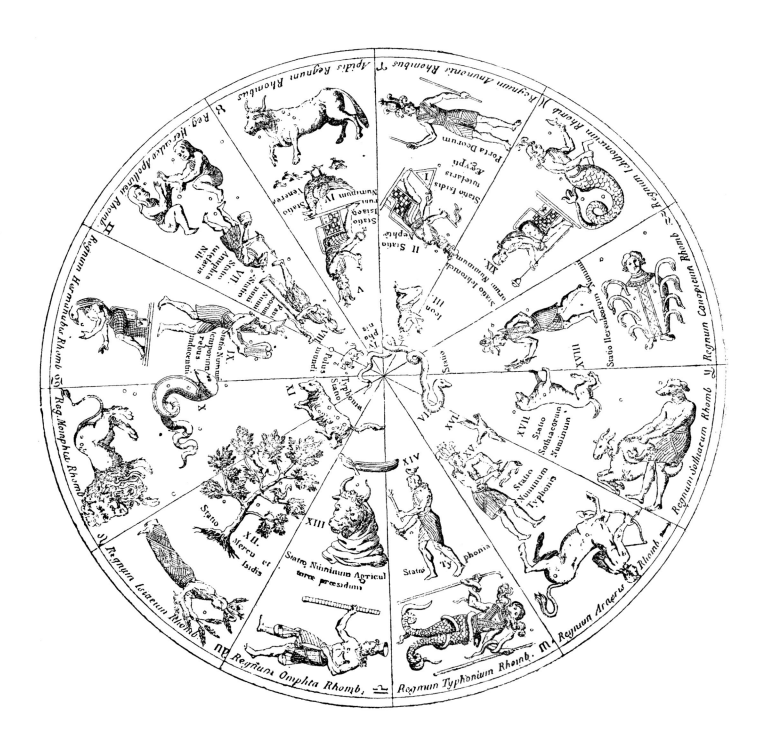

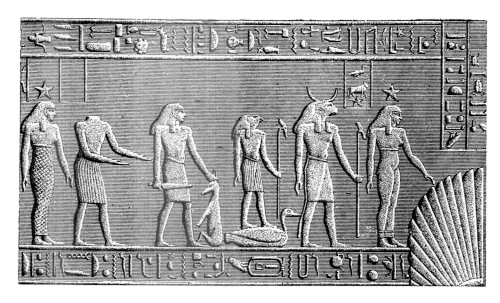

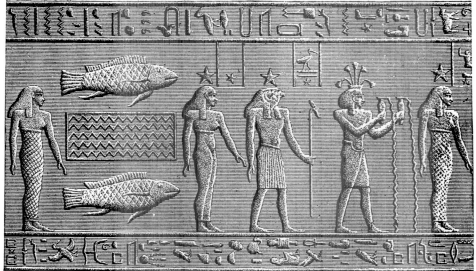

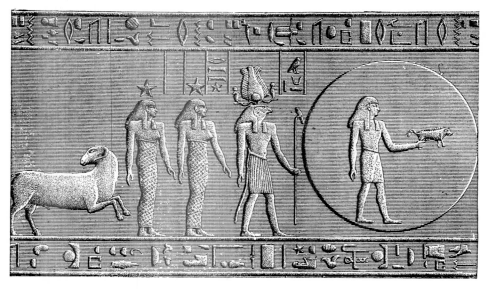

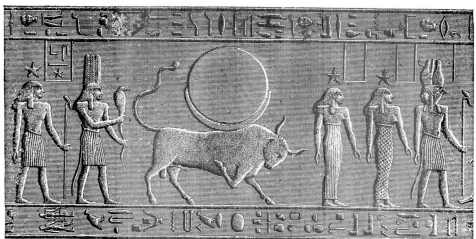

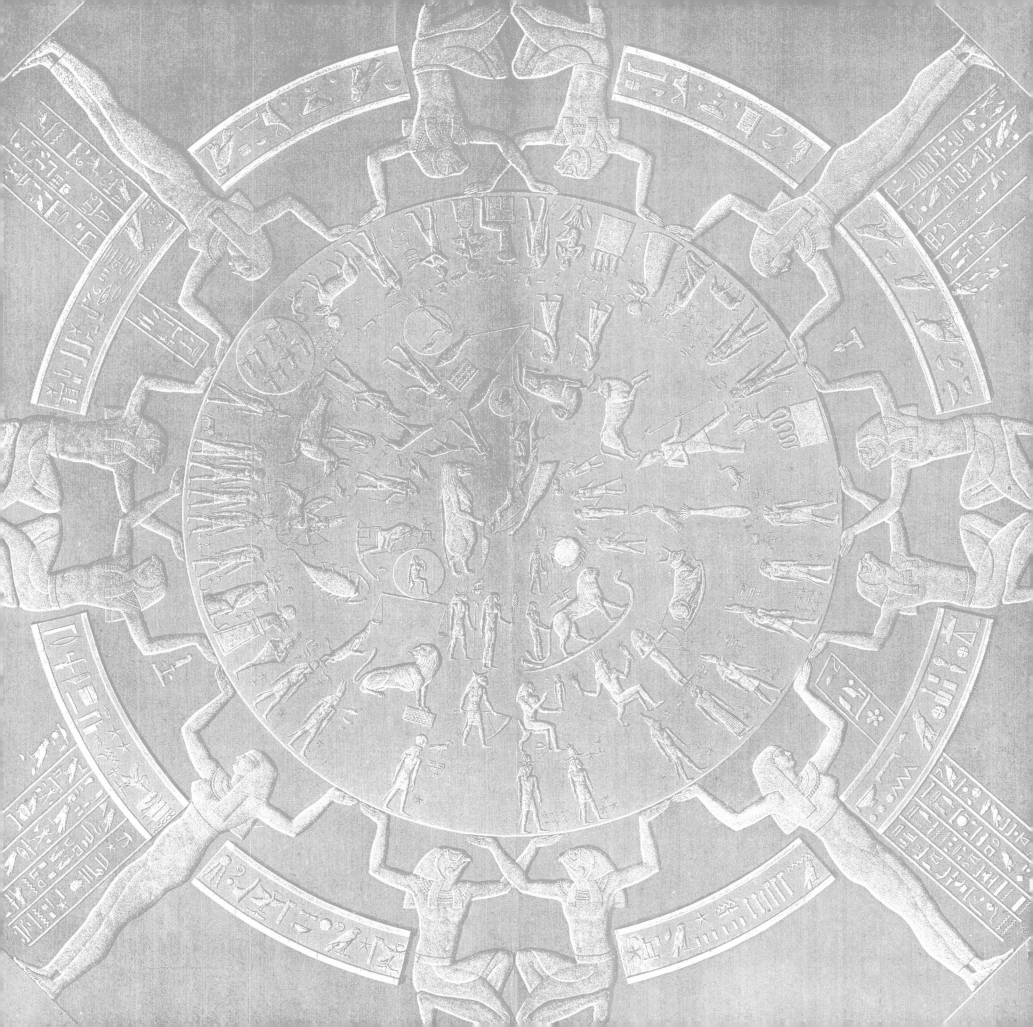

PLANISPHÈRE OU ZODIAQUE DE DENDERAH.

Tel qu'il était placé dans le Plafond du Temple de Denderah, en Égypte.

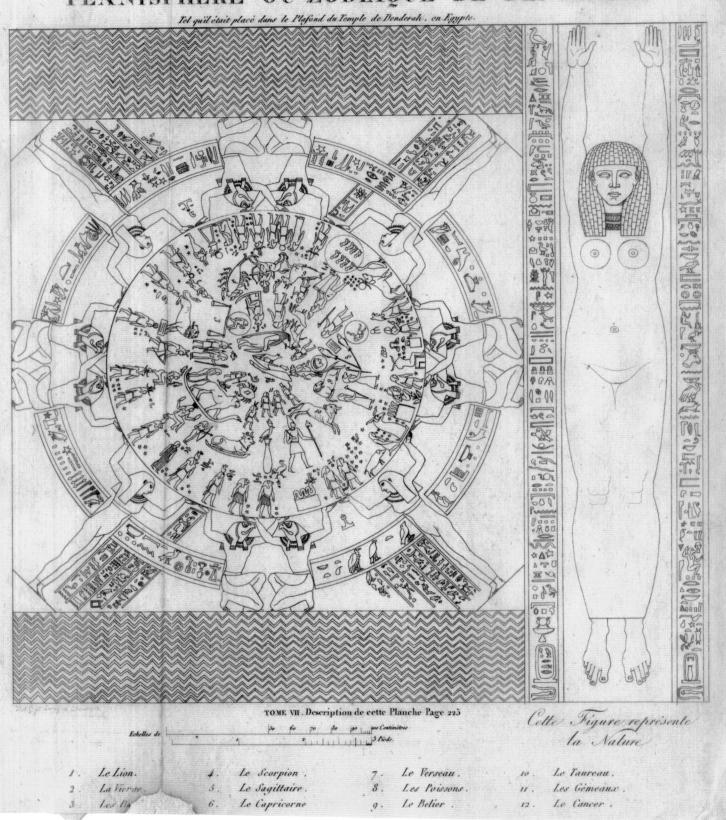

TOME VII. Description de cette Planche Page 225

Cette Figure représente la Nature

Echelles de [scale bar] Centimètres — 3 Pieds.

1.	Le Lion.	4.	Le Scorpion.	7.	Le Verseau.	10.	Le Taureau.
2.	La Vierge.	5.	Le Sagittaire.	8.	Les Poissons.	11.	Les Gémeaux.
3.	Les B...	6.	Le Capricorne.	9.	Le Belier.	12.	Le Cancer.

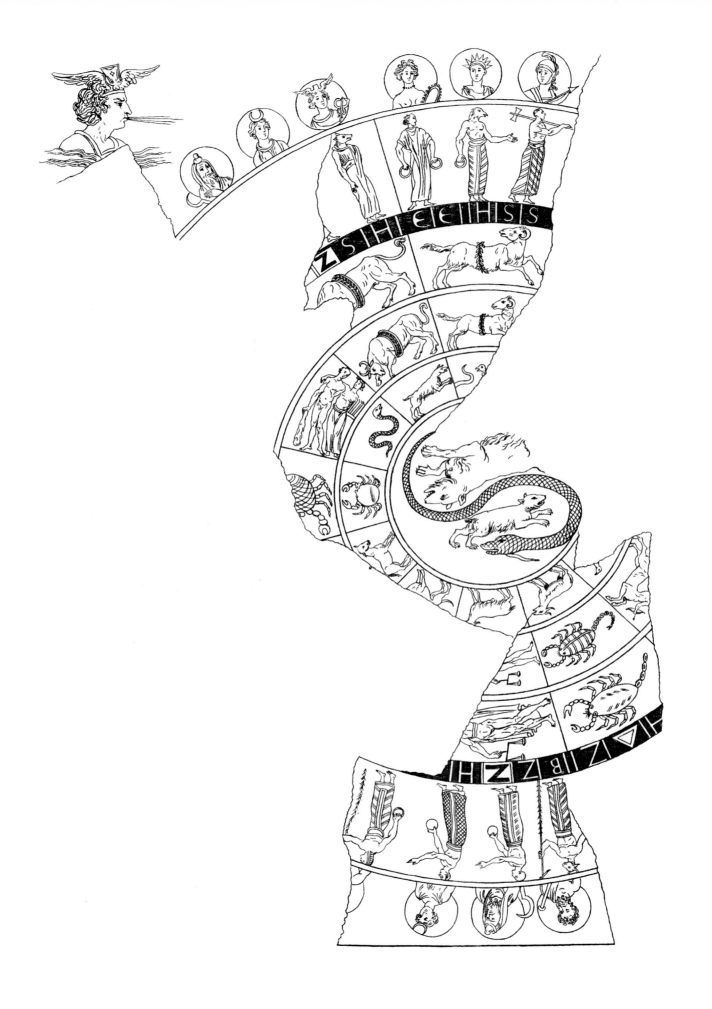

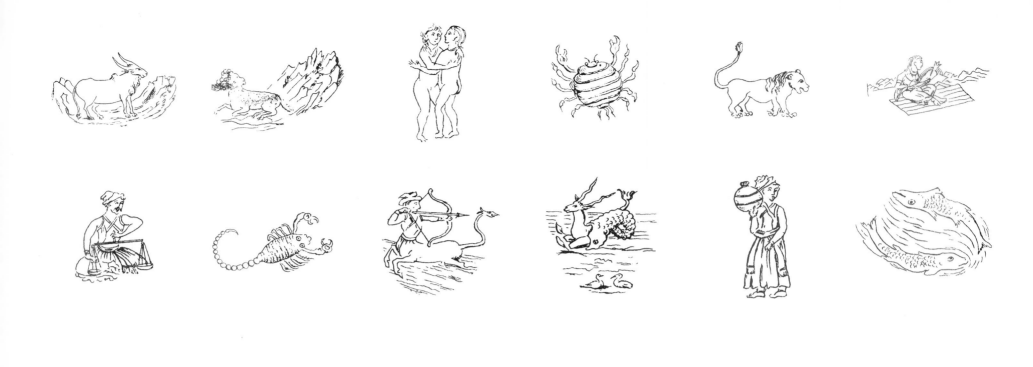

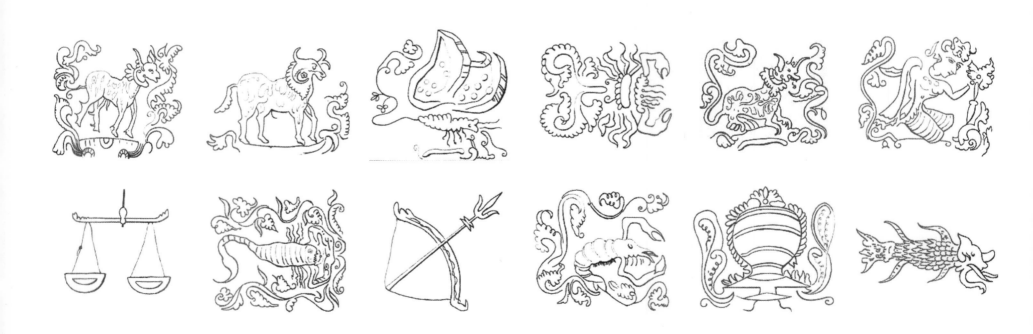

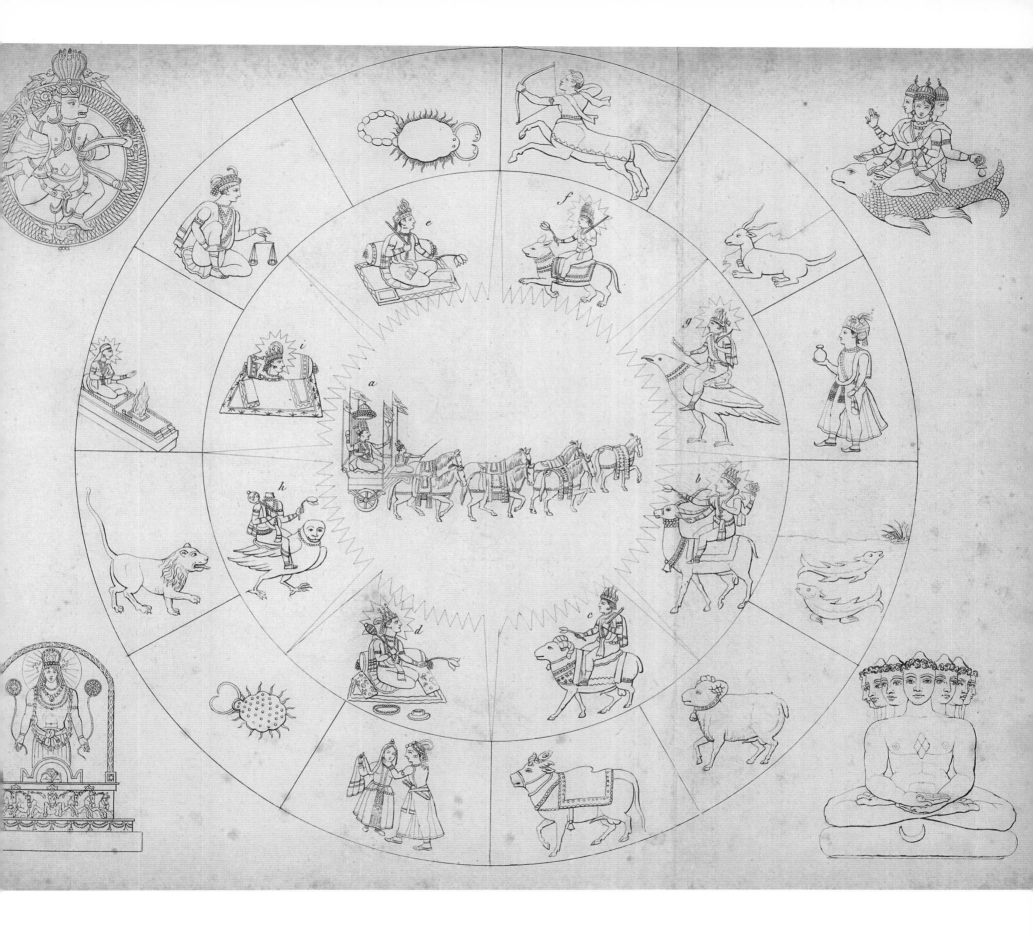

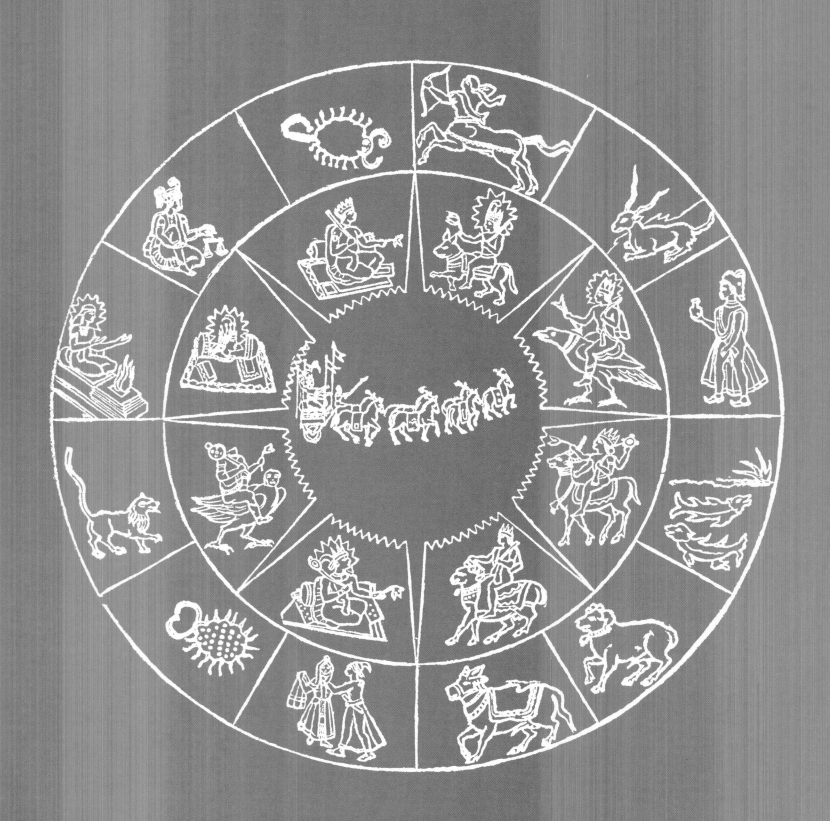

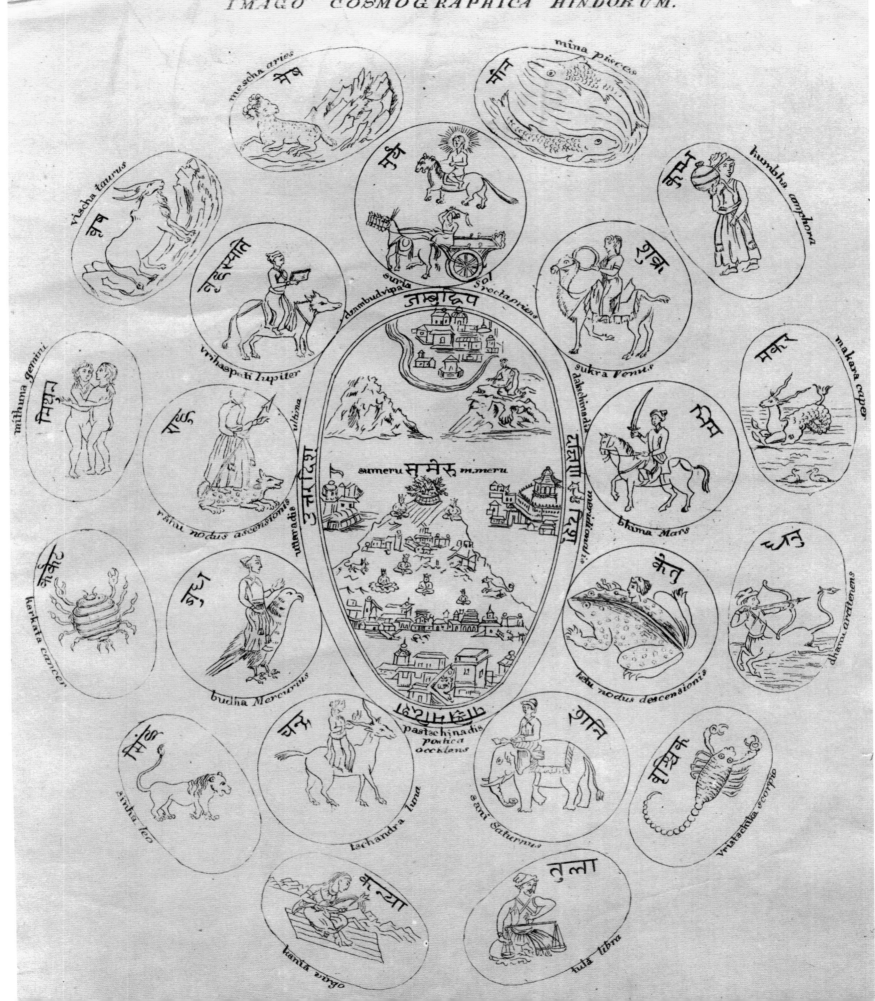

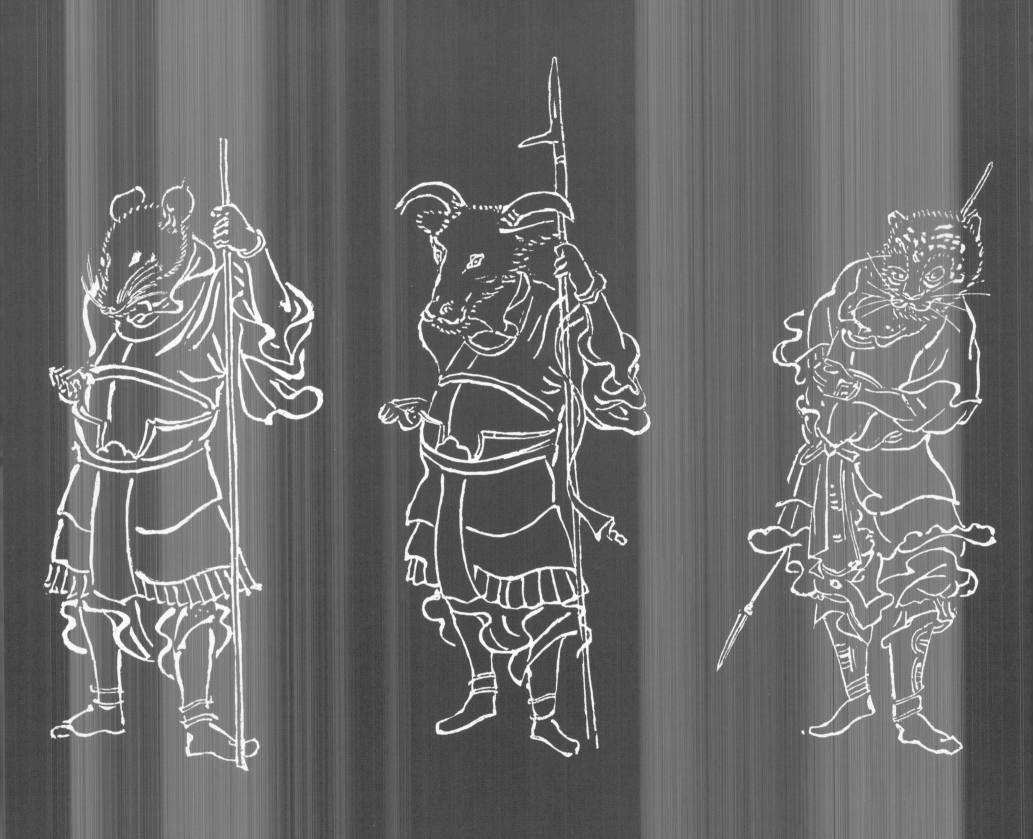

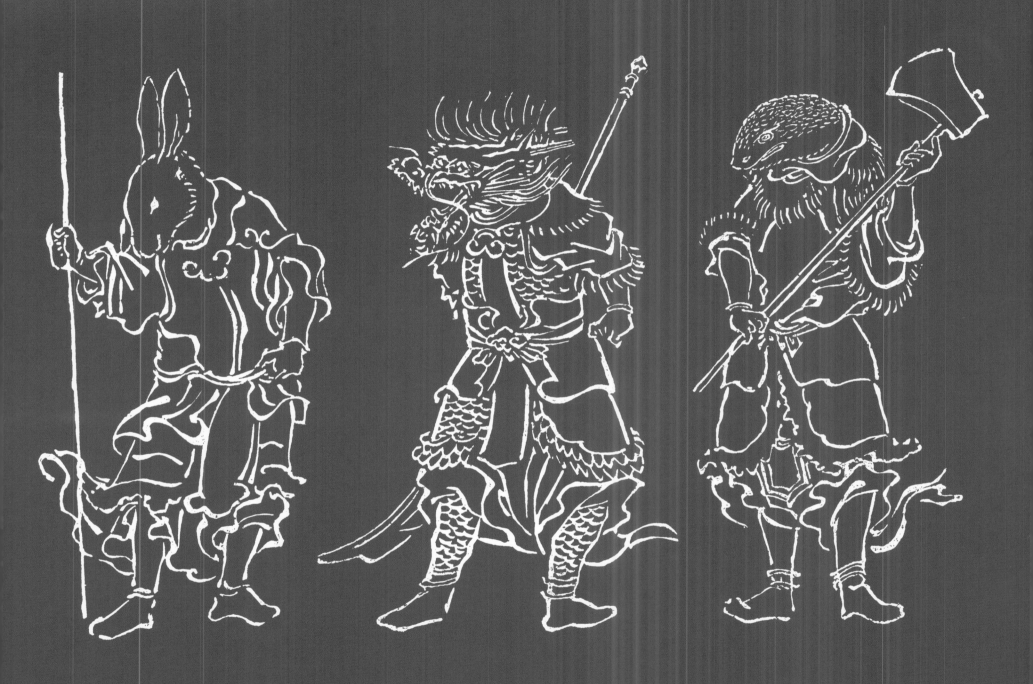

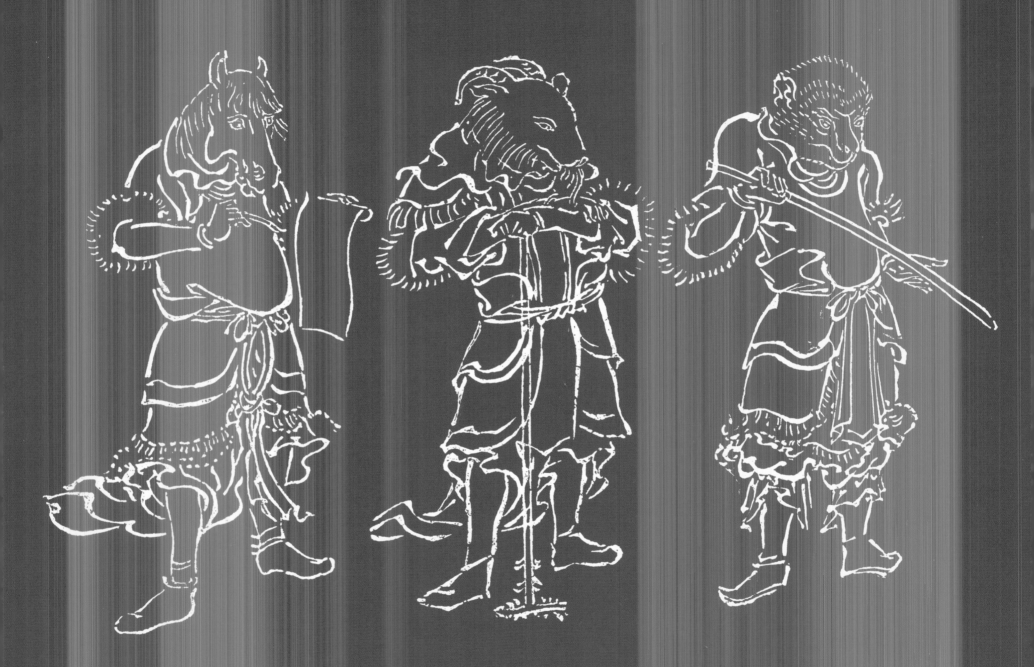

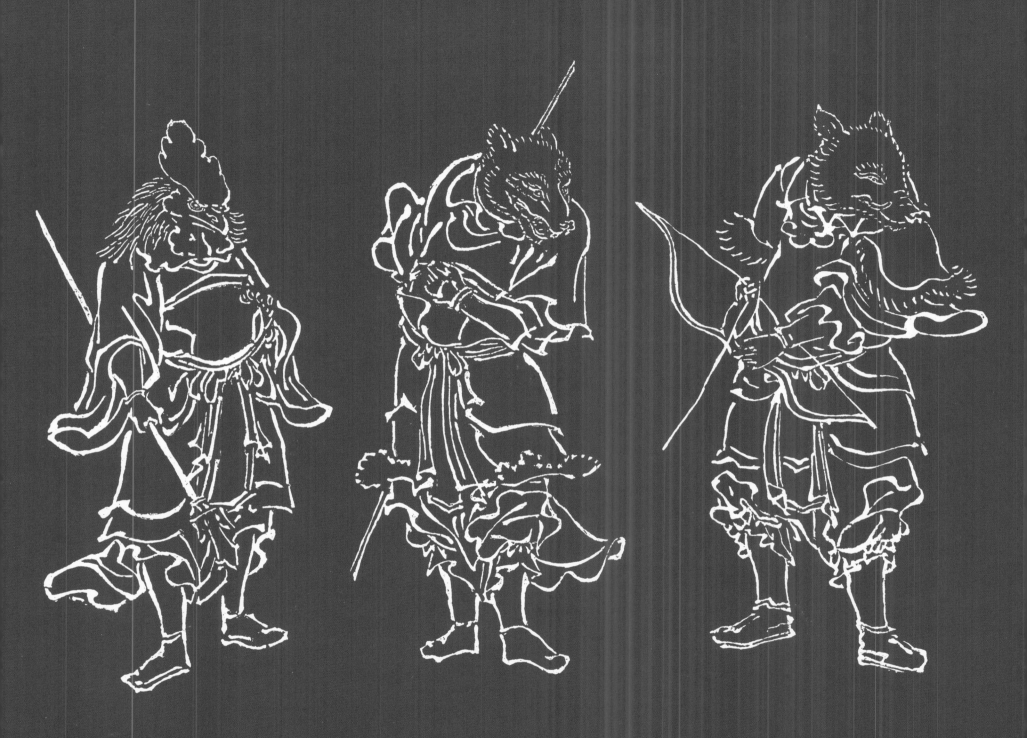

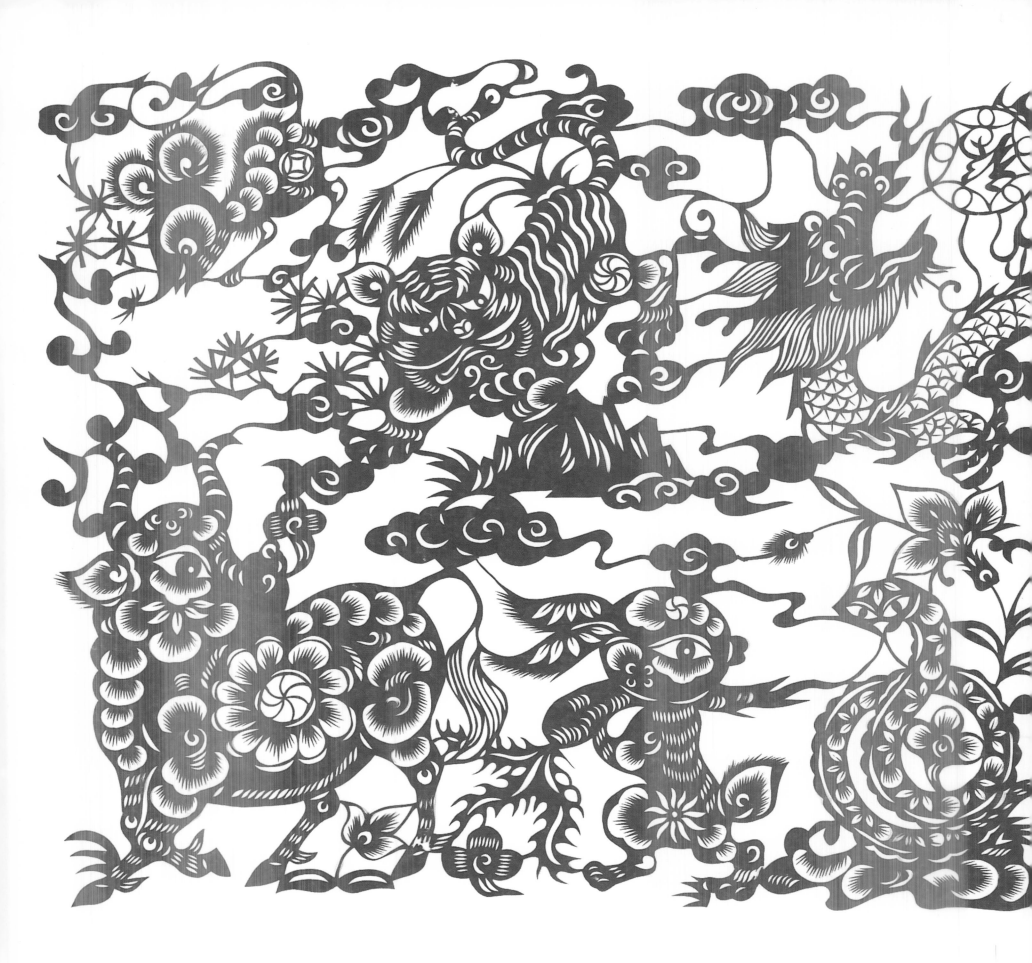

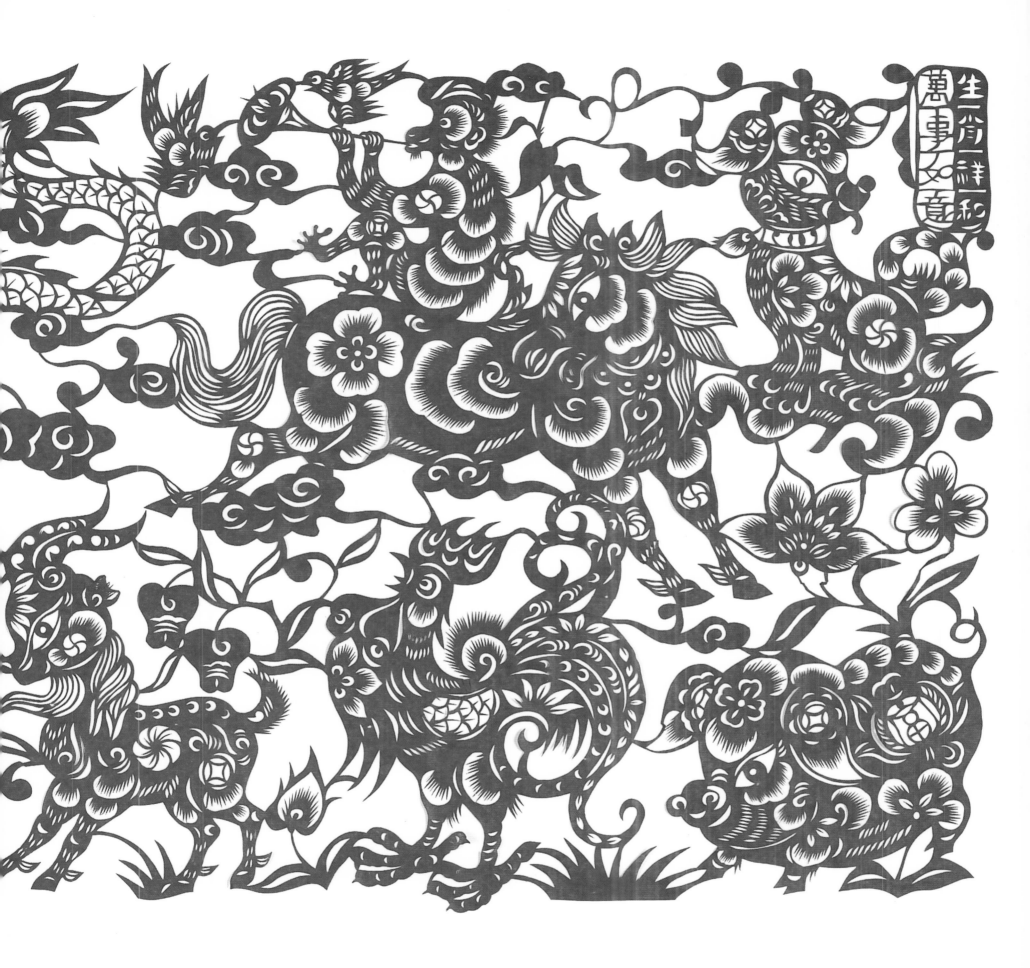

生肖一祥一和
萬事如意

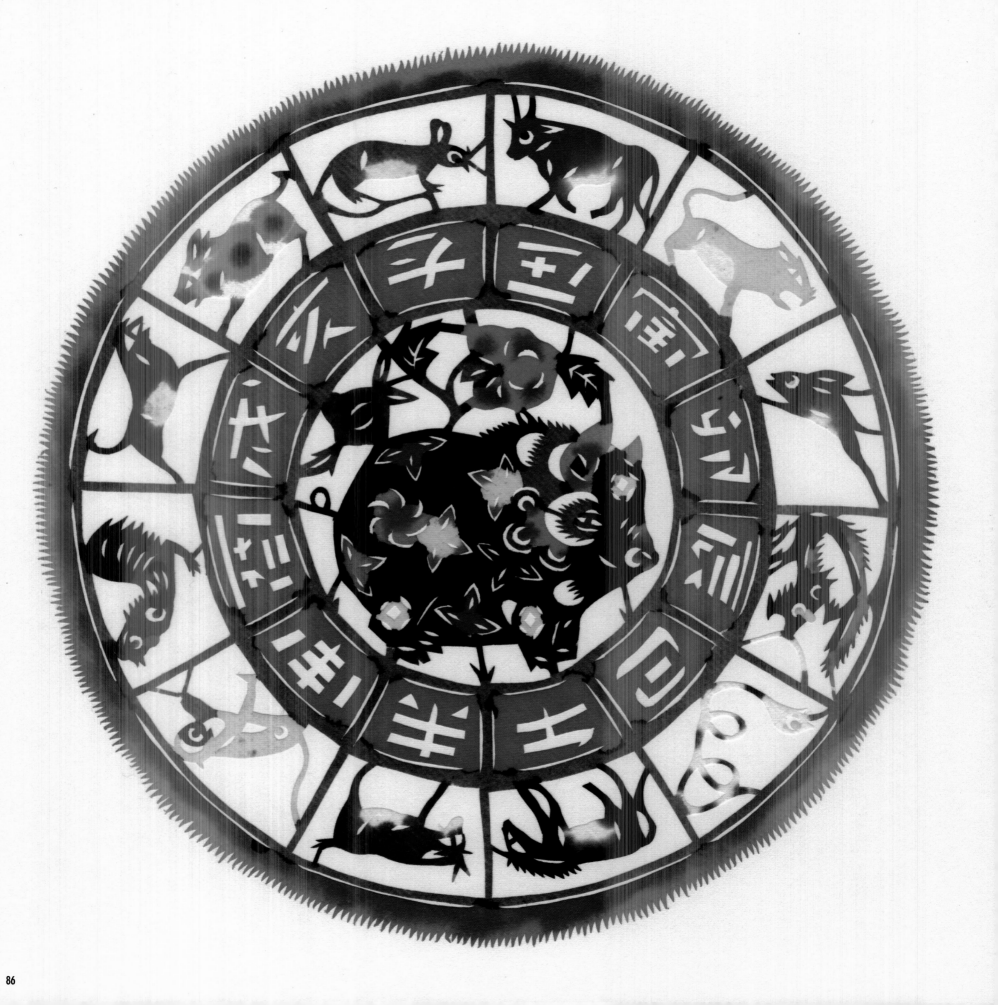

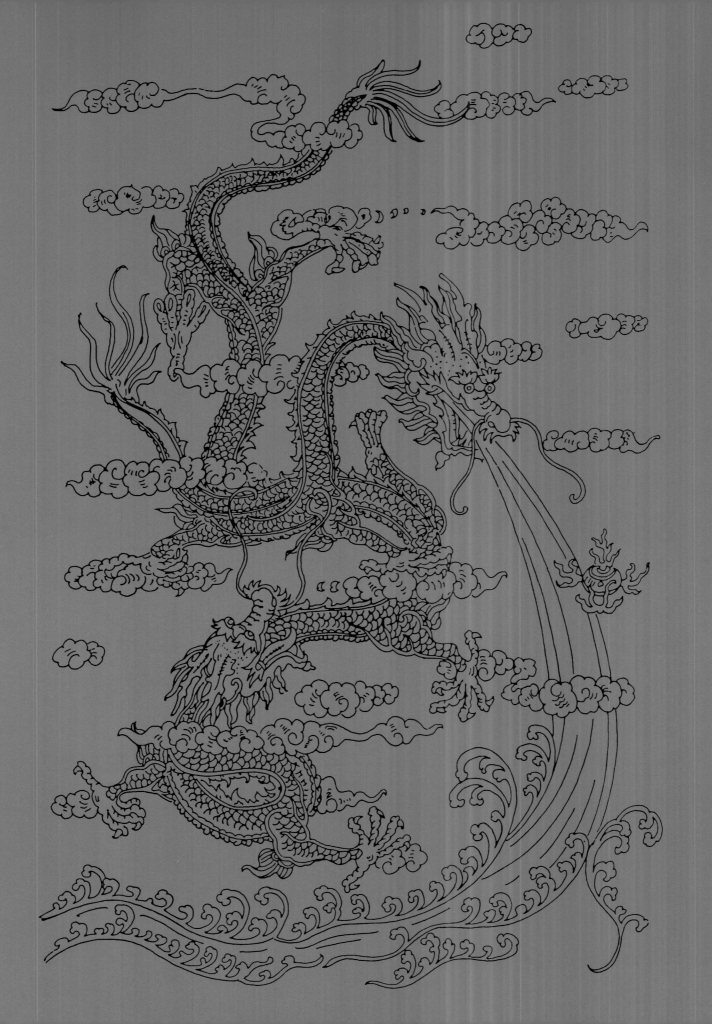

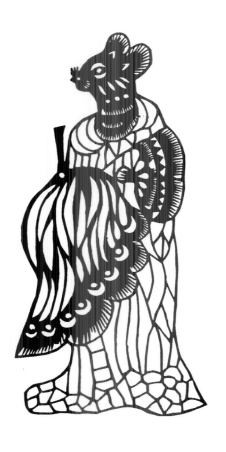
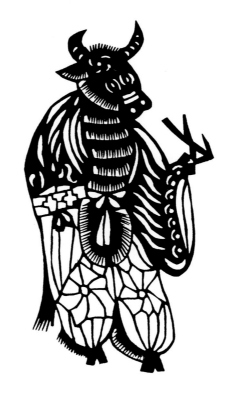
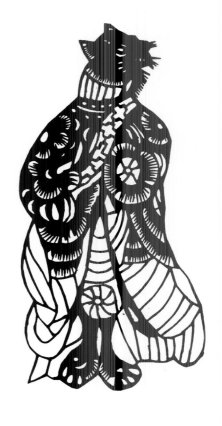
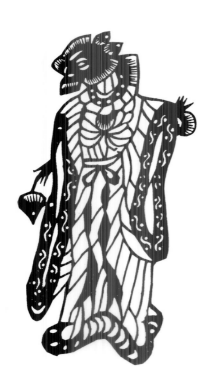
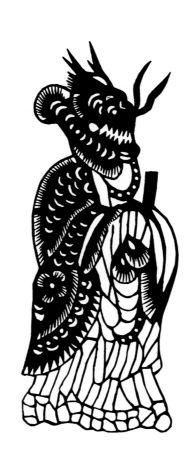
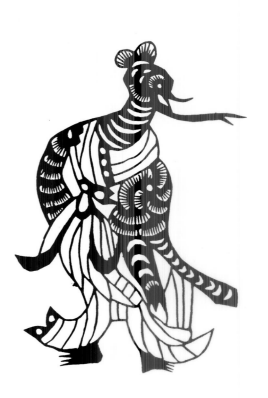

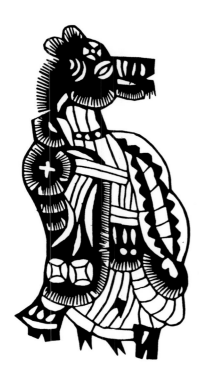

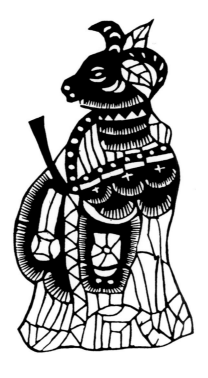

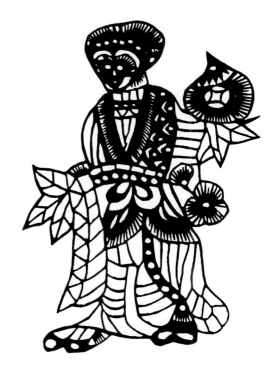

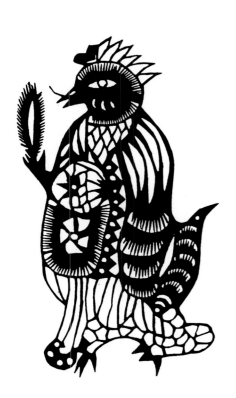

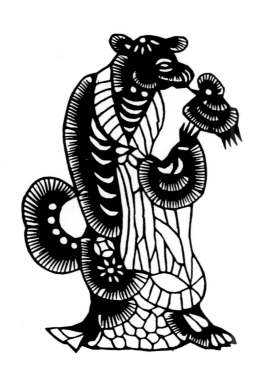

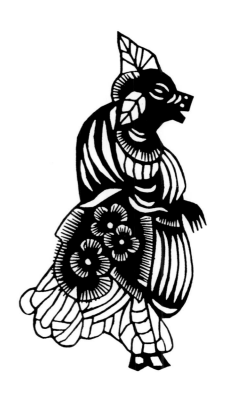

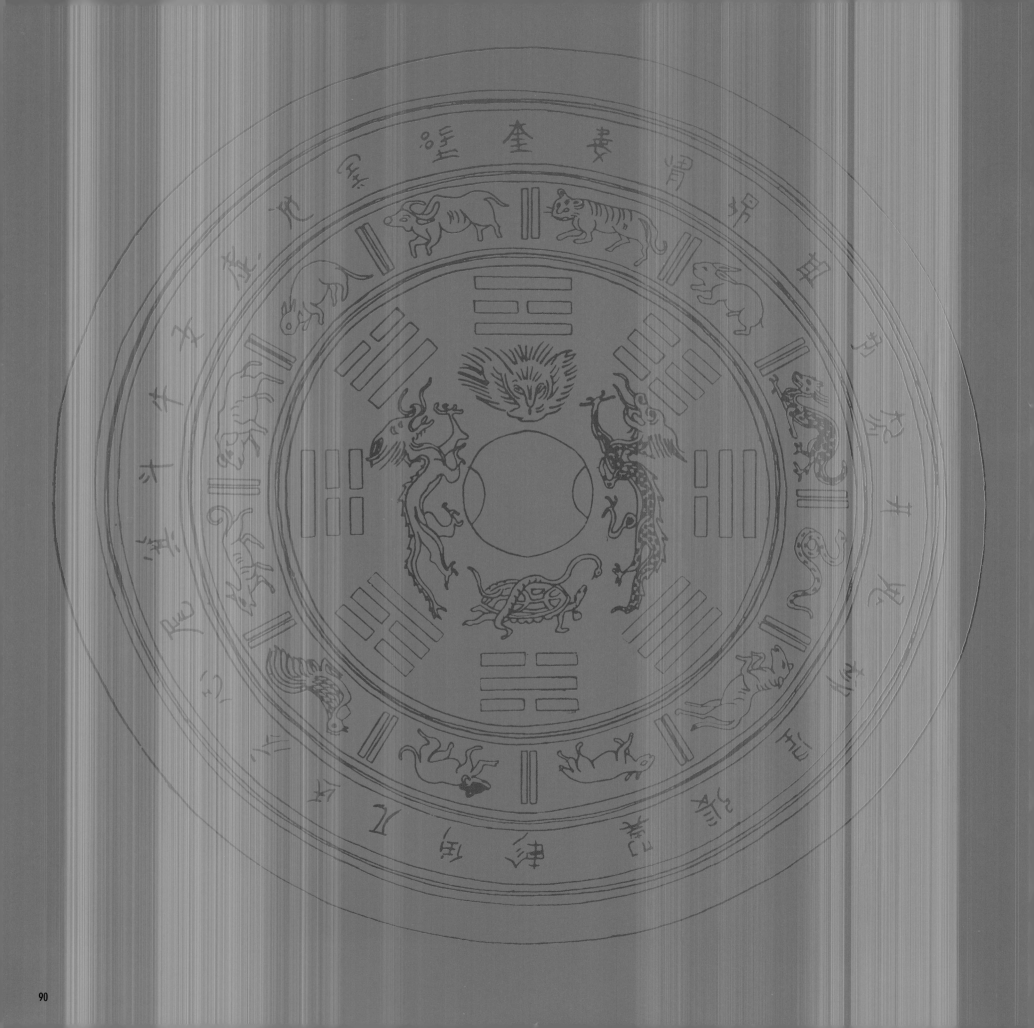

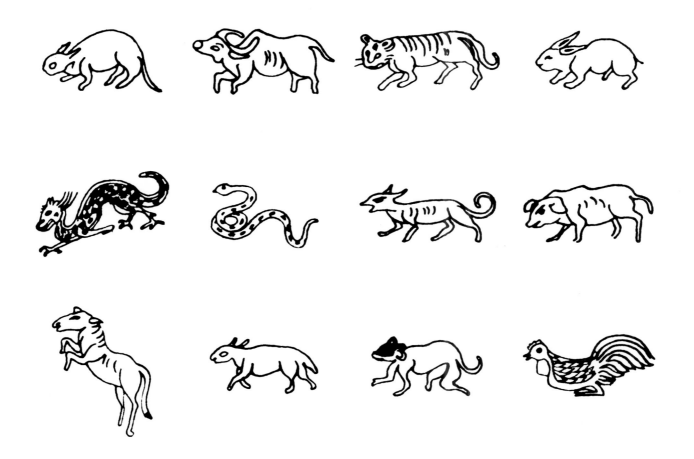

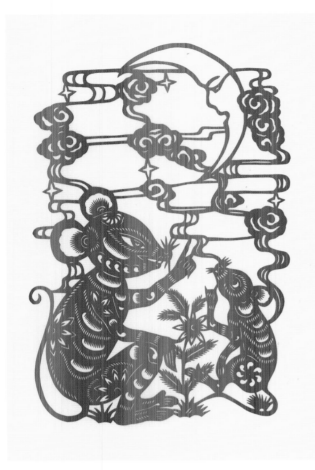
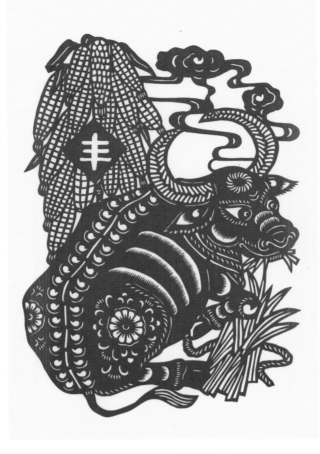
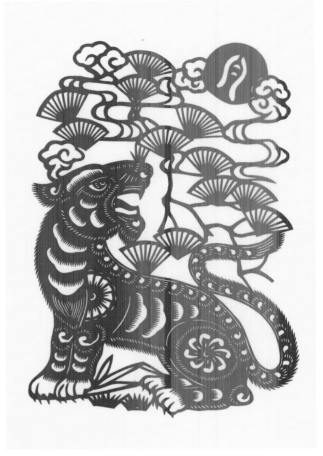
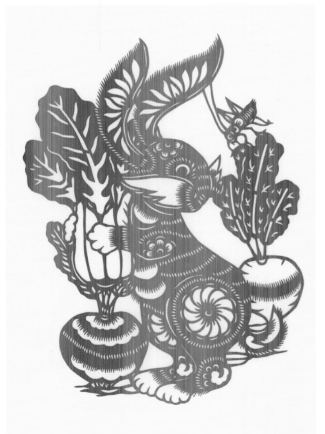
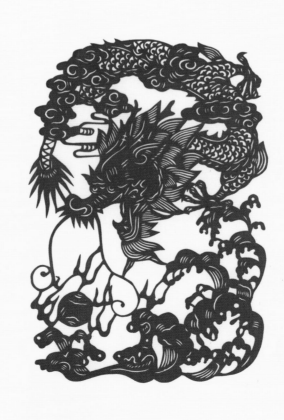
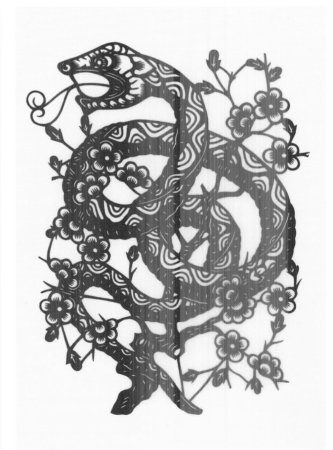

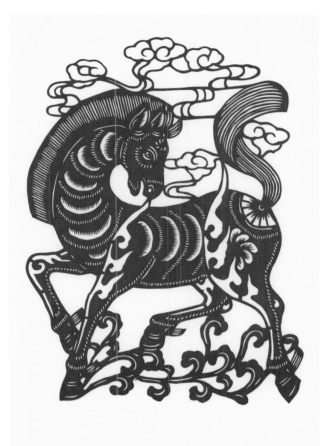
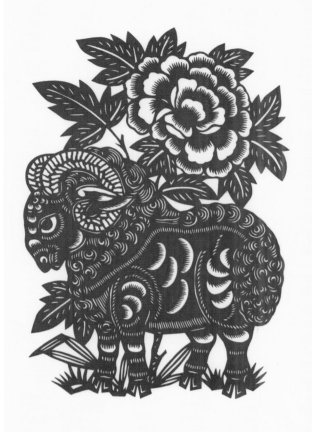
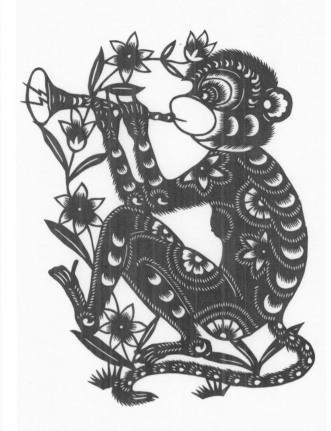
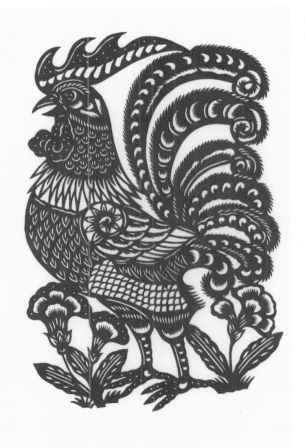
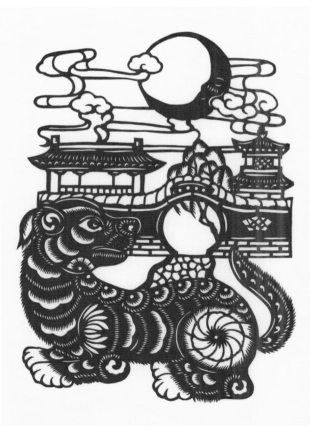
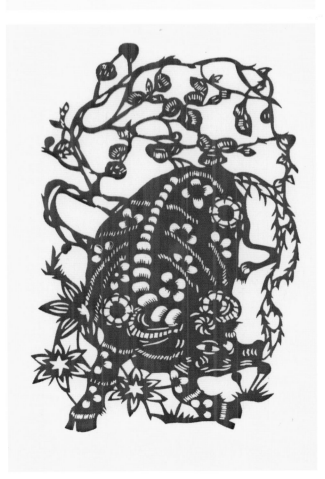

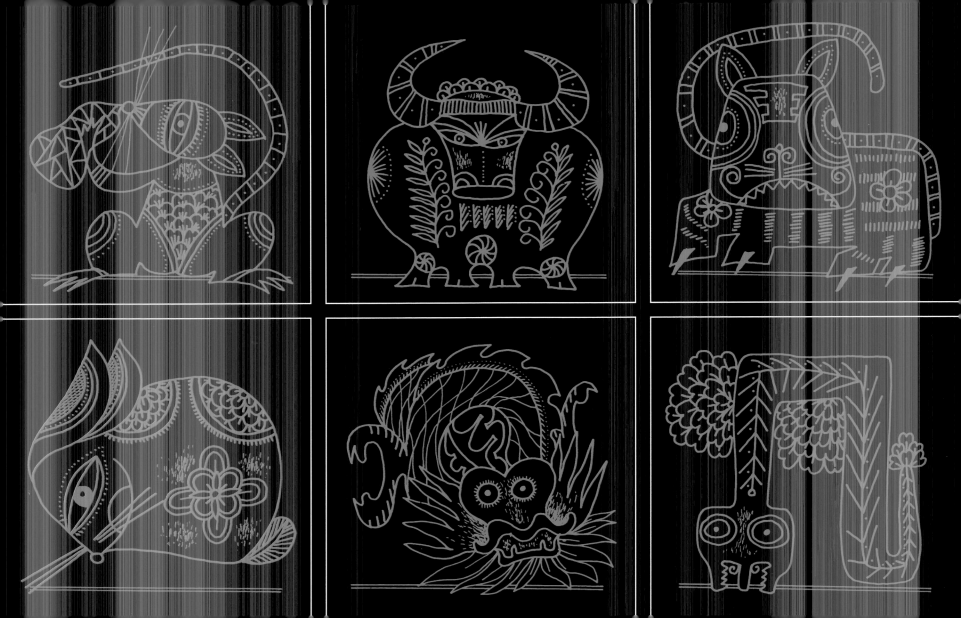

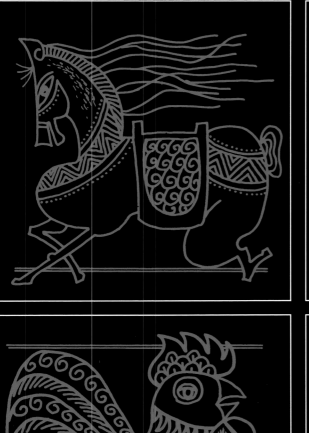
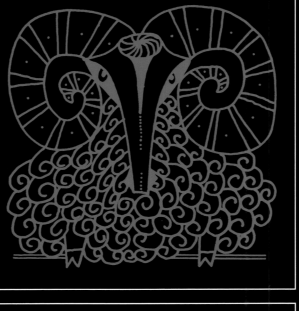
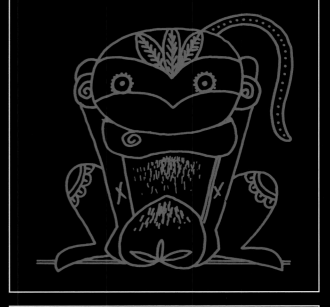
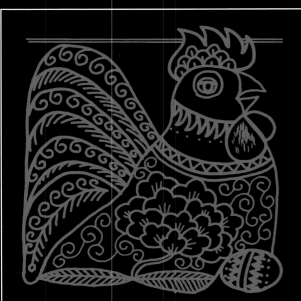
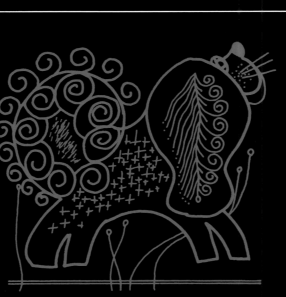
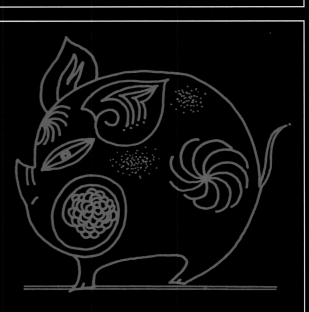

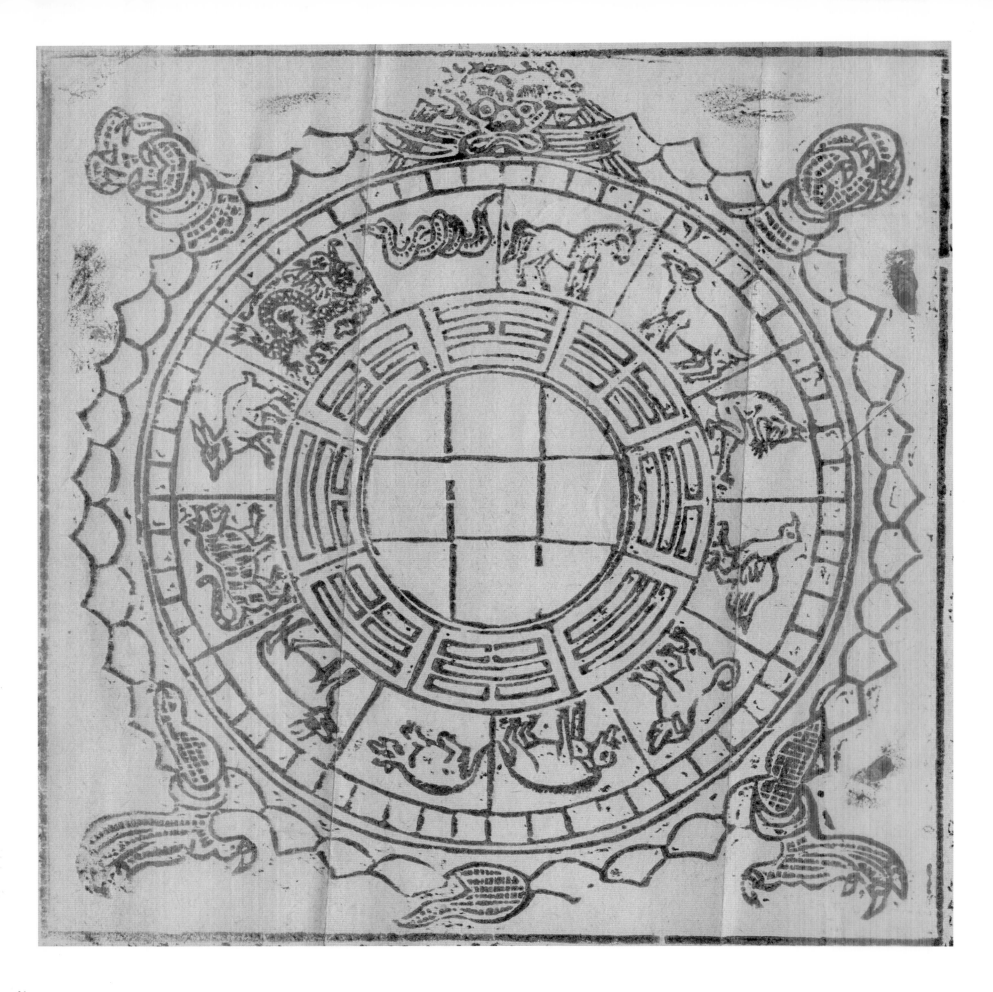

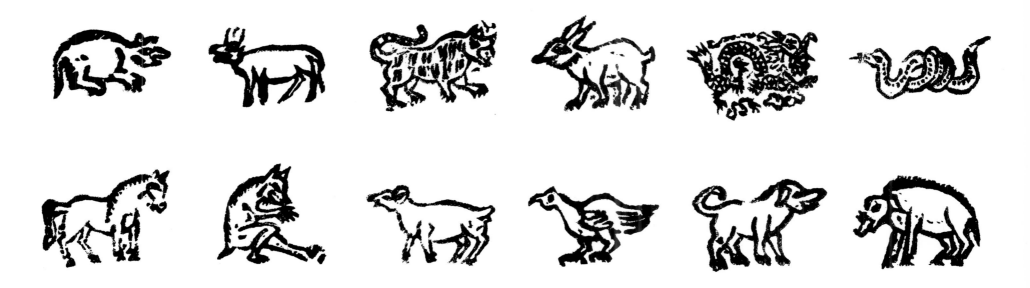

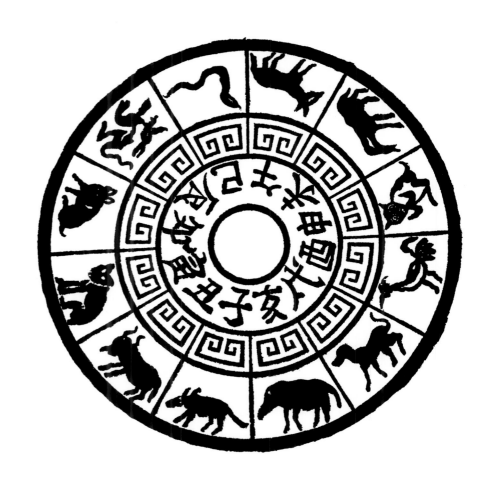

The twelve signs of the Zodiac

I — mouse

II — Bull

III — Tiger

IV — hare

V — Dragon

VI — serpent

horse

VII

Ram

VIII

monkey

IX

X
cock

XI
Dog

XII
pig

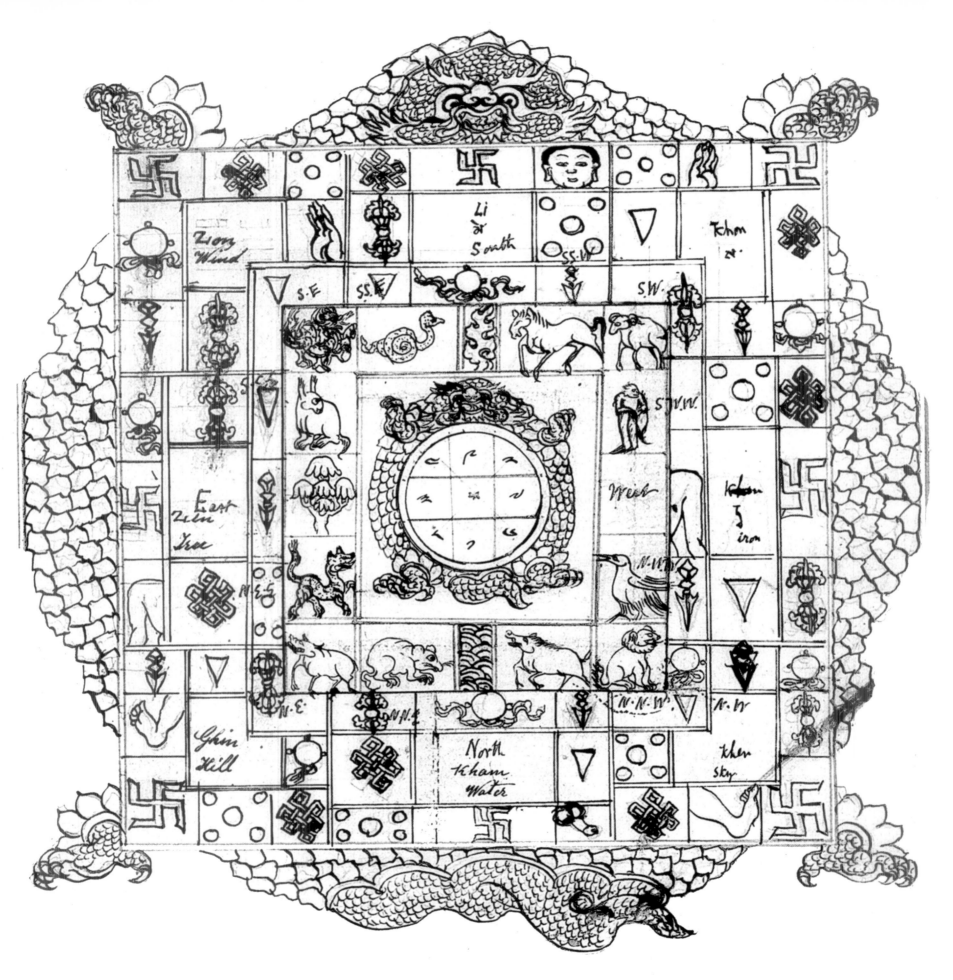

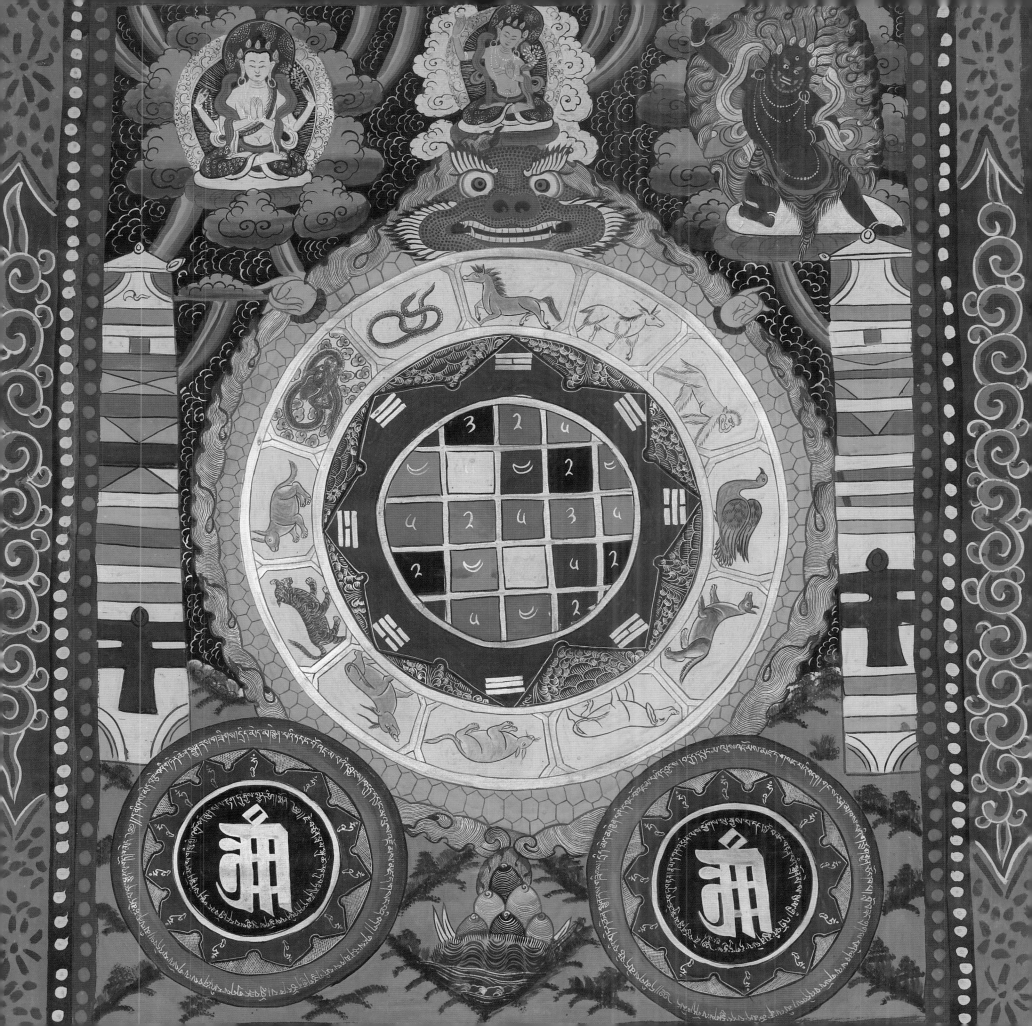

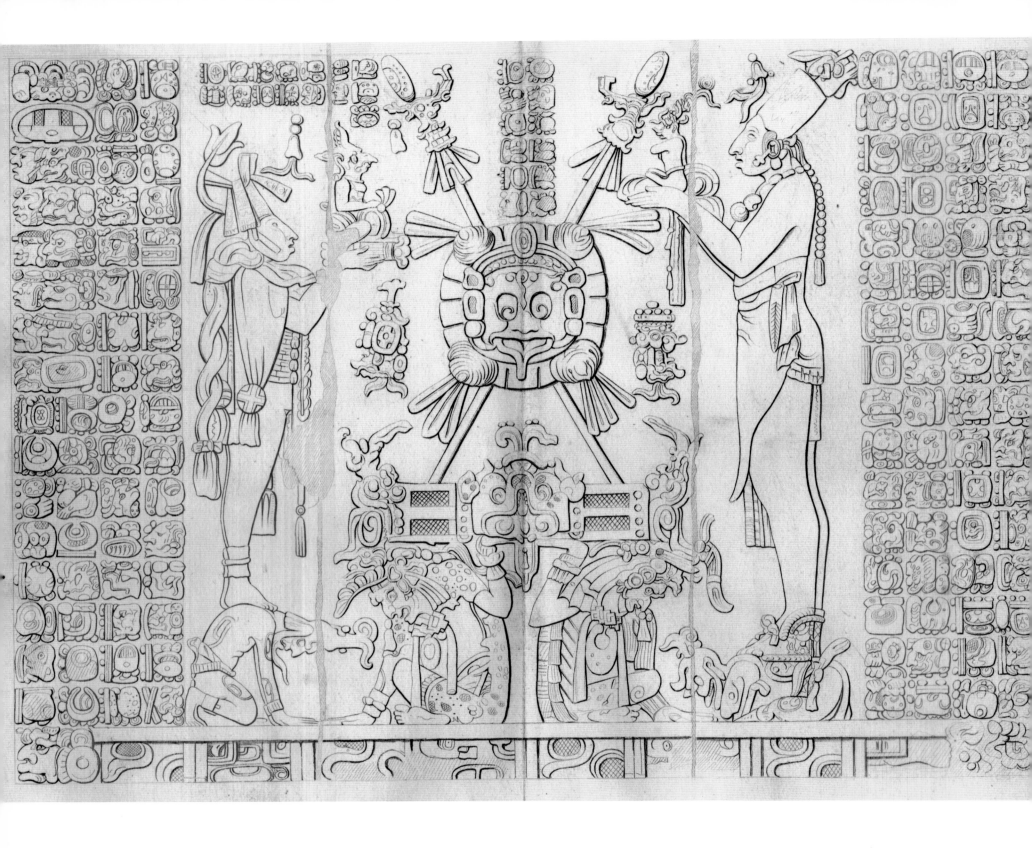

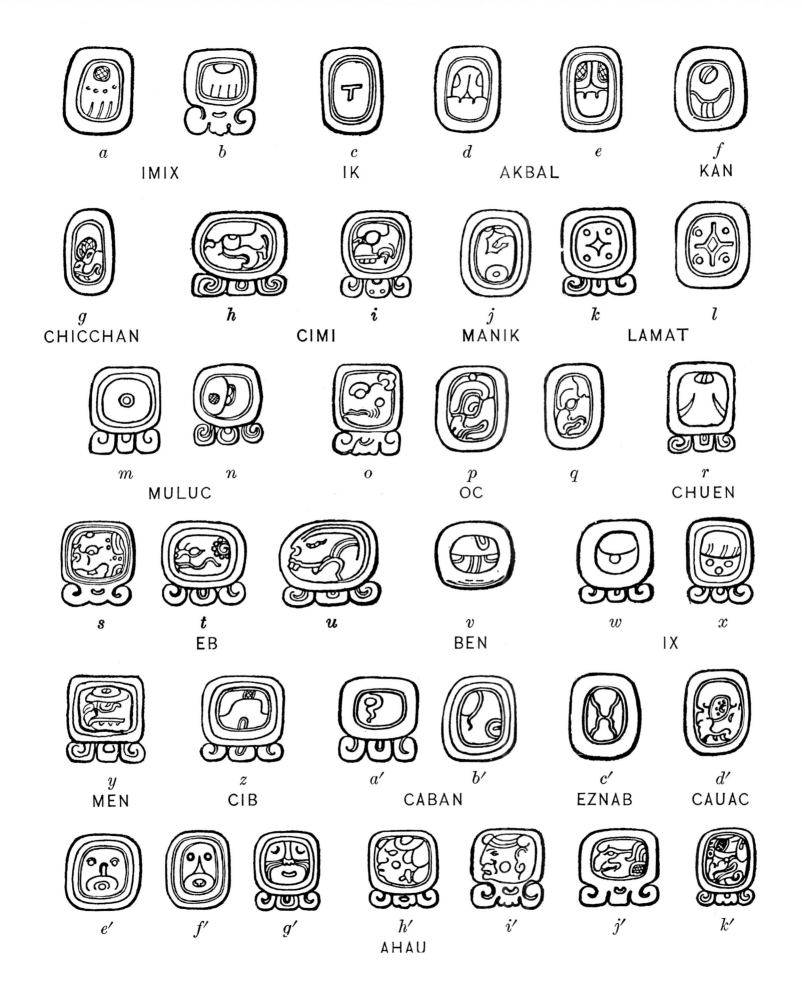

a	*b*	*c*	*d*	*e*	*f*	
IMIX		IK	AKBAL		KAN	
g	*h*	*i*	*j*	*k*	*l*	
CHICCHAN		CIMI	MANIK		LAMAT	
m	*n*	*o*	*p*	*q*	*r*	
MULUC			OC		CHUEN	
s	*t*	*u*	*v*	*w*	*x*	
EB			BEN		IX	
y	*z*	*a'*	*b'*	*c'*	*d'*	
MEN	CIB	CABAN		EZNAB	CAUAC	
e'	*f'*	*g'*	*h'*	*i'*	*j'*	*k'*
		AHAU				

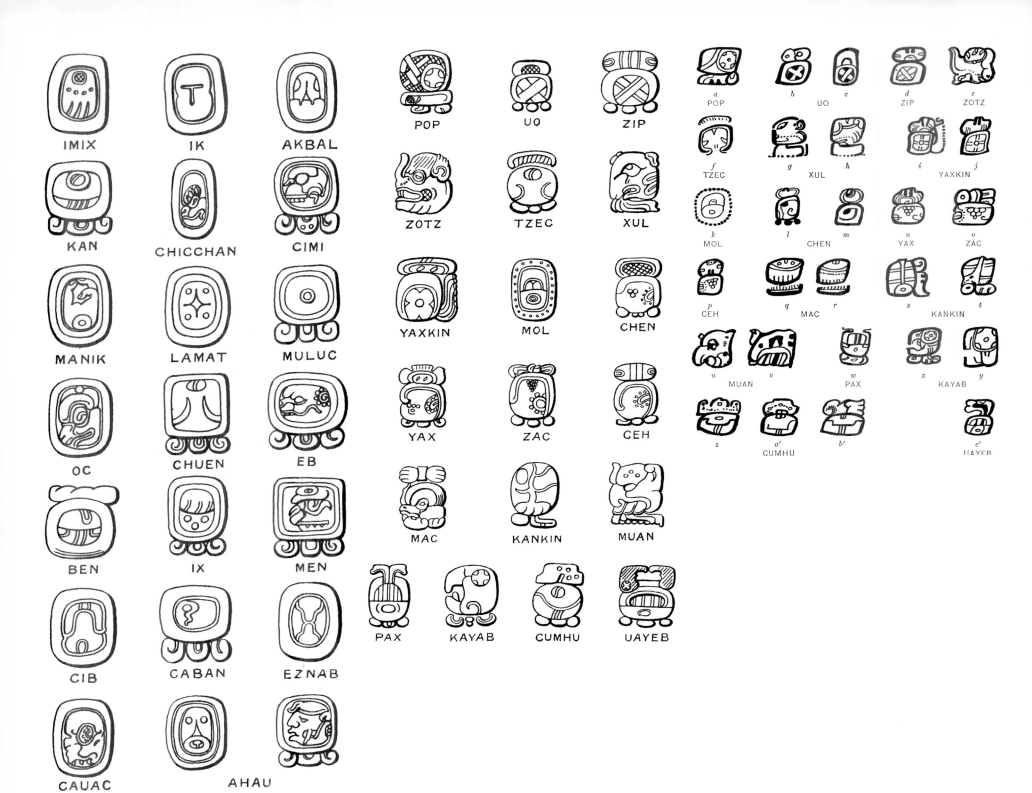

IMIX IK AKBAL

KAN CHICCHAN CIMI

MANIK LAMAT MULUC

OC CHUEN EB

BEN IX MEN

CIB CABAN EZNAB

CAUAC AHAU

POP UO ZIP

ZOTZ TZEC XUL

YAXKIN MOL CHEN

YAX ZAC CEH

MAC KANKIN MUAN

PAX KAYAB CUMHU UAYEB

a POP *b* *c* UO *d* ZIP *e* ZOTZ

f TZEC *g* *h* XUL *i* *j* YAXKIN

k MOL *l* *m* CHEN *n* YAX *o* ZAC

p CEH *q* *r* MAC *s* *t* KANKIN

u *v* MUAN *w* PAX *x* *y* KAYAB

z *a'* *b'* CUMHU *c'* UAYEB

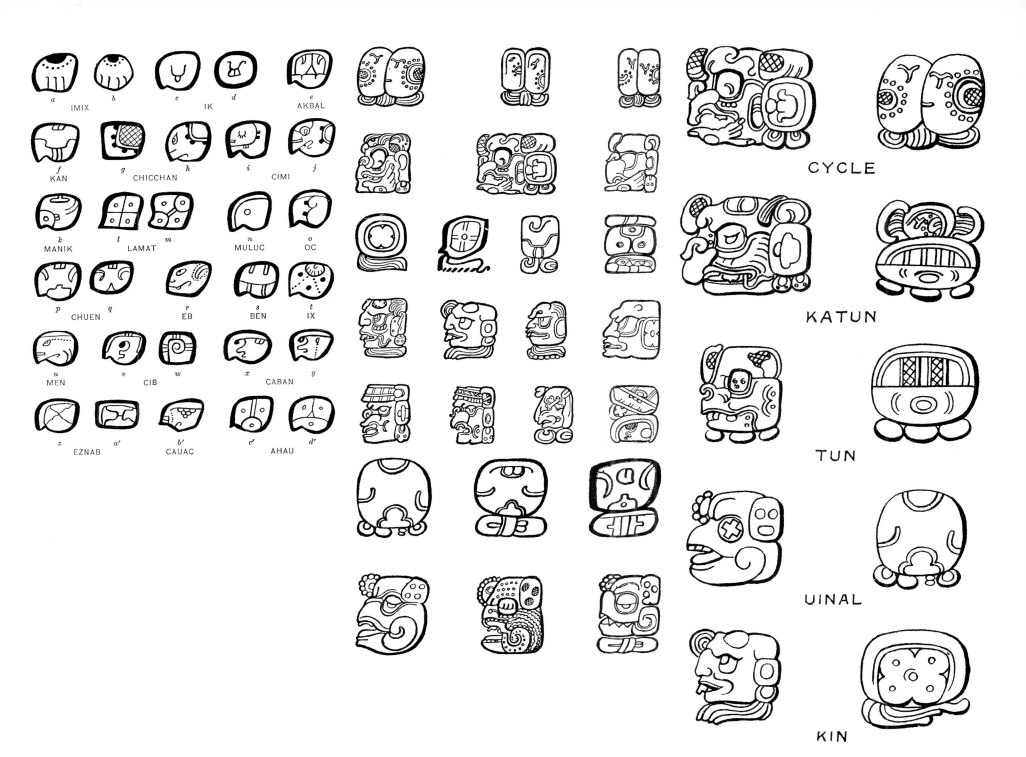

IMIX a · b · IK c · d · AKBAL e

KAN f · CHICCHAN g · h · i · CIMI j

MANIK k · LAMAT l · m · MULUC n · OC o

CHUEN p · q · EB r · BEN s · IX t

MEN u · CIB v · w · CABAN x · y

EZNAB z · CAUAC a′ · b′ · AHAU c′ · d′

CYCLE

KATUN

TUN

UINAL

KIN

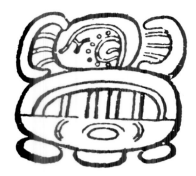 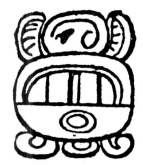 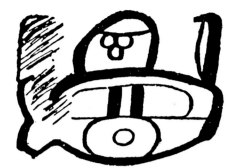 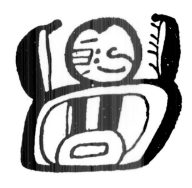

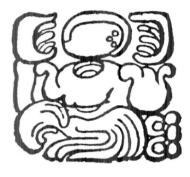 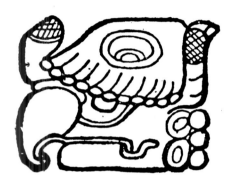 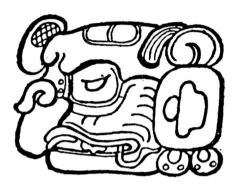 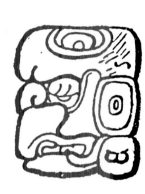

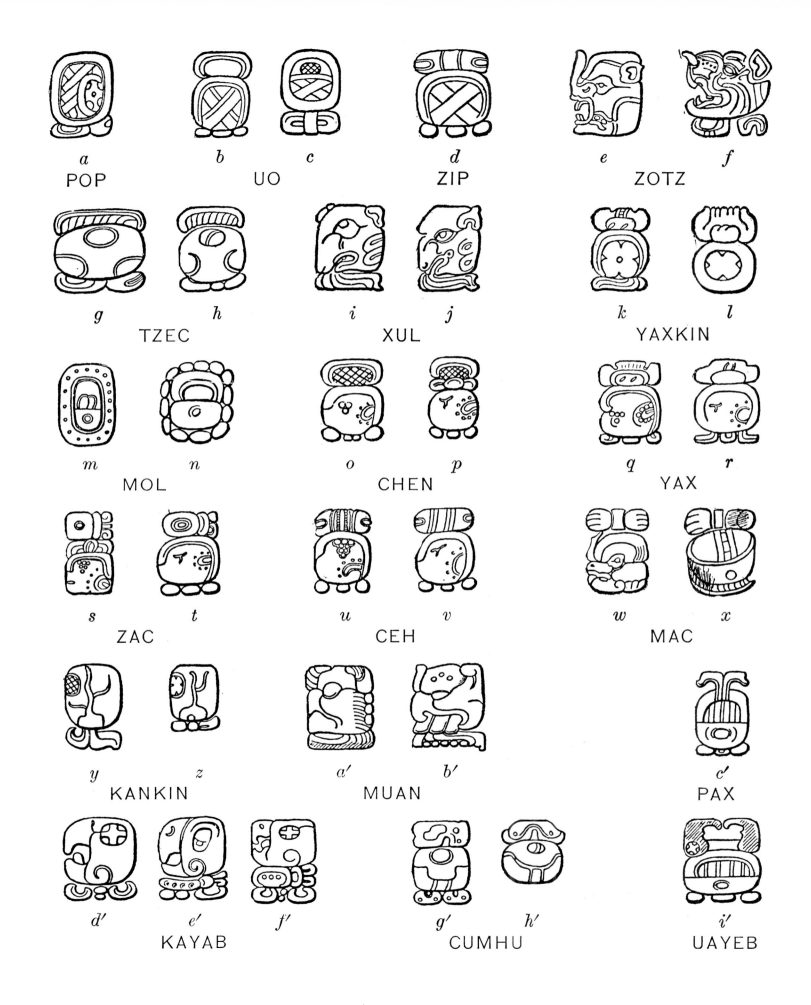

a	*b* *c*	*d*	*e* *f*
POP	UO	ZIP	ZOTZ
g *h*	*i* *j*		*k* *l*
TZEC	XUL		YAXKIN
m *n*	*o* *p*		*q* *r*
MOL	CHEN		YAX
s *t*	*u* *v*		*w* *x*
ZAC	CEH		MAC
y *z*	*a'* *b'*		*c'*
KANKIN	MUAN		PAX
d' *e'* *f'*	*g'* *h'*		*i'*
KAYAB	CUMHU		UAYEB

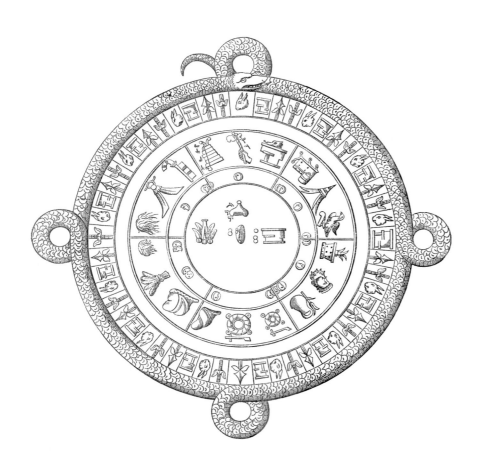

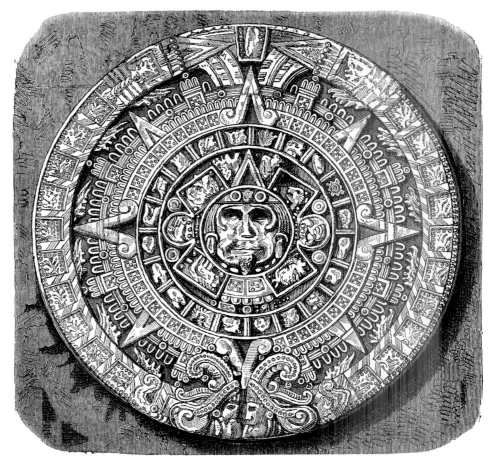

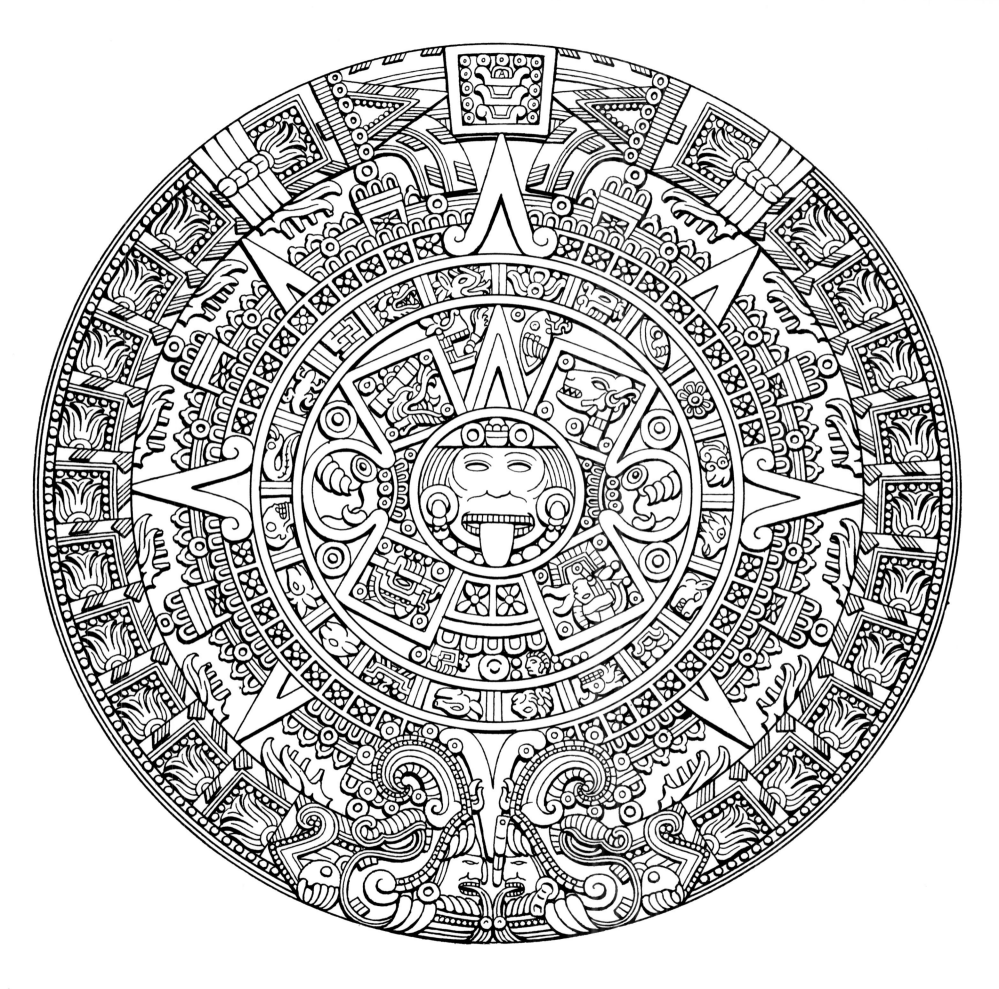

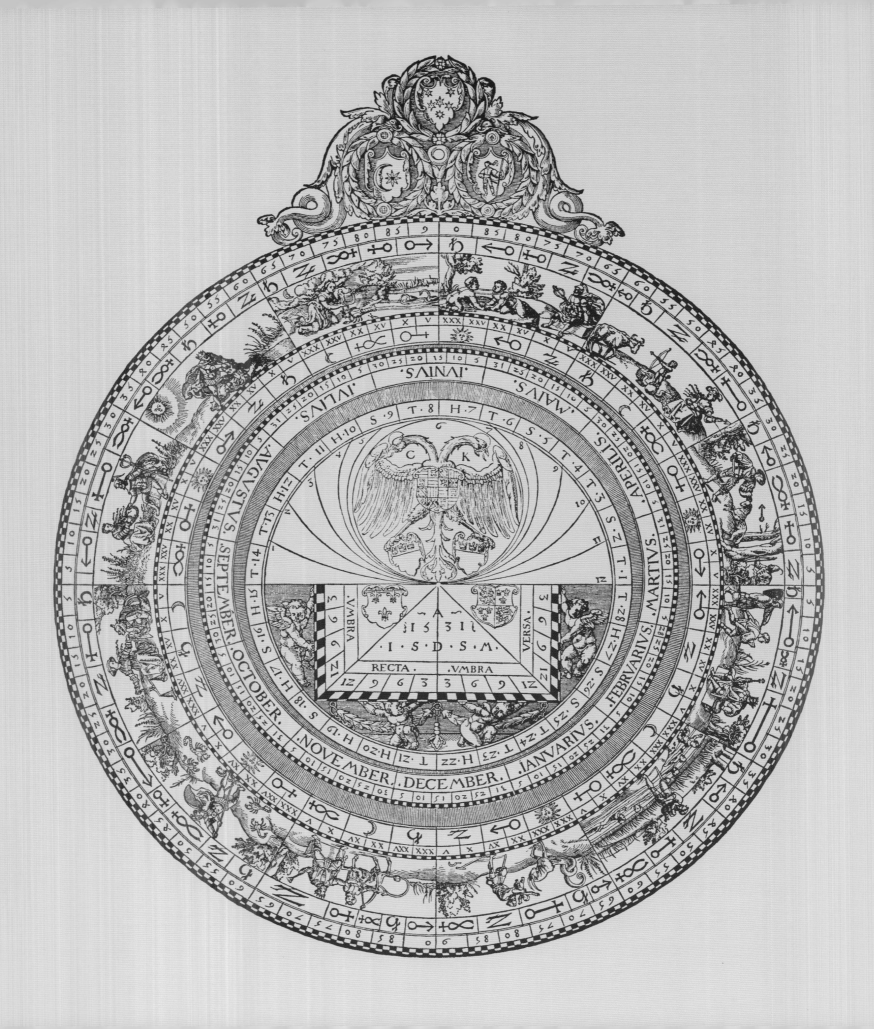

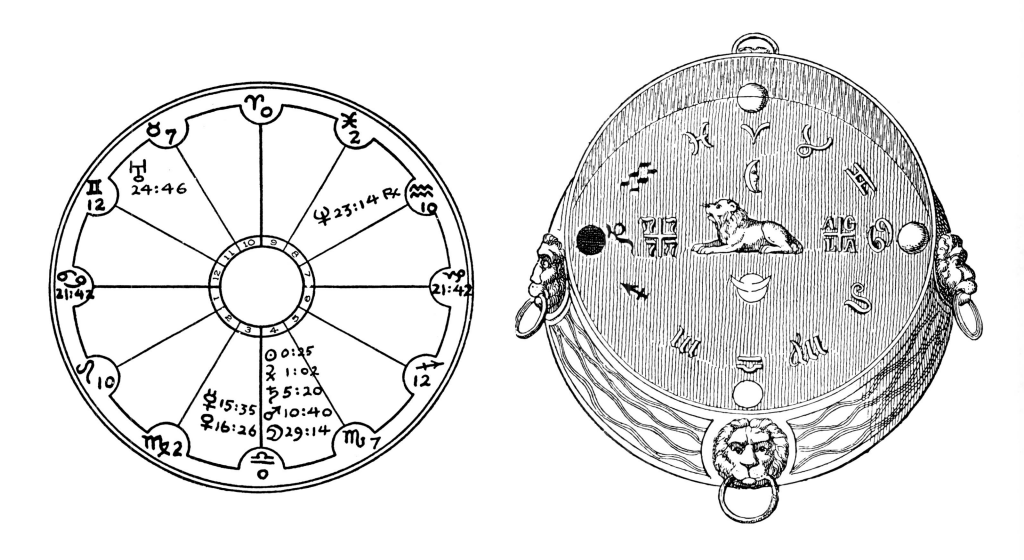

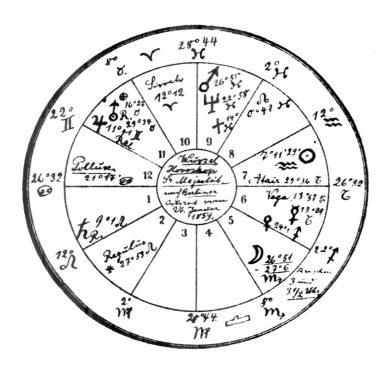

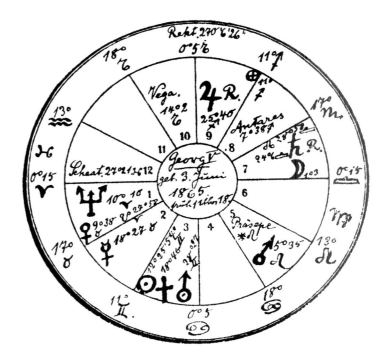

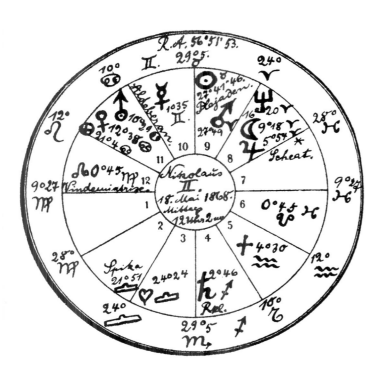

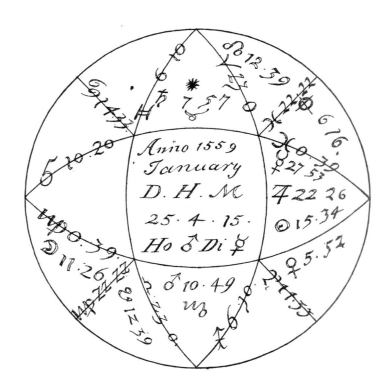

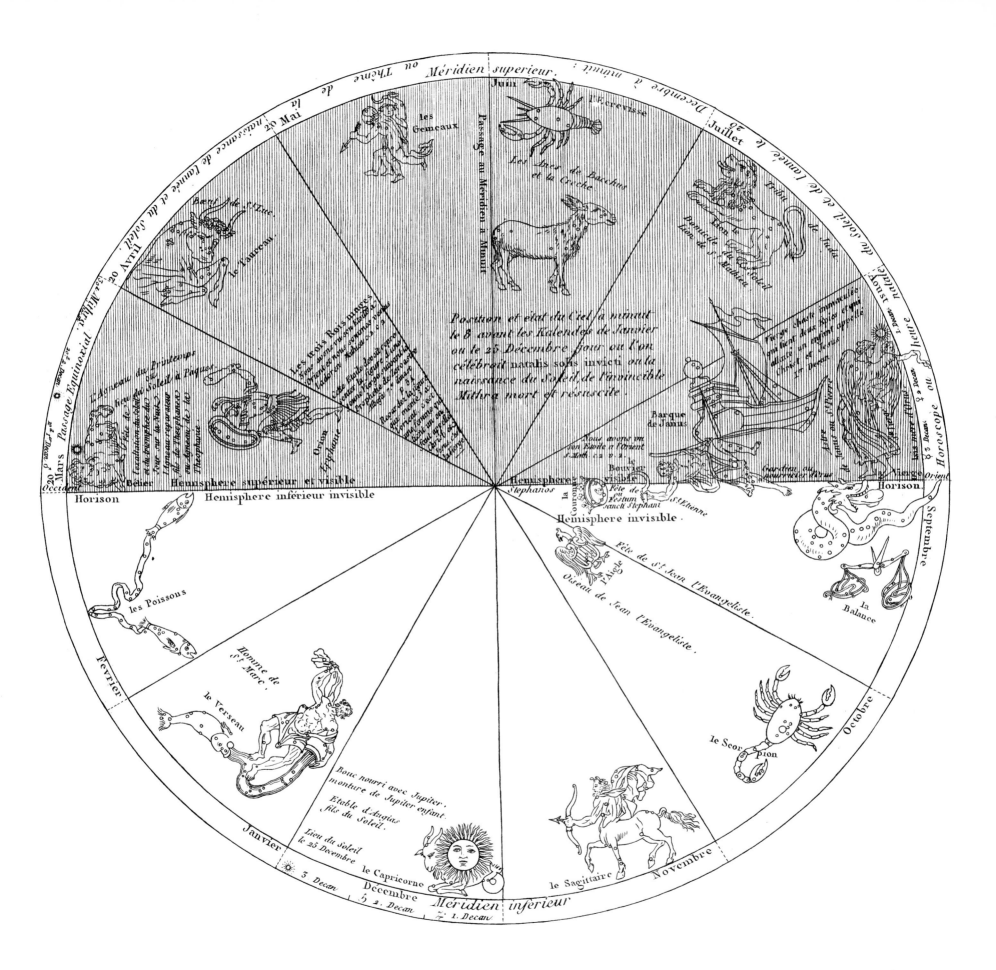

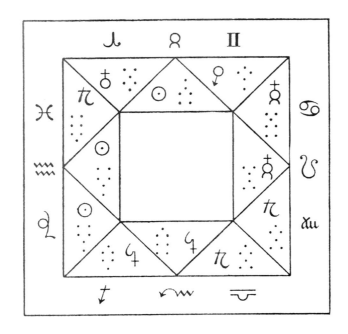

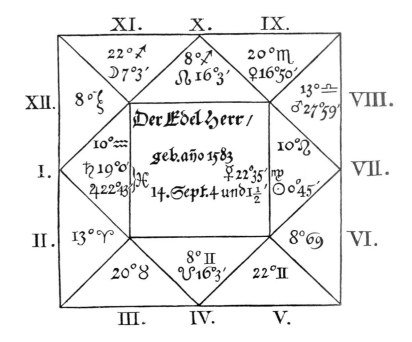

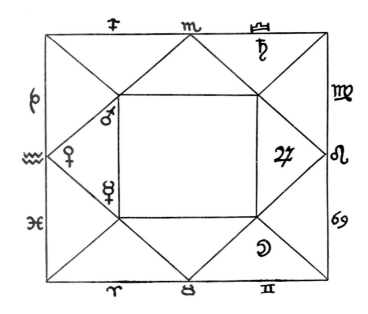

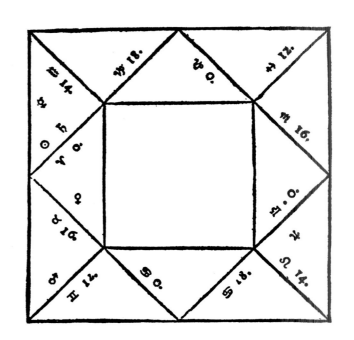

Venus Mercury	Sun Mars		Rahu
	RASEE DIAGRAM		
Birth 20			
Kethu	Saturn Jupiter	Moon	

SUKRA (Venus)	RAVI (Sun)	BUDA (Mercury)	KETU (Dragon's Tail)
KUJA (Mars)	HOROSCOPE *of* RAMA		LAGNA CHUNDRA (Moon) GURU (Jupiter)
RAHU (Dragon's Head)	SANI (Saturn)		

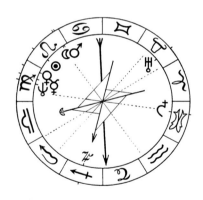

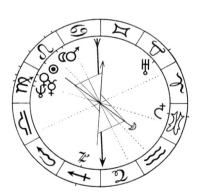

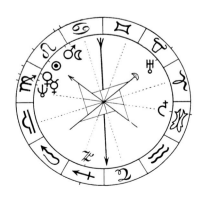

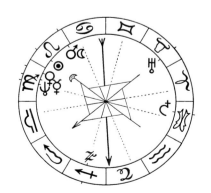

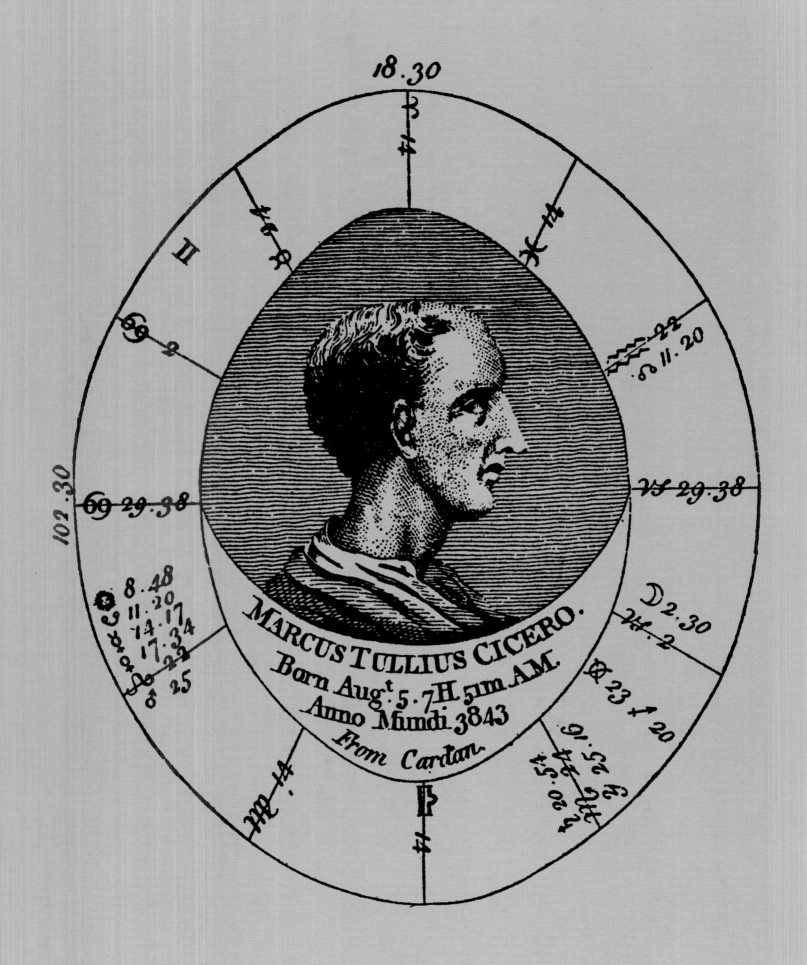

18.30

102.30

69 29.38

VS 29.38

8.48
11.20
14.17
17.34
22
25

D 2.30

MARCUS TULLIUS CICERO.
Born Aug.t 5. 7H. 5m. A.M.
Anno Mundi 3843
From Cardan.

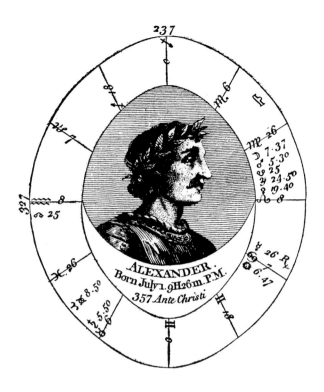

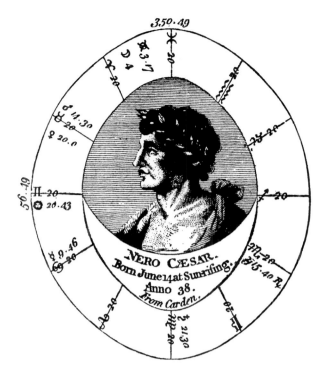

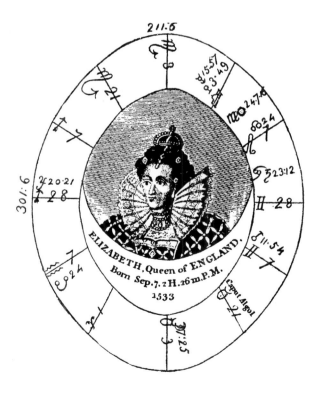

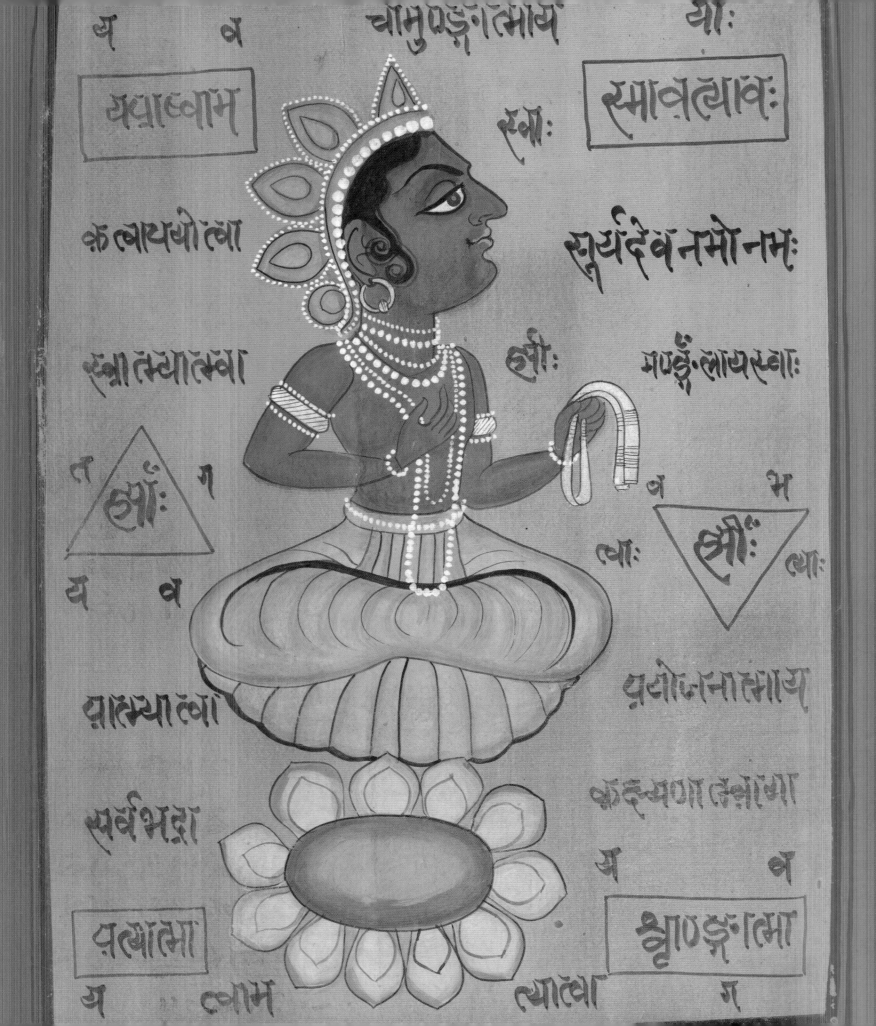

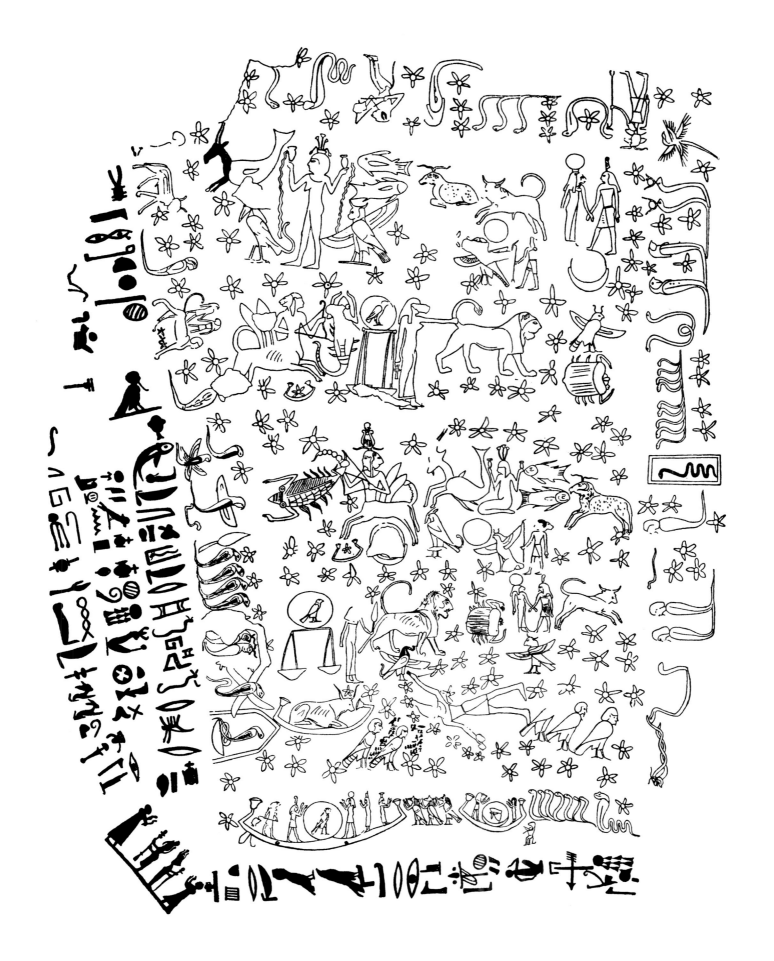

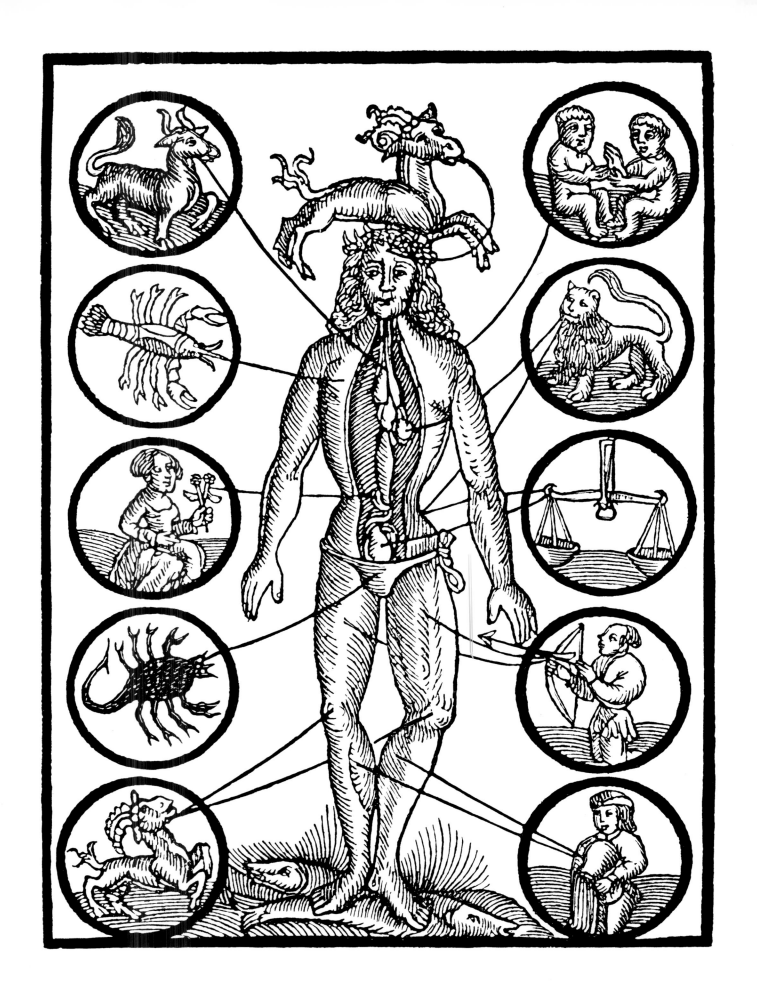

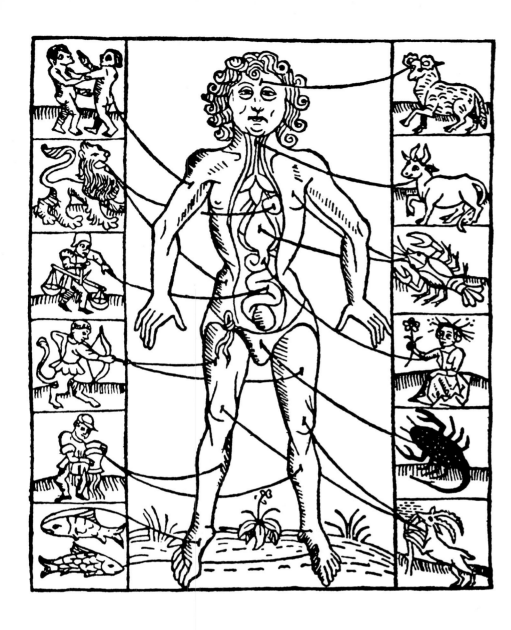

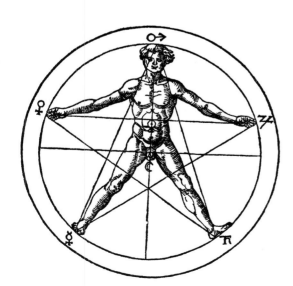

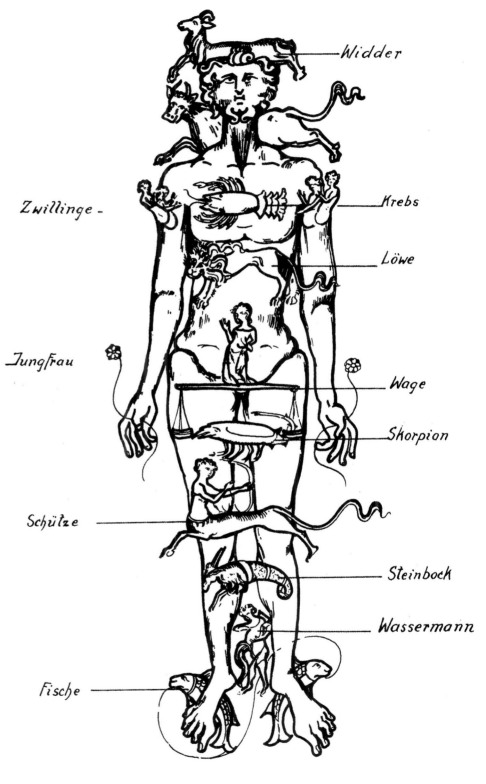

Widder

Zwillinge

Krebs

Löwe

Jungfrau

Wage

Skorpion

Schütze

Steinbock

Wassermann

Fische

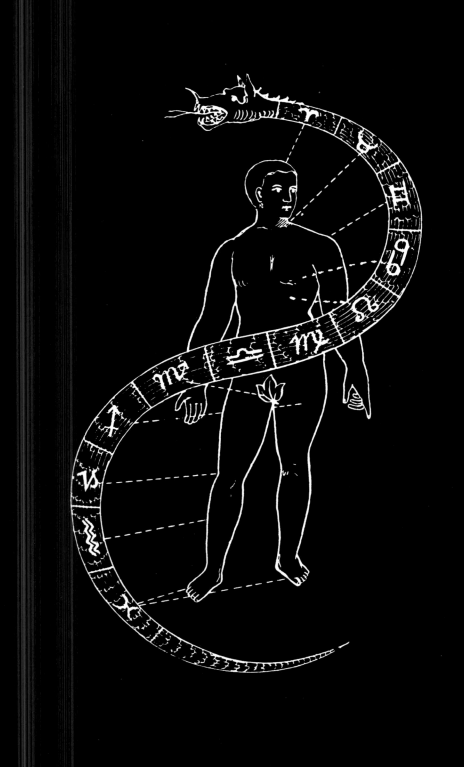

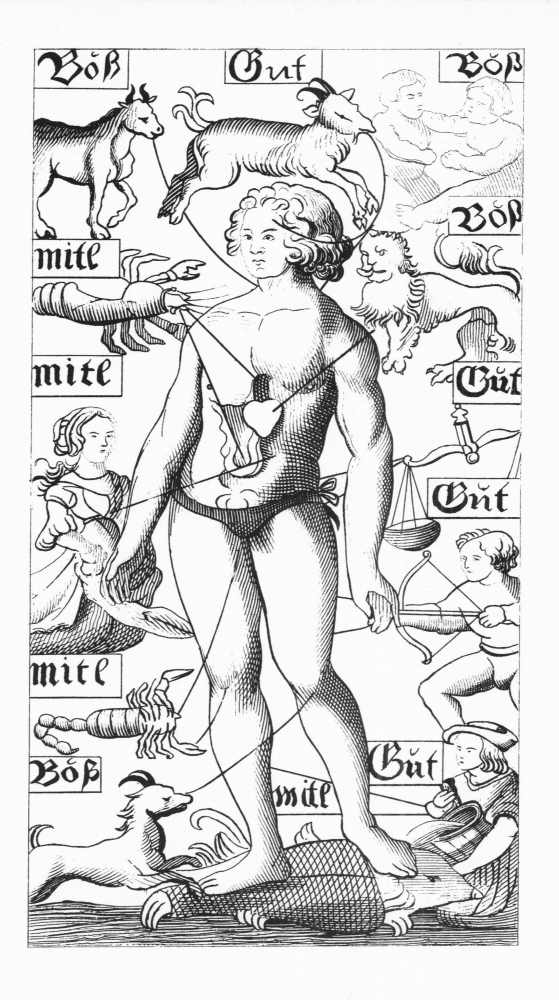

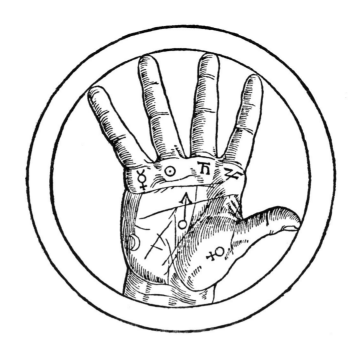

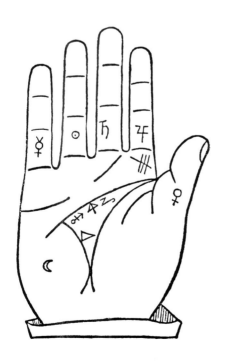

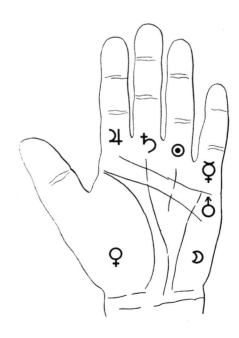

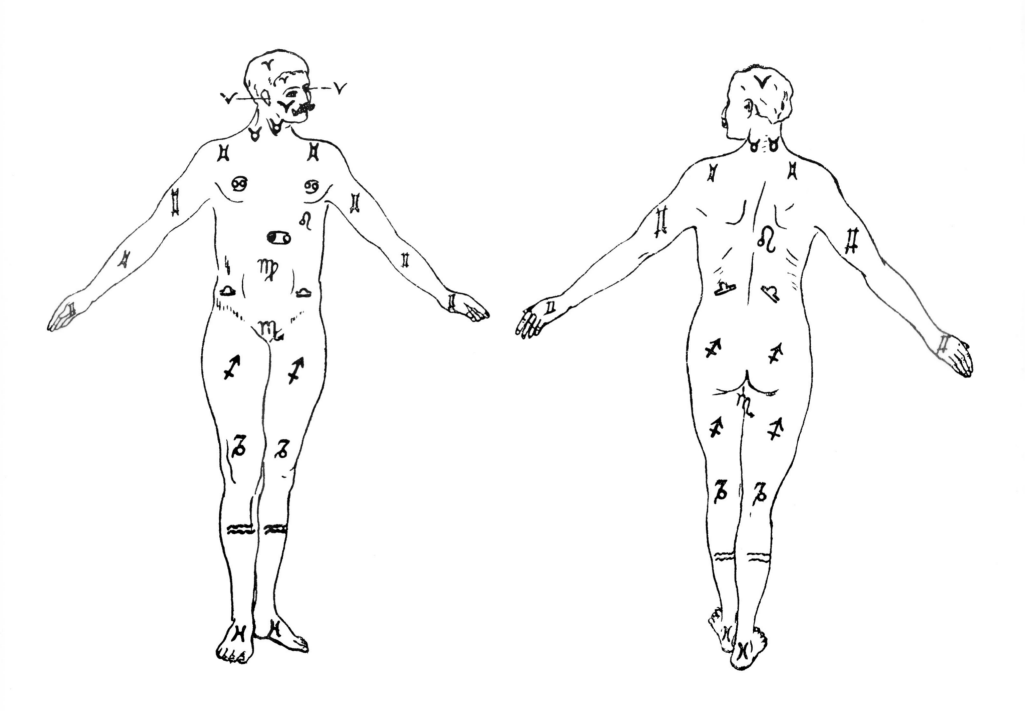

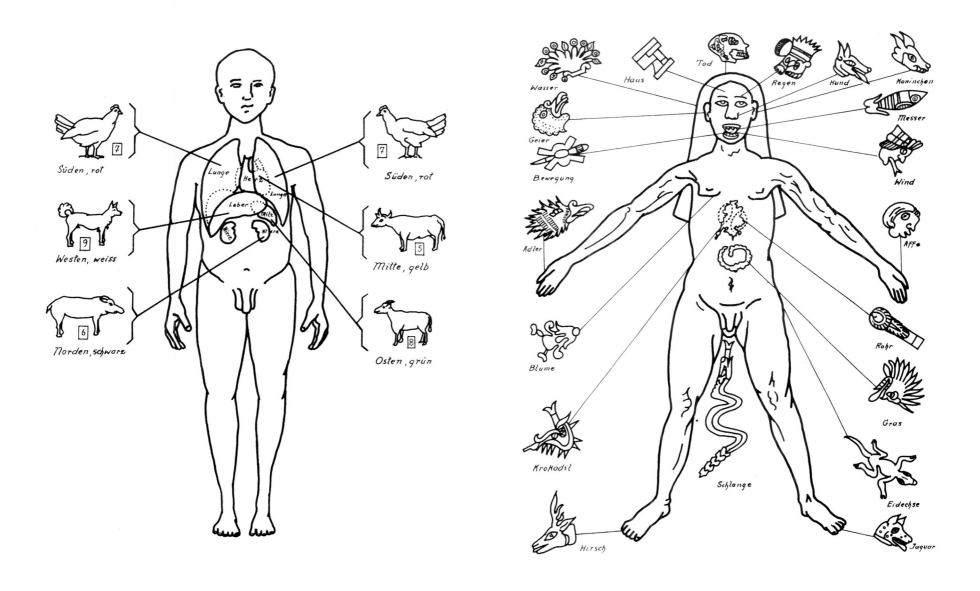

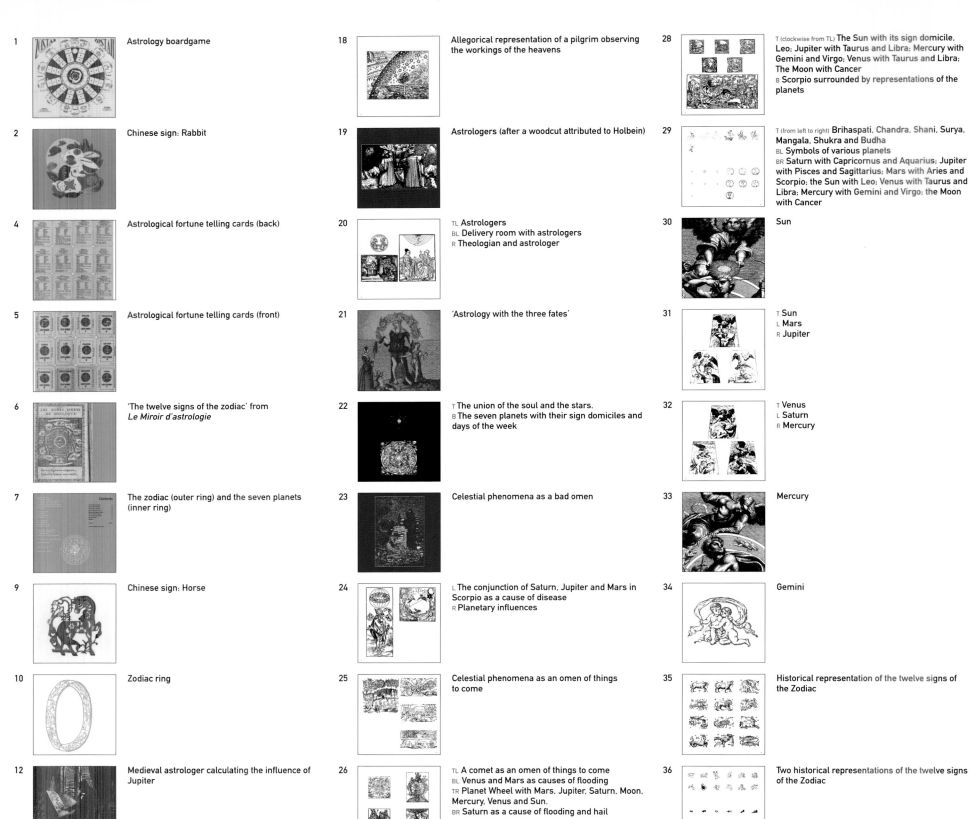

1 Astrology boardgame

2 Chinese sign: Rabbit

4 Astrological fortune telling cards (back)

5 Astrological fortune telling cards (front)

6 'The twelve signs of the zodiac' from *Le Miroir d'astrologie*

7 The zodiac (outer ring) and the seven planets (inner ring)

9 Chinese sign: Horse

10 Zodiac ring

12 Medieval astrologer calculating the influence of Jupiter

14 Zodiac ring with Astrology (left) and Ptolemy (right) at its base

18 Allegorical representation of a pilgrim observing the workings of the heavens

19 Astrologers (after a woodcut attributed to Holbein)

20 TL Astrologers
BL Delivery room with astrologers
R Theologian and astrologer

21 'Astrology with the three fates'

22 T The union of the soul and the stars.
B The seven planets with their sign domiciles and days of the week

23 Celestial phenomena as a bad omen

24 L The conjunction of Saturn, Jupiter and Mars in Scorpio as a cause of disease
R Planetary influences

25 Celestial phenomena as an omen of things to come

26 TL A comet as an omen of things to come
BL Venus and Mars as causes of flooding
TR Planet Wheel with Mars, Jupiter, Saturn, Moon, Mercury, Venus and Sun.
BR Saturn as a cause of flooding and hail

27 T
B Uranus carried by the eagle of contemplation.
Germany, year unknown

28 T (clockwise from TL) The Sun with its sign domicile, Leo; Jupiter with Taurus and Libra; Mercury with Gemini and Virgo; Venus with Taurus and Libra; The Moon with Cancer
B Scorpio surrounded by representations of the planets

29 T (from left to right) Brihaspati, Chandra, Shani, Surya, Mangala, Shukra and Budha
BL Symbols of various planets
BR Saturn with Capricornus and Aquarius; Jupiter with Pisces and Sagittarius; Mars with Aries and Scorpio; the Sun with Leo; Venus with Taurus and Libra; Mercury with Gemini and Virgo; the Moon with Cancer

30 Sun

31 T Sun
L Mars
R Jupiter

32 T Venus
L Saturn
R Mercury

33 Mercury

34 Gemini

35 Historical representation of the twelve signs of the Zodiac

36 Two historical representations of the twelve signs of the Zodiac

37 Two historical representations of the twelve signs of the Zodiac.

38 Two sets of symbols of the twelve signs of the Zodiac

39 Historical representation of the twelve signs of the Zodiac

40 Two historical representations of the twelve signs of the Zodiac

41 Cancer

42 Signs of the zodiac embroidery patterns
U.S.A., 20th century

43 Signs of the zodiac embroidery patterns
U.S.A., 20th century

44 Two historical representations of the twelve signs of the Zodiac

45 Two historical representations of the twelve signs of the Zodiac (the bottom set incomplete)

46 March with its zodiac signs Pisces and Aries

47 From left to right, top to bottom January, February, March, April, May, June, July, August, September, October, November and December; all with their corresponding zodiac signs

48 Historical representation of the twelve signs of the Zodiac

49 The portal of the Notre Dame in Paris, with zodiac signs

50 Decorated zodiac from *Orientalisches Traumbuch*
Potsdam, Germany, c. 1920

51 TL Coin with zodiac ring
BL Zodiac ring with related tropical and sidereal zodiacs
TR Complete zodiac ring with Earth at its centre
BR Zodiac ring with flat Earth at its centre

52 Astrology wheel and scheme from *Orientalisches Traumbuch*
Potsdam, Germany, c. 1920

53 TL and BL Zodiac rings divided into four groups according to their elements
TR Complete zodiac ring with associated months
BR Zodiac ring

54 Zodiac ring

55 'Astrology is the clock of destiny'

56 The position of the planets in relation to the zodiac

57 T The zodiac (outer ring) and the seven planets (inner ring)
L The position of the planets in relation to the zodiac, overseen by Jupiter
R Ptolemaic worldview with the zodiac and the planets surrounding the Earth

58 Astro-kabbalistical planisphere of the signs and constellations of the zodiac

59 The signs of the zodiac

60 Zodiac with symbols, signs and constellations of the zodiac

61 Domigraphe and symbols of the zodiac

62 Zodiac ring with playing card symbols

63 People observing the sky. In frame decorated with signs of the zodiac

64 The solar system, with ornamental zodiac

65 The solar system, with ornamental zodiac

66 Ancient Arabian zodiac

67 Two complete Ancient Egyptian sets of the twelve signs of the Zodiac

98 Tibetan astrological manuscript
Tibet, 19th century

99 Tibetan astrological manuscript
Tibet, 19th century

100 Tibetan astrological manuscript
Tibet, 19th century

101 Tibetan Thanka (scroll painting) with zodiac
Tibet, 20th century

102 Maya priests and altar with carved glyphs
from *Incidents of Travel in Central America*
Published in New York, 1848

103 Ancient Mayan day, month and period signs

104 Ancient Mayan day, month and period signs

105 Ancient Mayan day, month and period signs

106 Ancient Mayan day, month and period signs

107 Ancient Mayan day, month and period signs

108 TL The system of Maya chonology
BL The great Maya calendar stone
R Tonalamatl wheel, showing sequence of the 260
differently named days

109 Aztec calendar stone

110 Decorated horoscope of a rich man (1531)

111 L The horoscope of Genghis Khan
R Horoscopic amulet

112 TL The horoscope of Emperor Wilhelm II
BL The horoscope of Tsar Nikolaus II
TR The horoscope of King George V
BR Horoscope of unknown person

113 Stage of the sky at the moment of the birth
of Christ

114 TL Horoscope with planets, signs of the zodiac and
geomantic symbols
BL The horoscope of Plato
TR Horoscope of unknown person
BR Horoscope of Romulus

115 TL Horoscope of Mohammed
TR Horoscope of Rama
B Diagrams of the position of the planets in
relation to the zodiac

116 Horoscope of Cicero

117 TL Horoscope of Alexander the Great
TR Horoscope of Nero
BR Diagrams of Queen Elizabeth

118 Indian horoscopic portrait

119 Ancient Egyptian horoscope, from a tomb
near Athribis

120 The influence of the zodiac on the human body

121 The influence of the zodiac on the human body

122 Diagram showing the influence of each of the
zodiac signs on the human body

123 The influence of the zodiac on the human body

124 The influence of the planets on the human hand
(chiromancy)

125 The influence of the planets on the human brain

126 The influence of the zodiac on the human body

127 L The influence of the Chinese zodiac on the
internal organs
R The relation of Maya day signs to parts of the
human body

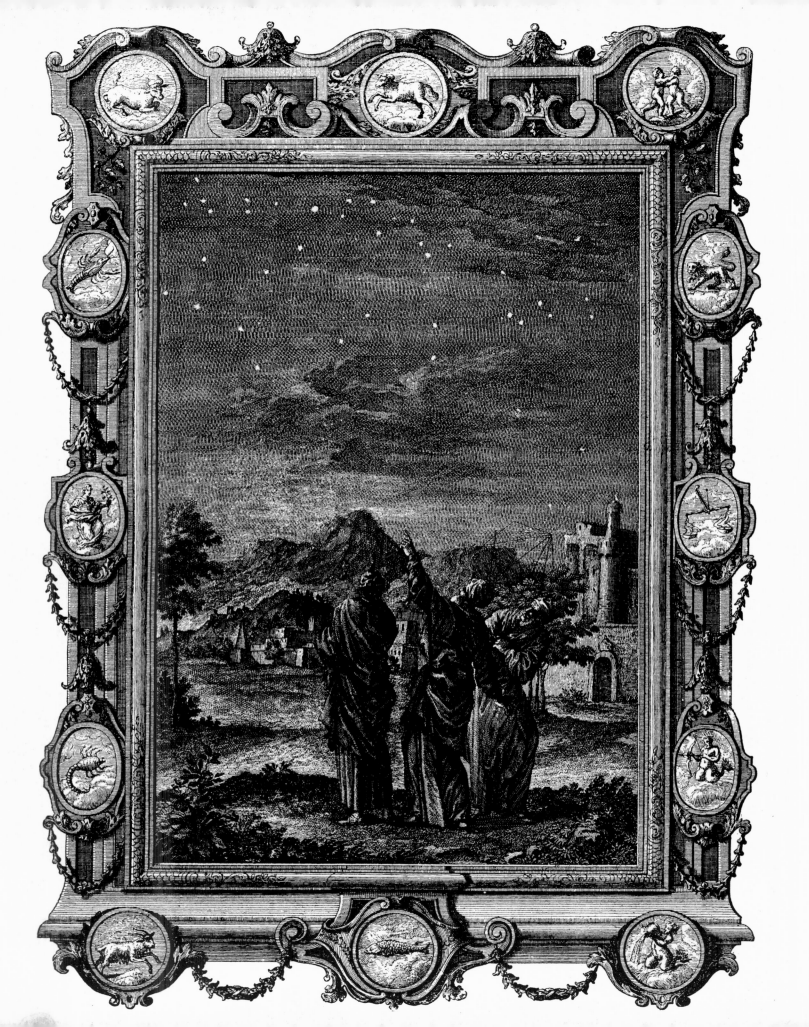